BLENDING COLORS FROM LIFE

Blending Colors From Life
Trenton's Own Watercolorist, Tom Malloy

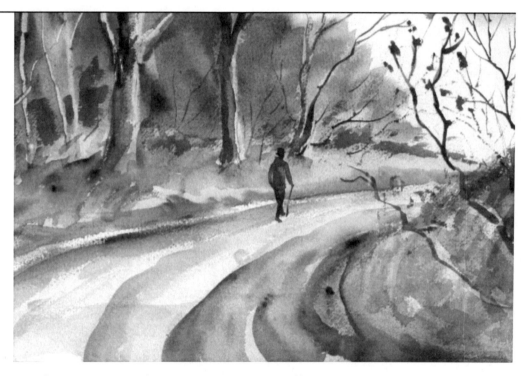

by **Charisa A. Smith** • with **Thomas Malloy** • photography by **Cie Stroud**

Africa World Press, Inc.

P.O. Box 1892
Trenton, NJ 08607

P.O. Box 48
Asmara, ERITREA

Africa World Press, Inc.

P.O. Box 1892
Trenton, NJ 08607

P.O. Box 48
Asmara, ERITREA

Book and cover design: Saverance Publishing Services
Cover Painting: Untitled, (1978), courtesy of Dr. Risa C. Smith

Library of Congress Cataloging-in-Publication Data

Smith, Charisa A.
 Blending colors from life : Trenton's own watercolorist, Tom Malloy / by Charisa A. Smith ; with Thomas Malloy ; photography by Cie Stroud.
 p. cm.
 Includes bibliographical references.
 ISBN 1-59221-433-9 (cloth) -- ISBN 1-59221-434-7 (pbk.) 1. Malloy, Tom, 1912- 2. African American painters--New Jersey--Trenton--Biography. I. Malloy, Tom, 1912- II. Title.
 ND1839.M326S65 2007
 759.13--dc22
 [B]
 2007021622

THIS PROJECT WAS ASSISTED

by a grant from the New Jersey Historical Commission, a division in the Department of State
by PSE&G of New Jersey
by the Office of Mayor Douglas Palmer, Mayor of Trenton, New Jersey
by Mr. Don Allen Smith
by the Radcliffe College Travel Fellowship

AUTHOR'S THANKS TO

The New Jersey Historical Commission, Project Funder

PSE&G of New Jersey, Project Funder

Douglas Palmer, Mayor of Trenton, New Jersey, and the Staff of the Office of the Mayor of Trenton, Project Funder

Mr. Don Smith, Project Funder

The Extended Malloy Family

The Extended Smith and Cardwell Families

Larry Hilton

Mr. Michael Byard

The Times (Trenton)

The Trenton Downtowner

Africa World Press / Red Sea Press

Cie Stroud, Photographer

Karey Maurice, Artist and Project Assistant

Brian Hill, Carolyn Stetson and Ellarslie Museum,

The Trenton City Museum

Sally Lane

Wendy Nardi and the Trenton Public Library

Robert McIntosh and the Staff of the South Carolina Department of Archives and History

Cadwalader Asbury United Methodist Church

Mr. and Mrs. Joseph P. Teti and Triangle Art, Faithful Art Suppliers and Collectors

Dr. Risa C. Smith, Agent and Collector

Charles H. Smith, Friend and Collector

Geraldine Doswell, Friend and Project Advisor

Dr. Jacqueline Saba, Friend and Project Advisor

Barbara Bakari, Project Advisor

Brenda Lewis, Project Advisor

Laura Baynard, Project Advisor

The Worthams, Friends and Collectors

Ted and Jane Boyer, Collectors

Kathi and Fred Bedard, Collectors

John and Debra Watson, Collectors

Malaga Restaurant and Its Management and Staff, Collectors

Mr. Henry Page, Restranteur and Collector

Mrs. Molly Merlino, Friend and Collector

The Various Arts Societies That Tom Joined, Which Are Mentioned Throughout the Book

Martha Runyan

Jack Washington

Leslie Hayling

The Goss Brothers, Goss & Goss Gold Medal Boxing Club

Roosevelt Butler

Jannie Harriott, South Carolina African American Heritage Commission

Don Barclay, Dillon County South Carolina Historical Society

Barbara Jenkins, South Carolina African American Heritage Commission

Donald Brown, Rider University

Janet Hunt, Director of the Coryell Gallery

June Ballinger, Passage Theatre

Carl F. West, Mercer County Office on Aging

Florence Bishop

Ruby Carter

James C. Crawford

Isabella Davis and Family

Inez Murray - Toles

Melissa Chiatti, Friend and Digital Photographer

Angela Ajayi, Cathy Mitchell (Esq.), Marvin Ross, NJ State Senator Shirley K. Turner, Jean and Richie Smith, The Crumel Family, The Jones Family, Aziza Johnson, Elizabeth Lee-Beck (Esq.), Bijal Shah, Ranessa Porter, Nissara Horayangura, Reema El-Amamy Dinkins (Esq.) and Fred Dinkins, Kapriece Harell, Cynthia Jung, Dale Bromberg, Holly Nimrov, Allegra McLeod (Esq.), Ewurama Ewusi-Mensah, Carl Moore, Rana Jaleel (Esq.), Chinwe Onyeagoro, G. Lisa Wick (Esq.), Jarrod Balmer, Intisar Rabb, Annie Harlan (Esq.), Shirley Ellis, Esther Naples, Ana Encarnacion, Dr. Marybeth Boger, Robert B. Davis (Esq.), Steven Connley and Brent Baker, Shana Alston, Felicia Medina (Esq.), Nina Davidson, Michelle Cheltenham, Amy Kim, Kristen Knepper (Esq.), David Kelly (Esq.), Stacy Davy (Esq.), Damara Griffith (Esq.), Kevin Chambers (Esq.), Shannon Scott, Quisquella Addison, Lorna Reid, Danielle Romain, Devant Whitfield, Kim Funderburk, Holly A. Thomas (Esq.), Jason Levitis (Esq.), Shelley Geballe (Esq.), Ellen Scalettar (Esq.), and Janice Gruendel (Ph.D.) at Connecticut Voices for Children, Mark Soler (Esq.), Mark Schindler (Esq.), Joe Scantlebury (Esq.), and Liz Ryan, Professor J.L. Pottenger, Jr., Professor Harlan Dalton, Professor Robert Burt, Professor Anita Allen-Castellito, Dean Natalia Martín, Dean Mike Thompson, Kenneth Chen (Esq.), Jamelle Sharpe (Esq.), Mijha Butcher (Esq.), Nicola Williams (Esq.), Shirley Udekwu Emehelu (Esq.), Ikenna Emehelu (Esq.), Kevin Herwig, Linh Dao, Nishat and Pieter Ruiter, Jeanne Milstein and the Office of the Child Advocate of Connecticut, Larua McCargar and Youth Rights Media, La Fundación Mujer-Iglesia, CEAESPA Panamá, Niños del Camino, Dr. Christine Chen, Sarah Kalloch, Oluwaseun Ajayi (Esq.), Brian Nelson (Esq.), Jessica Seebeok (Esq.), Debbie Green (Esq.) and Zakiyah Green, Sabrina Charles (Esq.), Phillip Smith (Esq.), Kamil Redmond (Esq.), Tico Almeida (Esq.), Adam Romero (Esq.), Lisa Powell (Esq.), Artrice Sanders, Andrew Mandel, Omolara Fatiregun, Geoffrey Fowler, Shakibria Anderson, Ying Ying Lee (Esq.), Trevor Blake (Esq.), Josh Simon, Irina Babushkina, Loren Krywanczyk, Karen Baldoni (Esq.), Ebonie Conover, and Harold McDougall (Esq.)—

All Friends and Advisors

The Honorable F. Lee Forrester and his Staff

The Honorable Michael Mack

The Baha'is of Lawrenceville, New Jersey; The Baha'is of Yale University; and the Baha'is of the greater New Haven, Connecticut area

The New Jersey State Museum

And the Countless Other Collectors of Malloy Paintings

TABLE OF CONTENTS

A WORD ABOUT THIS BIOGRAPHY

The reader expecting to open this book and find lofty, historical prose may be pleasantly surprised. In deciding how to write this book, it was first essential for Mr. Malloy and me to determine who the audience should be. Most important, we considered the audience we thought would want to enjoy reading this life story.

Tom Malloy's story is that of a man whose incredibly colorful life spans the interests of many people. He was a native son of both the North and South. His worldview can therefore teach us volumes about the spirit and traditions of both parts of America. Likewise, Tom offers valuable gems of wisdom in simple verse to inspire the common man. For he has walked in many different shoes.

Tom's journeys as a shy sharecropper's son, a troubled student, an intellectual, a preacher, a factory worker, a food service and mental health worker, an activist, and a professional artist all open windows onto the trials and tribulations of each of those groups. Consequently, there is a little of Tom Malloy's life story within us all. As Tom tried multiple paths on life's course, so should the readers of his story. Tom's constant faith endured multiple struggles and invites us to keep chasing the belief that *everything* happens for a reason. Tom's courage to pursue professional painting after the age of fifty can especially inspire everyone to keep their dreams alive, no matter how impossible it may seem.

The style of this biography reflects Tom's and my goals. In hopes of inspiring a broad audience, I used few formalities. I feel his life speaks for itself, and I wanted all readers to become personally, intimately acquainted with him. I chose the joy of enhancing Tom's own vivid, even humorous words rather than using the more analytical style of academic biographies.

We hope that through this book both young and old, scholars and craftsmen, and various cultural groups can learn directly from Mr. Malloy. Tom and I aim to reach not only minds, but also spirits, through the power of storytelling and illustration in this narrative. My personal concern for Tom's legacy particularly urges me to capture the warmth of his words and generosity to inspire others.

This book serves as a presentation of Tom Malloy's memories and insights. I have not altered his words and have only shaped them through continuous, third-person narration. When necessary, slight historical contextualization is given.

All text in quotation marks comes directly from taped interview sessions with Tom Malloy, which occurred over several years between 1996 and 2005. What makes the book particularly historical is its true representation of Tom exactly as he thinks and feels, with his own personal shadings of opinion and contrast. It aims to show his life as he would like others to remember it. I have simply helped him to tell his own story.

I hope Tom Malloy's story entertains you as a tale, and I am delighted that it proves traditional history can be found around every corner. Because of Tom's varied life experiences, accomplishments, and his vivid memory, his story naturally relays the gift of historical knowledge.

As Tom is one of Trenton, New Jersey's most skilled native artists, his memoirs and paintings brim with valuable facts about Trenton's past. Tom has seen the vibrant life of many Trenton communities. He has survived two world wars, the Harlem Renaissance, and the civil rights movement. Remembering a remarkable number of moments in compelling detail, Tom provides an inside perspective into the American experience within the 20th and 21st centuries.

I have so many collectors. All over the world.
And to all who've been supportive, thank you.

-Thomas Malloy
November 14, 2002

To my nephew Frank Malloy Junior
and to my niece Ida Malloy, thank you.

-Thomas Malloy
December 22, 2002

Lighthouse, (1999), courtesy of the author, Charisa A. Smith

INTRODUCTION

Tom's sincere, astute, honest eyes peer out from behind a pair of brown, slightly cocked eyeglass frames. As the ninety-three-year-old subject of this biography, Tom also possesses a heart of gold. His fascinating experiences could span the lives of several men.

We first met fourteen ago at Ellarslie Mansion in Trenton. At that time, I was a thirteen-year-old girl tagging along with my mother. I could not quite comprehend her newfound quest to buy the perfect "Tom Malloy painting" to begin her art collection, so I finally agreed to go see the work and the artist for myself. Upon entering the museum where Tom Malloy's works were featured, however, I soon realized that it was a great honor to meet the artist whose delightful works hung on the walls.

Tom Malloy's paintings easily conveyed the story of a world full of lovely landscapes, modest homes, and Trenton's unique character and charm. I was particularly struck by the serenely blended colors in Tom Malloy's art. Most importantly, however, Mr. Malloy's own words provided my young mind with intriguing insight. Through the years, his storytelling has shown me that each opportunity, place, and experience in life can become a vivid color in itself.

Ongoing conversations with Tom Malloy gradually convinced me that he was talented not only at painting, but at the art of *living* itself. Tom enthusiastically described the past and present around him with a fascination that is rarely found in young children, let alone within adults.

I realized that a combination of curiosity, faith, and courage characterizes Tom's life. This makes him an exemplary, passionate man. While Tom Malloy's path toward art was admittedly unmapped, he feels that fact is an asset. He has let his breadth of careers and experiences enrich him, and he has never regretted the situations that fate's hand has dealt him. Tom's positive attitude enabled his artistic dream to persist, even when he strayed far away from the art world in life.

After becoming aware that Tom's life story was so poignant and colorful, I asked if I might help him share it. I hoped to help him provide the world with a lesson in how we all can live, dream, and love. When helping him record his memories, an ironic idea suddenly occurred to me: Tom's life story is so intriguingly multifaceted that it resembles a watercolor painting by a master artist. As the technique that Tom chooses to paint with, *watercoloring* is therefore a perfect metaphor for the method that he used to construct his life. Throughout this book, I seek to show that we can all construct colorful, vibrant, masterpiece lives like Tom's. I suggest that we should all practice the magic of *watercoloring* in life.

In art, *watercoloring* involves applying "transparent colors, applied in delicate washes, one upon the other, allowing the paper to act as an illuminating agent." An artist will soon find that "considerable . . . brilliance is created by the contrast between the reflective luster of the . . . paper and the depth and richness of the heavily loaded color in the hollows."

In simpler words, *watercoloring* in art is the precise application of carefully diluted colors one upon another onto a page. A watercolorist who seeks to make a masterpiece will focus his emotions and energies specifically on each singular brush stroke at the time he is making it. This helps him achieve a painting full of feeling and depth. After a time, the paper itself seems to illuminate what is painted. The artist keeps the faith that the background paper will always be there, serving its purpose. And the artist can later sit back and be pleased.

In cultures like China and Japan, a watercolorist strove for "absolute coordination between mind and hand. As the point of the brush touched the surface of the paper, he attempted to communicate an inner feeling. . . through his hand to the tip of the brush and thence to the content of the painting."[1]

Watercoloring in life would be very similar to the artistic technique: I define *watercoloring* in life as allowing various experiences—or colors—to enter upon the canvas of our lives. It involves seeing each task, influence, joy, and sorrow as a unique, inspirational color, yet holding onto a consistent solid-colored backdrop of unchanging dreams as if it was the paper on which we paint.

As each new experience (color) presents itself in life, a wise person (watercolorist) would apply it with his brush—or focus on it with his whole heart, striving to communicate his feelings while experiencing it. He would not worry about where each color, or experience, will ultimately lead him or how his underlying dreams (or the background paper) will relate to each experience.

Just as the practice of *watercoloring* in art will best blend all colors at the precise moment fate would have it, so *watercoloring* in life can enable us to live exciting, deeply felt lives to the fullest. *Watercoloring* in life is what can keep us from being restricted by one path, career, or expectation for ourselves. It can help us reach our dreams while still trying various possibilities.

You will see in this book that Tom Malloy's story is a remarkable model of *watercoloring* in life. I only hope that his tale will inspire you to be a watercolorist in the most imaginative sense of the word. Through *watercoloring* both in life and in art, Tom happened to make an impact on many places and people.

Fourteen years after our first encounter, Mr. Malloy has made a profound impact upon my life. He has persuaded me to accept the challenges and opportunities as they come to me, to put forth my best foot in every situation, and not to worry about the sum total of my life.

At age ninety-three, Tom moves spryly. He peers as alertly from his spectacles as he did back when we first met. His strong, creased, yet gentle artist's hands are brown. They bear witness to a life fully lived, communicating with paintbrushes while maintaining a laborer's strength. Tom's enjoyable story has inspired me to hope that I can age as gracefully as he has aged. I, too, hope to make my life a faith-filled yet brilliantly colored work of art.

Writing Tom Malloy's biography has been a great pleasure and an honor. I thank him for the ongoing taped interviews, his openness, and his love of sharing with his community.

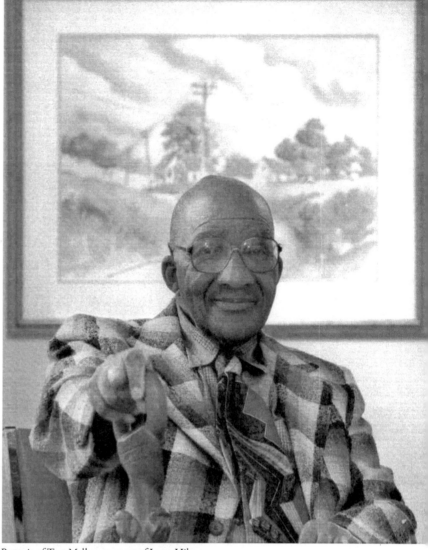

Portrait of Tom Malloy, courtesy of Larry Hilton

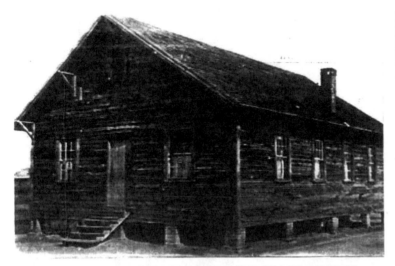

NEW TOWN (DILLON) COLORED SCHOOL AND DILLON COLORED
SCHOOL (DATE UNKNOWN). *COURTESY OF W.M.C. LEE'S DILLON (SC)
COUNTY SCHOOLS*

1920 SOUTH CAROLINA CENSUS RECORD FOR THE "MALOY" FAMILY.
(REEL 574, E.D. 32, SHEET 18, LINE 76). *COURTESY OF THE S.C. DEPT.
OF ARCHIVES AND HISTORY*

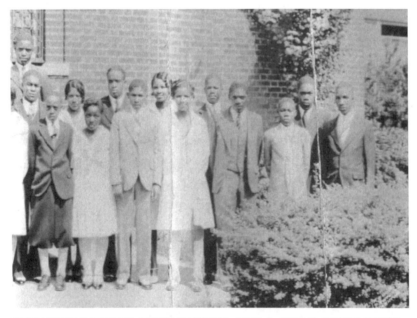

NEW LINCOLN SCHOOL (TEENAGE YEARS, 1920s). TOM IS ON FAR RIGHT.

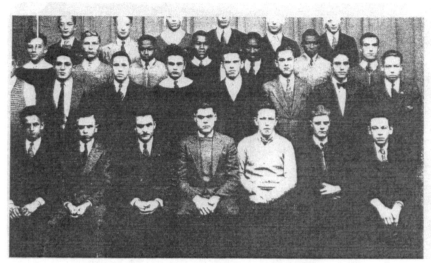

1934 "BOBASHELA"
boys' glee club

First Row — Henry Sharkey; Frank Wolf; F. Murray Westover, sponsor; Bruce Willever; Russell Drechsler; Arthur Holden; Max Allard.

Second Row — Allard Ford; Leon Rosen; James Hartwell; Gordon Latella; Harold Van Buskirk; Richard Smith; Arthur Masina; Henry Mantel.

Third Row — Lawrence Pitt; Stanley Wiedemann; Thaddeus Rice; Richard Dickinson; Thomas Malloy; Thaddeus Patterson; Alton Eby.

Fourth Row — Martin Petito; Hubert Thines; William Housel; John Masine; Albert Burash; Fred Beans.

TRENTON HIGH
YEARBOOK

BOYS' GLEE CLUB, IN 1934 BO-BASHELA (TRENTON HIGH SCHOOL YEARBOOK)

DEPRESSION ERA TRENTON, NJ.

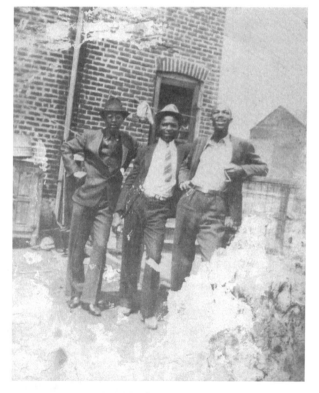

JAMES HARRIS, JOHN CASH MALLOY, AND FRANK MALLOY AT 121 KOSSUTH ST. TRENTON, NJ.

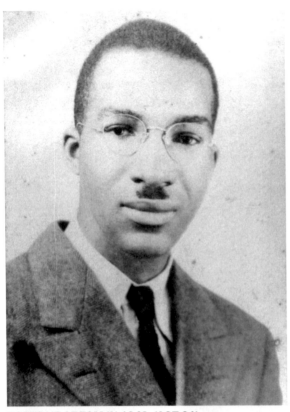

CHARLES HIGGINS CHOIR. (1940s). TOM IS IN THIRD ROW, FOURTH FROM FAR RIGHT.

PORTRAIT OF TOM IN 1943. (AGE 31)

TWO PHOTOS - TOM AND DOROTHY MALLOY'S WEDDING (1965, GRACE PRESBYTERIAN CHURCH. BALTIMORE, MD)

ART SHOW, POSSIBLY AT RIDER COLLEGE IN LAWRENCEVILLE, NJ. (1960s)

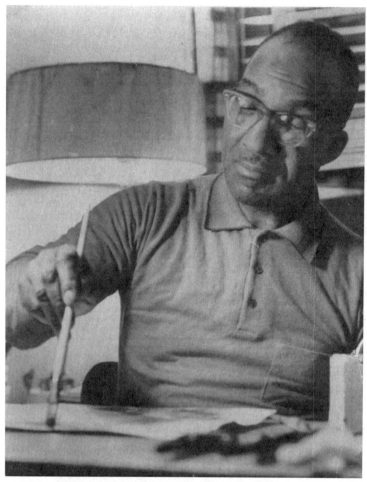

TOM AT WORK. (LATE 1960S)

DOROTHY PRESENTING TOM WITH GIFTS ON CHRISTMAS AT THEIR HOUSE ON SPRING ST. (CIRCA 1969)

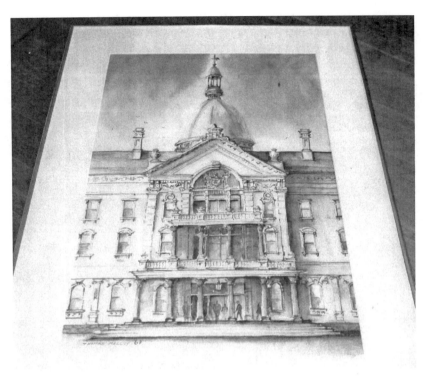

TOM'S SKETCH OF THE NEW JERSEY STATE HOUSE

TOM'S ART SHOW AND BOYS' CONCERT AT THE PRINCETON
BOY CHOIR SCHOOL IN PRINCETON, NJ. (CIRCA 1987)

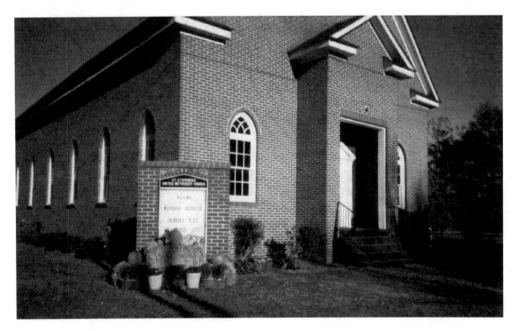

ST. STEPHEN'S UNITED METHODIST CHURCH
(CIRCA 1994). DILLON, SC

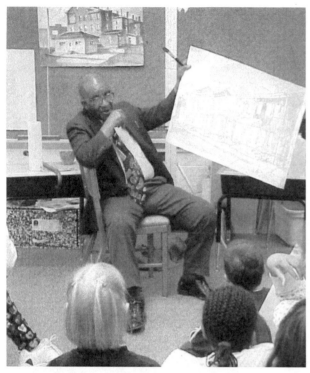

TOM AT CAREER DAY AT BEN FRANKLIN SCHOOL, LAWRENCEVILLE, NJ (1999)

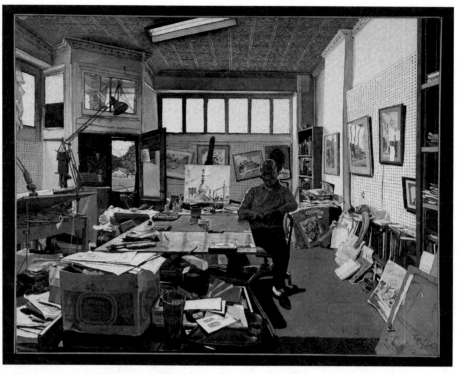

DRAWING OF TOM IN HIS STUDIO BY ARTIST MEL LEIPZIG

9

TOM AND CHARISA SMITH (AUTHOR)

TOM AND MR. AND MRS. JOSEPH P. TETI

TOM BY HIMSELF

FOUR PHOTOS - TOM'S 89TH BIRTHDAY CELEBRATION AT TRIANGLE ART CENTER. (AUGUST 25, 2001)

TOM AND LARRY HILTON

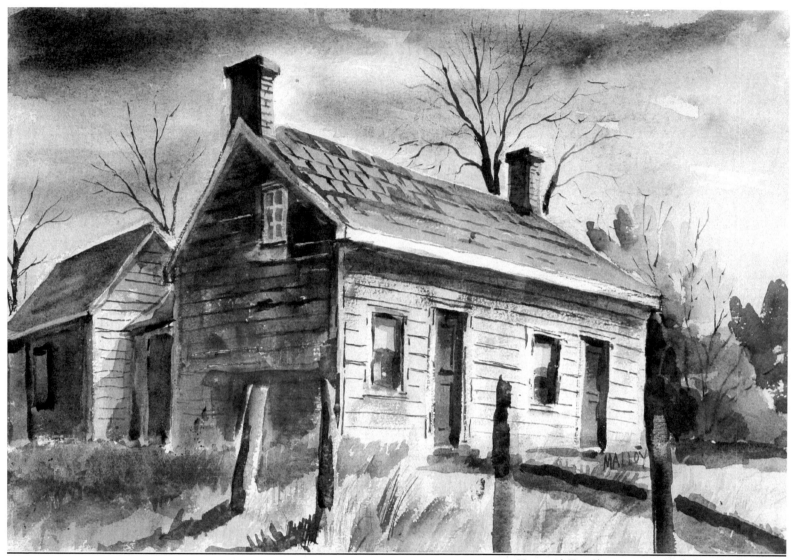

House with Two Chimneys, courtesy of John and Debra Watson

CHAPTER 1

Beginnings

The fields surrounding young Tom Malloy's house began at his front door. They stretched for what seemed to be miles to the small, observant boy. Upon the Malloy family's one hundred acres of sharecropped soil, little Tom was allowed to wander through the rows of tobacco, corn, string beans, cabbage, and other vegetables. Two pigs, many chickens, and one horse roamed the spacious terrain. They were treated as beloved family pets. Tom relished it when the creatures frolicked at the sound of his and his brothers' voices. Even the poorest black family in town used their own animals for sustenance, however. So most pets had to be bid farewell before long.

"Those were the days when you cut your own wheat," reminisces Tom today. No one could imagine that this small southern farm boy would one day sketch countless scenes and receive recognition before grand audiences—not even the curious youngster himself.

A PROUD START IN THE SOUTH

Born at midnight on August 23, 1912, Thomas Arthur Malloy, Jr. arrived only forty-nine years after the emancipation of American slaves.[1] Tom was the firstborn son of a family of black sharecroppers, and he lived a demanding life that many white southerners and urbanites took for granted.[2] He was born at home, like most children in the countryside, to Tom Arthur Malloy, Sr. and Frankie (Mary) Ford Malloy.

According to "the custom during that time, women about to give birth would often call upon someone in the family who was knowledgeable," Tom explains. "A midwife, as we called them, would otherwise be called upon," he adds. Tom's mother was assisted at his birth by a woman called Miss Hannah. Miss Hannah also delivered many of Tom's siblings and playmates. Within six years after Tom's birth, three younger brothers would follow. John, Frank, and James completed the Malloy family portrait. John was born in 1914, James in 1916, and Frank in 1918.[3]

Tom's family imparted him with the tools to become great. He asks, "To whom do I give credit for what I've become? An artist, a social activist. . .a leader helping people and interpreting [the] things others cannot? I owe it all to my faith and my ancestors." He poignantly continues, "Why am I Malloy? Because at the time when I was born, people had knowledge of slave times. First of all, I am a man of faith from my mother's apron strings and her mother's apron strings, and

her mother's before that. The elders would always think, 'What saved us? If it wasn't for the Lord, we wouldn't be here!'"

Tom was descended from black slaves, whites, and Native Americans. Tom's African slave ancestors were primarily on his father's side. "My great grandmother was a slave in South Carolina," he begins. "My father's mother Ida Malloy used to remind me of that. . . ." This legacy of slavery inspired Ida to prepare her kin for success. Tom recalls how she'd repeat, "'You weren't made to spend your life in jail! Your great grandma prayed so much for her unborn generations that God would hold them.'"

Like most slaves, most members of the Malloy family were field hands. "All you needed was a weak mind and a strong back," Tom says sadly. He imagines that "Abe Lincoln freed" slaves like his father's family "because they prayed to God for deliverance." Tom ponders historical incidents like Nat Turner's slave rebellion "to kill white men who held men in bondage." Tom envisions that his ancestors must have "absolutely" participated.

The Malloy family name is Irish in origin, but it was passed down to Tom's family by those who owned them as slaves. "There's a variation of names that come from the Irish name 'Malloy,'" Tom explains. "As the Muslims remind us, that's a slave name. Allah will tell us what our real name is." Tom's paternal grandmother was named Easter Farley, and she married a man named Malloy. As far as Tom can remember, no one ever mentioned "who her husband was," and he asserts that "if it was known" that information "has long since been lost"

Mary Magdalene Ford, Tom's mother, brought a mixture of white and Native American blood into this picture. Tom notes that "you could see the Native American strain" in the Ford family. "They were the mulattos, sons and daughters of both whites and blacks [and Indians] for a long time back," he adds.

Although there was "no mentioning of slaves" by members of the Ford family, they were certainly part of slave plantation society. The Fords were the children of actual plantation owners and their slaves, and Tom notes that "their ancestral fathers couldn't disown them." Unlike other people of African descent, "they weren't cotton pickers or sharecroppers."

Henry Ford, Tom's maternal grandfather, was nicknamed "Uncle Henry" around Roland, North Carolina. He was married to a woman called Miss Jane, whose maiden name was Nichols. The Nichols themselves were part of the island cultures off the coast of the Carolinas and

they spoke an odd "Geetchy" or "Gullah" dialect. Miss Jane and Henry lived in a town just across the South Carolina state line. Tom Junior and his childhood friends used to climb over a hill of sawdust to see trains from the North stopping in Roland.

Tom admits that the Ford family was a "Gypsy-like crowd of railroad folk and many bad characters." Many of them were "jailbirds, womanizers, and moonshine drinkers" who would "fight to defend themselves at the drop of a hat." Like other railroad workers, Henry often traveled in his work. Tom recalls that "while Henry might stay away for as many as six months at a time, he still knew to have a fixed place for his family."

Tom especially recalls the wild antics of one hell-raising uncle on his mother's side. "My mother's brother Vance killed five men. He was not a railroad man. He liked the sporting life. He was like many people with Indian strain in them—they are very quiet people. He'd been warned that no Negro better mess with Mr. so-and-so's woman because she was a white man's woman, but he did."

Meanwhile, Tom's grandfather Henry often "told railroad stories" to entertain members of the Ford clan. "Black men kept the trains running, kept the hand cars running, and saw to the necessary equipment to tend to a section of the tracks," Tom remembers. In those days, "the section head" of a railroad gang would be a white man who'd sing the lead of a song to which black men would respond. "He'd say 'I got a woman who. . .' and the [black] men would come down with their hammers saying 'talk dirty!'" Tom states with glee.

The upstanding culture of the Malloy clan gave Tom Malloy Jr. a family tradition of honor and etiquette. "My grandmother was the most formative influence I have had," Tom clarifies. Mrs. Ida Malloy would always tell Tom, "Live, but have a principle in your life. Hitch your wagon to a star . . . Aim high and you'll hit something worthwhile."

Although the Malloys were not wealthy, Tom's grandmother was committed to raising her descendants nobly. She sought to challenge the class system that bound her people to poverty for many generations. Ida had first taught Tom's father in the art of genteel behavior. Ida worked as a domestic servant in what Tom calls "The Big House." Ida was fascinated by this prosperous world of whites. This was "where people acted proper," Tom explains.

Despite having only three days of schooling to her credit, Ida was determined to raise children who spoke like educated southerners.

She admired the speech of the white aristocrats they called the "Big Bukras," preferring that to the broken speech of other sharecroppers and the poor whites they called "Little Bukras." Southern slang and illiteracy prevailed in the Malloy's southern town of Dillon, but Ida sought to etch out a new identity for her kinfolk. "If you'd met her, you'd never believe she had so little education," Tom remarks about his beloved grandmother. Ida's intelligence was also due to her admiration for great black speakers and educators. "She told stories of such dynamic people. She talked about Booker T. Washington often," Tom remembers. "She spoke of Dr. I. Garland Penn preaching, of Charlotte Hawkins Brown, of Walter White. People would go to Harlem to hear them speak and she was among them. Mary McLeod Bethune's brother-in-law was a preacher to Ida, as well."[4]

All these black intellectuals gave Ida her own sense of importance to pass down to her family. They expanded her views of the race and the world. Most importantly, they convinced her that her family could strive for quick minds and strong morals. At times, Ida would even brag that the Malloys were "McLeods"—relatives of Mary McLeod Bethune's family—simply to boost their self-esteem. Truthfully, however, she was only on close terms with Mary's brother-in-law.

Ida's careful instruction of her family had also made Tom's father one of the most well-respected sharecroppers in the region. Tom Senior was both well-spoken and polite. He worked diligently in the fields of a family named the Hamiltons,[5] yet he maintained a high sense of honor. Tom Junior recalls how his father would wake up before sunrise each day to cure tobacco, grow cotton, and tend the corn that would feed both their family and the animals. He admired his father's physical strength and his refined character. In addition to working for the Hamiltons, Tom Senior and other members of the Malloy family also worked for the Thomas A. Dillon family from time to time, doing odd jobs and working the land.[6]

Whenever Tom Junior observed his father's steady workmanship and regal composure, he felt a proud desire to imitate him. In an era where most people believed that "father knew best," Tom Junior also learned to obey his father. He accepted the harsh discipline of spanking, or what was called "whippins" in those days. Tom Senior wisely told his son, "You will appreciate it later." Yet, whippins still "felt like death at the time" to little Tom. He recalls his father's constant reminder, "You must learn to be responsible!" Tom and his brothers were sternly admonished whenever they failed to do their chores.

Tom Junior's mother encouraged toughness in her son, in addition to the gentility and obedience taught by Ida and Tom Senior. Mary tried to forge a heartier, no-nonsense character in Tom due to her own rough beginnings.

A tomboy by her own admission, Mary was nicknamed "Frankie." Her family took this nickname from a man named Mr. Frank Nuntz, in whose house the Ford women had worked.[7]

In her life and work, Frankie learned to be quick-witted to defend herself against criticism of her "yellow" complexion. For a light complexion often earned scorn in the Deep South.

Tom recalls that it could be "a curse to many southern blacks because it showed mulatto or white blood." Some people called his mother a "high yellow heifer," which was a common insult in the black community. By enduring name-calling like this, Frankie developed a thick skin. She aptly responded to such comments and learned to easily convince others that she would not tolerate disrespect. Frankie was not ashamed of her looks.

Frankie's toughness also came from her family background. She was separated from her father, Henry, for as long as six months at a time while he repaired rails up and down the dusty mainline railroad tracks. She and her mother, Miss Jane, cared for the family farm during this time, and they became particularly independent, resilient women in their community.

While the absence of a patriarch cast a somewhat shameful shadow onto Frankie's home, she proved strong in the midst of the adversity. When Frankie began to "woo" Tom Senior, haughty Ida's dismay was no match for Frankie's spunk. Determined to land Tom Senior even though "he'd walk by her house with his nose in the air," Frankie forced him to speak to her. She used her creativity and resorted to surprising him by "climbing into a tree to imitate a bird!" Tom Senior then politely spoke to Frankie. Yet his mother Ida disdainfully called her "that Ford girl!" Subsequently, a romance between Frankie and Tom Senior slowly developed.

Ida was particularly bitter about Tom Senior's relationship with Frankie Ford because of her jealousy toward light-skinned women in general. Tom explains that "a mulatto woman took Ida's husband," who was named Will Malloy. Will had said he was going downtown to get sharecropping earnings one day but never returned. While Ida was "there hungry. . .with her children hungry," Will had gone to start a new life.

Ida also resented the wild roots of the Ford family. "She had plans for her son and wanted him to be another Booker T. Washington. My father was loved," Tom explains. He continues by noting that Ida simply "couldn't understand why her son married the kind of woman that he did. My grandmother loved brilliant people, and here this mixed girl who belonged to a gypsy crowd of railroad workers came along!"

Upon the formation of Tom Senior and Frankie's family, Frankie maintained her tomboyish pride. She refused to smother her four boys. Instead, she scolded Tom that "life is no bed of roses." She spoke from experience. Through tough love, a powerful example, and very little coddling, Tom Junior learned to be independent. He developed an adventurous spirit like his mother's. Tom remembers that his mother's looks ironically sometimes worked to his family's advantage. As a racial hierarchy sadly translated into areas like education in the post-Civil War South, light skin was as much "a sign of stature" as a curse. Many people teased Frankie for her complexion, but they also envied her and her family. They associated her "yellow" color with an intelligent, wealthy heritage. Tom finds those assumptions to be ridiculous, but he laughingly confesses, "a man at Howard University in those days better not come there with no black woman! That school was started only for mulattoes from the first families of Virginia!"

In addition to fulfilling the expectation of marrying light-skinned women, many southern black college students of Tom's day were truly the descendants of George Washington, Thomas Jefferson and their slaves. "We should give a lot of credit to those mulattoes because many of them did not let their ancestral fathers disown them," Tom adds. He recalls that because these peculiar racial associations were applied to Frankie's complexion, the rest of their family was also assumed to have a link to gentility. This was despite the fact that Tom Senior and his sons were dark-skinned. Several men had sought Frankie's courtship to elevate their status, but Tom Senior alone gained Frankie's consent. Tom Junior also learned to have pride in his own identity at a young age. He discovered the extent of his mother's natural beauty and outspokenness, regardless of her complexion. Tom reminisces that men would actually "steal Frankie's pictures because she was so beautiful!" She had an admirable face and figure, and her tomboyish wit made her very charming. As Frankie grew up with both a high self-esteem and the assertiveness to match others' teasing, she gained confidence to teach her sons.

As a wife, tomboyish Frankie followed many of her mother-in-law Ida's ideas about teaching her sons the manners of South Carolina's aristocracy. She also became a domestic servant in a "Big House" after financial troubles plagued their home. Tom laughs as he remembers his mother saying, "I don't know a time when I went hungry until I married your father!" Frankie had decided that nothing was too good for her sons, regardless of the obstacles against their race. She scraped together whatever resources she could find to present family meals in a lovely fashion, taking inspiration from the meals she prepared for her white employers, the Nuntzes. Tom Junior proudly recalls how he learned polite conduct and customs:

> I'll never forget the day my mother went to town and brought back a real knife and fork set. In those days, most people like us used the lids of lard cans for plates. Most poor blacks and whites in the south didn't know what it was like to eat meals at a set table. But we finally got real plates. We were taught to sit down correctly. Grandma and mother taught us 'proper manners.'

"Because we believed we were a God-fearing family, we were taught to always say grace and thank the Lord for our food. We spoke differently, too. 'No cussing like sailors,' mother would say." These polite customs that Frankie and Ida taught the Malloy boys were taught only to a select group of blacks at training schools. Booker T. Washington and other leaders after the Civil War brought etiquette to blacks through institutions like Tuskegee.[8]

"Also, when I was coming up, a phrase I remember so well is that 'cleanliness is next to godliness.' You can rest assured when my mother went to tell you to go and wash, you'd better go outside and get the Octagon soap! Those who could afford it would go to the store and get lye and make their own lye soap. When we'd come in from washing out at the pump, mother would check behind our ears. And she used to get lye soap when store-bought soap wouldn't do it. It must've been costly, but cleanliness was important."

SOUTHERN CUSTOMS AND TOUGH TIMES

Tom recalls that Frankie and other rural women reserved Monday for "wash day." They used a washboard and a tub of boiling water. Tom explains this ritual: "For some reason, women who scrubbed clothes always had another woman to keep them company." Inquisitive little Tom knew this was a good time to try and savor some town gossip. To his dismay, however, he would be shooed away and told not to meddle

in "grown people's talk." Today, Tom gratefully compares his moral upbringing to his present surroundings. He is now often "disturbed" at the indiscretion of modern parents, who don't monitor "what their children hear." In the days of Tom's youth, children were kept sheltered from the serious affairs of their parents. They therefore learned to obey respectfully.

Impeccable manners and cleanliness ruled the Malloy household. Yet such practices did not protect them from the hardships of sharecropping life. In the sharecropping system, black families lived in small homes on the land of white landowners. They grew crops on that land in exchange for a "share" of the crop, for use of the house, and sometimes for a garden and farm animals. Yet many sharecroppers were never even given a large enough share of the landowner's crop to provide for their own basic needs.

This rugged way of life also straddled southern blacks and whites with a social dynamic that closely resembled slavery. For instance, black men still devoted their lives to working tracts of southern land that they did not own, while black women still served white households. Black livelihoods depended upon the disposition and generosity of a landlord, and starvation was always a constant threat.

For Tom Junior, his parents, and his three younger brothers, life in the sharecropping system was often severe. Tom recollects:

> In October, you would go to town and discover what was to be your share of the harvest. Very often farm owners would tell you crops were bad and you'd get next to nothing. Or they would say that since they'd had to carry you through a hash winter, you had very little or were literally in debt. That's what sharecropping amounted to. You were always in debt. Unless you could find a fair owner, and everyone was always in search of a better owner.

Tom also notes that sharecroppers and their children were sometimes forced to work indefinitely without wages. If landlords alleged that they hadn't produced enough crops to make a profit, free labor was demanded. By observing the sharecropping system, Tom Junior learned the meaning of injustice and struggle early in his life.

SCHOOL DAYS

The future of Tom and other sharecropping children was sadly often determined by the extent of a white landowner's generosity. "A charitable, constant Christian farm owner might make it possible for a sharecropper's children to attend school," Tom explains. Tom was one of

the boys who was lucky enough to receive an education, although he also performed farm work. He describes his early, rustic school experience:

> My first school was in a very small church. The teacher was a man, and he'd tell the older boys to cut him some switches in case some children misbehaved. The church was so small that if the teacher saw some children in the back 'cutting up,' he would raise that switch and he could reach the back pew and nail any culprit [that] he thought was doing wrong! He was so accurate that he wouldn't miss! That was the way of teaching in the south. We'd also learn by recitation. The teacher would say, 'spell cat.' Well, God help you—if you didn't spell it correctly, the teacher would tell you, 'come up here' and you'd hold out your hand!

Tom recalls that many a classmate endured the harsh tap of a ruler for forgetting proper recitations. Tom chuckles as he remembers the old schoolyard song, "School days, school days, dear old golden rule days! Reading and writing and 'rithmetic. Taught to the tune of a hickory stick!" Tom recalls that he and his schoolhouse playmates would also chant arithmetic time tables in sing-song voices.

Sunday school was also a necessary part of a sharecropping child's life. Tom recalls how they "would have church celebrations, recitations, and plays for Christmas and Easter." Chuckling, he admits, "*that's* when you found out how brave you were and how much of a voice you had! Some of us would have stage fright and just stand there." Tom notes that his brother James "had a sing-songy voice" and that other children "would make fun of him" during Sunday school performances.

Today, Tom closes his heavy eyelids and reminisces fondly about his youth. He speaks of the sweet prayers said at bedtime. After a hard day of school, chores, and play Tom and his brothers used to kneel on the dirt floor of their home and say, "Now I lay me down to sleep. I pray The Lord my soul to keep. If I should die before I wake, I pray The Lord my soul to take." These traditions helped Tom remain spirited and keen-minded despite the challenges of poverty and racism.

DEALING WITH THE LIMITATIONS

Rural education nevertheless had many shortcomings. Tom explains that "because of necessity, even the most advanced children could only go to school so long each year. Because when the first frost softened the soil, school would end and you had to come out to help with the farming. It is a wonderful thing that we as a people have done so well, because if you were a country person you were lucky to learn any kind of writing.

"We accepted the fact that the school teachers and most county folk spoke Negro dialect. It was because they were black. It wasn't by choice that we said caint' for can't or it 'aint' instead of isn't. It's because of poor schooling."

After Tom's early years in the church-school, the next school Tom remembers by name was called The Graded School. "This was a wooden building built for the sole purpose of being a school, which was rare in those days, and it had more than one room," Tom notes.[9] Although Tom was fortunate enough to attend school, his childhood in Dillon was difficult. His home consisted of two sparsely decorated rooms, which was customary for most sharecroppers. The Malloys lived snugly in an unpainted wooden shed set upon bricks for pillars. "There was no cellar or attic, only a kitchen and one room which served as the living room," Tom explains. The Malloy family was not even prosperous enough to afford clothes for its young children. They had to "make diapers out of flower sacks," as was the custom for blacks "out in the country." Childhood has also changed considerably since Tom was young. Childhood is an extremely free-spirited, playful phase of life today. Yet childhood for Tom and his brothers was an era of serious preparation for manhood. "We are now becoming the greatest urban society ever known," Tom ponders. "But back then we were not thinking about that. We were thinking in terms of preparing the boys down on the farm only for *that* kind of work."

Tom recalls that farm girls were also taught to be good future mates for the boys. Sharecroppers' daughters were told, "One of these days you're going to meet a man who you'll fall in love with, so you must learn how to be a good wife and be a good mother to your children." As the "oldest boy" in the Malloy family, it was Tom's responsibility to accompany his father into the fields by the time he was six years old. He was also expected to "set the standard" for his brothers when his parents weren't at home. He explains, "The responsibility of keeping the other brothers straight in the world fell upon me. That was the social structure of the family." Tom grins and adds, "I can hear my mother even now saying, 'I'm not blaming your younger brother for what happened. You know better, Tom!'" Tom Junior was lucky enough to have an extraordinary role model teaching him the ins and outs of southern manhood. Unlike most other sharecroppers, Tom Senior was uniquely enterprising. He acquired additional occupations each season to earn extra money. For example, Tom Junior explains, "while waiting for the crops each season" his father "went and dug out swamps for new ground using dynamite."

Back at his humble home, young Tom followed his father's resourcefulness. He helped tie tobacco stems so they could be cured and stored in the barn. He also loaded the crops into sleds so they could be carried off to whites at auctions. After packing the crops, little Tom could not resist a bit of play. He loved to jump aboard the crop sleds and ride along for a while. Although he did not fully understand why his family was unable to keep all the crops they toiled over, Tom was always excited to assist.

ENJOYING THE GOODNESS OF THE COUNTRY

On his way to becoming a sturdy young farmer, Tom Junior still found time to wander and play. The countryside around Dillon, South Carolina, held countless adventures for a small Negro boy. Little Tom adored Dillon's captivating expanses of blue sky and fresh soil. Many of the watercolor landscapes he paints today are reminiscent of Dillon's environment. Thinking back, Tom reflects:

> Because we were rural, we recognized the significance of nature. I was fascinated by the bugs, the animals. Now we have destroyed so much of nature that we are having problems with things like deer coming into our areas and creating accidents. But back then, the forest was not that far from where we lived."

Tom was also deeply fascinated by the sounds of downtown Dillon. For downtown was within earshot of his backwoods home. Tom also remembers being nearly hypnotized by "the lights of the town off in the distance." Whenever he could, he would venture out to his front stoop to listen for the Atlantic Coastline Railroad whistle letting out its shrill cry. Springing up from his various duties, Tom would run forth to wave happily at the train passengers.

Jump rope, hide and seek, and tag were all familiar childhood games to Tom. Yet he admits that he was "always a wanderer" in his youth. While he enjoyed occasional horseplay with peers, he still preferred private journeys. Tom often sought to freely explore the countryside alone.

Despite the stresses of sharecropping in Dillon, there were also numerous amusements for black families to share during their leisure time. Tom recollects that one local sport shared by both young and old was snake capturing. He proclaims with a gleeful smile, "Anybody walking through someplace who'd yell 'There's a snake out here!' would bring on a local commotion!"

In the community pastime of snake capturing, men and women would peer into the grass. They would carefully look to see the trail of bent weeds that a snake had left behind. After gathering "their hoes and sticks," they would continue to "run out there until they could hold that snake up," Tom explains. Soon enough, he continues, "that poor snake, minding its business, would be pried out!" Tom laughs heartily with a shake of his head as if he can see the frenzied scene before his eyes now. "The poor snakes in that town!" he bellows with a grin.

The average sharecropper's home was so simply built that the Malloys and their neighbors at times could even gaze at their ceilings to find snakes slithering across the rafters. These families always immediately tried to remove the snakes, which brought more welcome entertainment. Such a pastime was a fun way to necessarily rid the household of pests.

Despite his family's poverty, Tom also speaks fondly of holiday celebrations in the old South. "On Easter and Christmas day," he recalls, "that was the day you knew you were gonna get something new to wear, whereas you hardly had shoes otherwise, if the weather was warm." Tom remembers how "a little before the holidays," adults in the community would begin to sing, "You better watch out, you better not cry. . . . He's making a list. . . . Santa Claus is coming to town!"[10]

There were realistic limits to holiday gift-giving for Tom and his playmates, however. "I remember my parents saying, 'This is a poor year for Santa Claus. . . .' so we knew not to look for big gifts," Tom comments. All in all, holidays in Dillon were special for Tom because of the family cheer and togetherness. "You'd know you'd have a dinner as never before [during the holidays]," he remembers with a wide smile.

THE EVER-PRESENT SHADOW OF RACISM

Another diversion for members of Dillon's country community was the County Fair. Yet this setting unfortunately brought one of Tom Malloy's first poignant encounters with racism. The young boy recalls joining other "coloreds" at the fair, after eagerly changing out of their "Sunday best" clothing after church. They would all rush to the fairgrounds in hopes of gawking at various musicians and "freak show" acts.

However, after leaving St. Stephen's Methodist Church,[11] the Malloys and other blacks had to flock inside a small tent at the separate Negro Fair. Tom mentions that "thrills and chills" of excitement tickled his spine as he walked past the brightly painted wagons. Yet, he felt distinct resentment at the *un*fairness of the Fair. He and other blacks were also kept from eating the scintillating food that "white

folk" were eating at the main part of the fairground. As a youngster, Tom therefore learned that mean-spirited injustice lurked even in the happiest of places.

Tom recalls clearly the way the cloud of racism came to darken bright days filled with childish play, explaining, "We played with the white kids up until a certain time. Then it was time to separate." In addition to ceasing to play together, children recognized the racial boundaries after reaching a certain age because the black children had to start calling the white boys "mister" and the girls "miss" while the white children were taught to demand that kind of recognition.

Other incidences of racism were far more obvious and threatening to little Tom. He notes that his community adamantly warned him to be "respectful" of whites to avoid getting "roughed up." Living in the days of legal lynching, Tom watched many terrifying lynch mobs ride through town in search of "bad niggers." Trouble brewed for any black man who had dared to "sass" a white man or to flirt with or insult a white woman.

The Malloy family was not immune to the personal misfortunes of racism either. Tom's own uncle was abducted and never found, after being accused of disrespecting the town's whites. While southern life was not all struggle and toil, realities like Tom's uncle's disappearance made the boundaries of southern conduct painfully clear.

A BUDDING ARTIST SPROUTS IN SOUTHERN SOIL

Tom's early closeness to nature instilled a sense of keen observance and artistic inspiration within him. Viewing and recording the world's details became second nature to Tom even when he was a small boy—long before he knew what an artist was. Tom recalls noting and probing the elements of Dillon's rural wonderland. He was fascinated by shade, movement, and variations of light.[1] Later, he could not resist capturing the details on a makeshift "canvas." He explains, "I would take a stick and draw certain impressions of things I saw in the sand." Tom lacked the necessary pencils, paper, and chalk in his early home but was an artist nonetheless.

The more practice Tom gained sketching on the dusty ground, the more he desired to draw. He sought to depict the world more and more vividly with his hands as the years went by. Even then, Tom was on his way to developing his true natural artistic talent. One Saturday after soaking up the amazing sights and sounds of the County Fair, Tom was especially inspired. He took a stick and drew a circus scene he saw "entirely in his mind." He recalls drawing the scene as freshly

as if a photograph had been before him. Although such an incredible memory and a unique talent were to go underused for some time, nothing would keep Tom from his passion for art.

Throughout nine decades, a love of art would burn fiercely in the heart of this man who once wandered meadows and played with chickens as a boy. Tom Malloy's early instincts for drawing never translated into the full goal of an artistic career until he was well into his fifties. Yet, Tom never let soot smother the glowing embers of his fiery love of art.

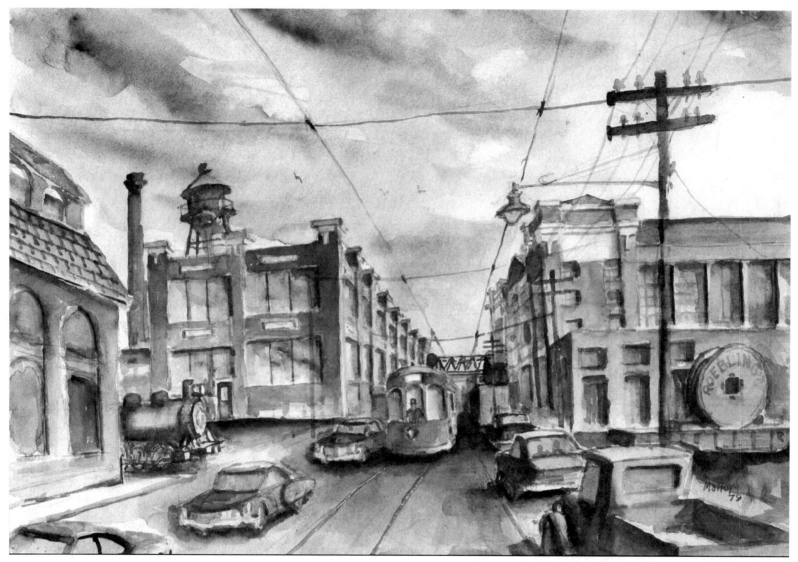

Street Scene, from the collection of Kathi and Fred Bedard

CHAPTER 2

Trenton — A First and Lasting Impression

Heaviness and dust plagued the worn feet of young Tom Malloy and his sharecropping family. Still, hope created an inner weightlessness that let their spirits fly free. The day they moved north, a new life would begin. This was all that mattered. As they joined over 500,000 fellow African Americans who migrated from southern farms to northern cities in the 1920s, they became part of history.[1]

Once he was inhaling the pungent aroma of Trenton's markets, factories, and unique ethnic eateries, young Tom gained a new perspective on the world. Learning new skills there would enable him and others to find endless opportunities. The great contributions that Tom himself would make to Trenton would hardly have been guessed by him back then. Yet he was awed by his journey's destination. For Trenton had made a favorable impression.

PUSHING NORTHWARD

As a sharecropper, Tom Senior had first envisioned a rural future for his sons. However, a twist of fate would prevent Tom Malloy Junior from more years of backyard sketchings and a quiet life on a farm. This fateful change began when Tom Senior started searching for lucrative jobs out of town.

In order to provide the best life for his family, Tom Senior found a job toiling in the West Virginia coal mines with his brother David. He performed this job whenever he could stray from the crops. Tom Senior eventually spent over a year in West Virginia while his wife Frankie and the boys stayed behind on the farm. Tom Senior's savings relieved the family of performing difficult sharecropping duties during his absence. Yet Frankie disliked the separation. She felt that her family deserved more, and she used her independence to find new choices for them all. Quick-witted Frankie decided to expand her family's options by trekking to Atlanta to visit friends. She traveled on the steamboat *Queen Elizabeth II*[2] and loved the luxurious ride. As Tom explains, Frankie soon became enchanted with "city life," and she relentlessly spoke of moving after her trip. Each time Tom Senior wrote letters from West Virginia, Frankie would write back pressuring him to return and move them to a city. Finally, one day Frankie took matters into her own hands. Tom Junior recalls that she angrily threatened her husband, "'If you don't provide that life for me and my younguns, I will.'"

When asked to explain exactly what his mother was threatening to do, Tom Junior. sighs and laughs. He shakes his head fondly at the extent of his mother's stubbornness. "She didn't have to *say*!" he exclaims. "She would have *done* whatever it took!" After Frankie's extreme persistence, Tom Senior reluctantly agreed to come home and move away with the family. "He never would have left if Frankie hadn't insisted!" Tom Junior adds.

Tom Senior began asking around about job opportunities in large cities. He sprang to action as soon as a family friend described a job offer in Trenton, New Jersey. He left for Trenton to secure a job in a rubber factory, then wrote to his family a few months later. The time had come for all of them to join him. They packed a few belongings and left the family home in Dillon in 1923.[3] Tom Junior today tilts his head back and closes his eyes as he recounts one of the most exciting experiences of his early life. "In Richmond I saw my first streetcar," he muses. Tom was particularly amazed to peer out the window of his segregated southern train to see another train where black and white passengers sat beside one another. His awestruck gaze caught his mother's eye, and she proudly explained, "We're no longer below the Mason Dixon Line!" Tom recalls "an indescribable feeling" within his pounding heart at that moment. He realized that freedom, self-worth, and adventure all awaited him in the North. It was late April of 1923 when ten-year-old Tom arrived in Trenton after staying awake all night on the bumpy train ride.[4] The trip took over thirteen hours. "We greeted my father with happy hugs at the train station," Tom proclaims. After the Malloys arranged their suitcases and bundles of clothes along the platform, they made their way out of the station to find a new urban home.

TOUGH CHALLENGES AND AMPLE OPPORTUNITIES

Difficulties immediately awaited Tom Junior in his new hometown of Trenton. Early sharecropping schools were less rigorous than even the first year of school in the North. Even the names of the school levels were different, as Tom remembers it. "The first year was called 'Primer,' not 'Kindergarten,' as it was when we came to Trenton," he remarks. Unfortunately, Primer in South Carolina had not prepared Tom for Trenton's more sophisticated system of learning. He had to begin elementary school at the age of eleven, falling behind his fifth-grade peers.

Tom first entered the Escher School on Jefferson Street, but he did not stay in the four-room former beer hall for long. Because more educational opportunities were finally available in their new environ-

ment, the Malloys decided to send their eldest son elsewhere. Tom was moved to the New Lincoln School on Montgomery Street, which later became the Revere School and Junior School No. 5.[5]

Despite the challenges of his new assignments at the New Lincoln School, Tom began flourishing under the tutelage of dedicated black administrators and educators there. "They were refined, gifted, and many commuted from New York just to teach there," Tom notes. He adds that "sixty-five percent of those teachers were women."

Tom's teachers at Lincoln were so dedicated that "they would visit children's homes" to assure good behavior back at school. Lincoln's Principal Arthur T. Long also labored to ensure that his teachers upheld an especially high standard. "Principal Long said, 'although we are segregated, we will get the best black educators there are'" recalls Tom.[6]

Tom's grandmother Ida had come to live with his family, and her vigilance also assured Tom's swift educational advancement in Trenton. "She came to school to follow my progress so much the teachers thought I had no mother!" Tom jokes. Ida was an extremely influential force and would remain so throughout the future artist's life.

MAKING STRIDES IN FAMILY SURVIVAL

At the same time that educational obstacles confronted Tom, housing dilemmas also plagued the Malloy family. After moving to Trenton, they first rented a room in a brick house in East Trenton near Assunpink Creek. Unfortunately, the seven Malloys were horribly cramped and uncomfortable in their new house.

Tom recalls how his irate mother screamed at their landlady, "'I bring my younguns, and then the bed bugs bite em!'" Regardless of Frankie's protests, the Malloy children had to continue sleeping in miserabl slatted, wooden beds in their first home. The little bugs they called "chinches" would bite them in their sleep and scare them often. "There were also still outdoor toilets, a water pump, and no bathtubs or showers" Tom adds.

By the end of 1923, however, the Malloys were living a bit more comfortably in Trenton. They found more suitable housing at 8 Jefferson Street, then later moved to houses on Kossuth Street and Southard Street. This region, which Tom says was called "the Coalport area," had been rebuilt after the Civil War. It is near to where The Trentonian and Trenton Times buildings stand today, and it was also called "Goosetown" before its revamping in the 1940s.[7]

The Coalport area was the scene of many more pleasant moments for Tom and his family after such a rough start. Tom and other youngsters played innocently around a building called Terradelphia, near Jefferson and Ewing Streets. Tom once explained to an interviewer, "This building was a broom factory in the front, the Salvation Army in the rear, and outside there was a big iron yard, a junkyard owned by David Lewis. Before our time the Terradelphia building had been a place where bums and other men down on their luck could come and live and make brooms." This gigantic building had been the idea of a noted man named Thomas Terradell.[8]

However, in Tom's youth, he failed to realize that he lived in what was actually a dirty, extremely unhealthy area of town. There were pungent smells from the smokestacks that bellowed from a crematorium located near the Southard Street Bridge. There were also unsavory pimps, prostitutes, and many gamblers loitering there. Tom once noted that the neighborhood was so dirty, his "mother used to put a wash out on the line. And in a few minutes it would be covered with a layer of soot and stuff. If it wasn't from the crematorium it was from the trains in the roundhouse and the marshalling yards."[9]

This region of Trenton where Tom spent his youth also had a rich cultural history. Tom once noted to a newspaper interviewer that "Goosetown got its name" from "a German family back in the late 1800s who had a pond full of geese and ducks off Southard Street, near Ewing." He added that "Coalport was only part of Goosetown.[10]

For the Malloys, new luck soon appeared around every corner of this fascinating part of town. Frankie Malloy loved her new ability to travel more frequently. As a Trentonian, she could visit her neighbors easily, without the long day's walk through the fields that was required when she lived in the country.

Frankie could also catch the ferry to Camden for amusement and shopping. She sent gleeful postcards to her southern relatives to tell tales of her independent adventures. Trenton and the northern lifestyle were simply "unbelievable to her," Tom recalls. Tom himself also gained chances for liberation in this new setting.

FREEING THE ARTIST WITHIN

Tom's artistic instincts soared to new heights as he explored Trenton. He enjoyed walking around the city as much as he had savored his old romps through Dillon's fields. There were millions of new sights in Trenton that Tom had never even imagined. As an observant newcomer, he studied and sketched his city with relish and glee.

Tom particularly enjoyed watching peddlers stroll along the colorful, bustling downtown streets. All of Trenton's vendors had a unique song that they shouted to sell their wares. Tom was able to savor these visual images in his mind even when he was inside his home. For Tom remembers that Frankie "would sing around the house all day to imitate the jolly, distinct tunes of the meatman, the fishman, the coalman, and the milkman." Tom was also astounded at the quantity of large horses and wagons in the city, and there was even the occasional car to tantalize his curious young eyes. He also recalls the sturdy trolleys that used to run up and down Clinton Avenue.[11]

Holidays in Trenton were also a delightfully sensory experience for Tom. He had received his first taste of Santa Claus from the jolly "man [that] stores would hire down South." Yet southern storefront Santas couldn't touch the Santas and decorations in Trenton.

"In Trenton the Salvation Army Band would play music on Sunday," Tom muses. "After you listened to the band, the speaker would give a spiritual message in the neighborhoods. Kids liked to listen to the music. There was a portable organ which would fold up! You could go down there and get second-hand clothes. It used to be on Perry Street but is now on Mulberry Street."[12]

Thanksgivings were also far more memorable and more richly celebrated in the north. "Today you can have chicken 365 days a year, anytime you wanted. But few people were able, when my mother was coming up, to know what it was to have turkey at Thanksgiving. You could have an old roasted hen, but you didn't talk about any turkey. That was a no-no. Turkeys were unable to be trained and caught as easily. It was the rareness of it."

Saturday trips to the cinema with Tom Senior and his brothers also helped Tom Junior's imagination take flight. The five of them would view silent Western films that filled Tom's mind with numerous foreign fancies. Tom now grins and admits that he was "a constant doodler" back in elementary school. His teachers would regularly catch him sketching "cowboys and horses" in class the week after he saw a Western film. Several of Tom's grade school teachers foresaw his destiny in art despite his own uncertainty about his future. Even though Tom's doodling frustrated the educators, they knew he had the ability to maintain his grades. Tom reminisces, "The teachers began to notice, for example, that I'd be in any class and seemingly I was inattentive. Although there was doodling of various kinds of things, my progress showed that I had trained myself to listen." Recognizing Tom's natural capacity to draw amazing picture while still understanding his classes, Trenton's teachers decided to encourage young Tom Malloy's art. This child who had begun school several years behind his peers was proving highly intelligent for his age. The schools gave Tom special support by encouraging him in their art classes. This was Tom's first chance to experience art in a formal setting, as a discipline in itself. Naturally, young Tom was thrilled.

"At the New Lincoln Elementary School, I was first exposed to an actual art teacher," Tom recalls excitedly. From elementary school until graduation, Tom joined all Trenton students in the required "routine drawing" classes, but these classes had particular significance for him.[13] After struggling to find time to draw in dust and sand with sticks throughout his childhood in South Carolina, Tom finally had proper drawing materials and continuous opportunities to practice.

At that time, a woman named Mary Caver became the particularly supportive art teacher that Tom would continue to admire throughout his life.[14] He fondly explains, "Miss Caver told me, 'what I see in you, if you choose to follow it, is a natural gift that I can't teach you and that nobody else can teach you—' She told me that she saw that possibility."

Tom was touched that someone had at last spoken to him about his longtime beloved hobby. With pencils and crayons, he joined Trenton's art students in making unique creations at school. Miss Caver's kindness gave Tom increased faith in his artistic skills while making class exciting and fun. Thinking back to those days, Tom assures, "If I hadn't taken great joy in it then, I wouldn't be an artist today." Miss Caver herself went on to marry James Smith, longtime principal of Junior School No. 5.[15]

While encouraging Tom to draw, Trenton's schools also helped him develop his artistry and overall intellect in other ways. Schoolteachers applauded Tom's active imagination. Tom remarks, "Even teachers that were not artists appreciated that I could go beyond an academic subject and stretch my mind creatively." Today, Tom is thankful that he was recognized as a talented and smart child. "As Plato once said, 'imagination is the eye of the mind,'" Tom points out.

Math was always troublesome for Tom, but all other subjects luckily came easily. History was a favorite. Tom admits, however, that he rarely loved "books without pictures." He maintained his love of visual arts like drawing, painting, sculpture, and photography throughout various academic experiences during his youth.

With such strong encouragement at school, Tom was fully aware of his artistic potential by junior high school. Tom comments, "I knew art was more than a passing fancy by my teenage years." He began focusing more time on art and now reminisces, "I drew movement, the motion of the sea, the sunrise, Trenton scenes, or whatever I thought was beautiful back then. I drew whenever I could."

Later, at the integrated Trenton Central High School, Tom's color and his age difference from the other students did not prevent him from being distinguished as a talented ninth-grade student either. Instead of holding prejudice against Tom, Tom's high school art teacher Daphne Koenig continued Miss Caver's encouragement and kindnesses. Mrs. Koenig and another teacher named Mr. Siegfried pushed Tom beyond the limits of his peers and his coursework. [16]

"I got special assignments because they knew I was far too advanced and had an innate understanding about art," Tom notes. He recalls that several Trenton High School teachers even invited him to lectures where important intellectuals spoke. They gave him these opportunities in hopes of inspiring both his academic success and his artistic skills.

Tom was particularly enthusiastic about accompanying Ms. Koenig to New Hope to meet nationally acclaimed artists. He loved to learn of their intriguing world. Thanks to a stimulating education and supportive teachers, by the end of high school, Tom was asked to assist art teachers in teaching the other students at school.

THE TROUBLE WITH BECOMING AN ARTIST

Unfortunately, Tom could not be too openly proud of his artistic potential. Instead, his talents were nearly a source of shame. Black neighborhoods of the 1920s were largely comprised of poor people who had recently arrived from the South. Tom once explained to a newspaper interviewer, "As blacks, our economic situation was one that just did not lead to our venturing into art. So our parents and black society as a whole did not encourage those who sought to become artists."[17]

Today Tom muses, "My mother knew I wanted to be an artist, but she thought it weird." In those days, black migrant families felt that men needed to eke out a steady living to assure their place in northern society. A boy who dreamed of an unstable career as an artist was therefore "looked down on." Industrial careers gained much more respect than artistry, and for the most part, black artists of his day earned little credibility in their hometowns.

The lack of appreciation for Tom's artistic goals was sad, given the fact that more sophisticated northern blacks were promoting artists in other neighborhoods. Young Tom lived in an era nicknamed the "Harlem Renaissance," when black artists and writers like Alain Locke and Zora Neale Hurston were gaining more popularity than ever before.[18]

Tom once explained to a newspaper interviewer that the Harlem Renaissance was when "People began to see that the black artist as a visual artist, and to a great degree as a sculptor, as in the case of Selma Burke, had something to say aesthetically in the arts."

Tom feels that Trenton unfortunately lagged behind Harlem's cultural awakening. Trenton's black intellectuals and artists didn't form strong identities as a group until much later, and Tom's fate might have been different had he lived elsewhere. Tom once thoughtfully pondered that he "would not" have been "one of those radical and angry types" of artists even if he had blossomed during Harlem's Renaissance, but "would have been the same type of [spiritual] man" he is today.[19]

Girls in Trenton especially thought that Tom's artistic interests were effeminate and odd back in his youth. Although he denies being effeminate, Tom admits that the girls' observations about his oddness were correct. "I have been, all my life, a unique type of person," he explains matter-of-factly.

As time went on, the discouraging attitudes of Tom's family and peers convinced him to make art secondary in his life. Slowly but surely, "don't tell!" became Tom's attitude about his love for art as he grew up. Tom recalls: "I was a Sunday drawer most of all. I didn't show my drawings outside of school because that was all they'd think of me. And in those days you'd better be something spectacular or else you would be shamed."

Tom never considered the possibility of his own artistic success in New York or in another community during his school days. Even though he knew he had uncanny artistic potential, he began focusing his enthusiasm on other activities while staying put in Trenton.

TRAGEDY STRIKES—ANOTHER OBSTACLE CONFRONTS TOM'S ARTISTIC DAYDREAMS

Tom became further discouraged from any dreams of being an artist when his father fell ill. Tom Senior developed health problems only two years after his family arrived in Trenton. He was told that he had heart failure, which was a devastating blow to such a robust working

man. This diagnosis hit the Malloy family hard, Tom remarks, because Tom Senior "had never been sick a day before in his life." The Malloys had always depended on Tom Senior's earning power without having doubts. Once he was ill, however, their future became uncertain. Today, Tom sadly recalls how doctors told his father the unfortunate news. They explained that many years of hard farm labor and industrial work had "weakened his heart." Time spent in coal mines, rubber factories, Cook's linoleum factory,[20] and construction work had exposed Tom Senior to dangerous fumes and physical stress. "Those were also the days of unfiltered cigarettes," remembers Tom Junior, "and strong ones were preferable to working men like my father. Although today we could handle it," he notes, "back then you'd count your days when you were told you had heart problems." For roughly one-and-a-half years, Tom Senior suffered from chest pain, weakness, and other symptoms. After a trying illness, he died in the spring of 1926. He was only thirty-seven years old, and Frankie was thirty-two.

Tom Junior was thirteen years old when his father died, but he was suddenly faced with the task of being the man of the house. With three brothers and a widowed mother to assist, Tom Junior could not afford to waste time doodling with pencils and paints. Frankie did domestic work mostly in West Trenton, but her salary didn't always make ends meet.

Although Tom's grandmother Ida helped the family finances by working as a cook at Trenton Psychiatric Hospital, pressure was placed on Tom to acquire more responsibilities. Tom Senior's death was yet another reason for Tom Junior not to upset others' expectations of him. This event made him even more determined to gain steady employment and to make art a hidden hobby rather than a true goal.

LEARNING THE ROPES OF TRENTONIAN BOYHOOD

While adjusting to his new life in Trenton, Tom befriended neighborhood youngsters of all backgrounds. The Coalport area was awash with immigrants from Ireland, England, Italy, Poland, and beyond.[21] Most of Tom's boyhood friends were therefore also from families that were relatively new to Trenton. "I learned 'the dirty language' from Italian immigrant children nearby until my mother caught on!" Tom mischievously recalls. As Frankie quickly learned the meaning of northern slang words, she promptly banished Tom's newfound curse words from her house. Yet Tom remained fascinated by his boyhood friends and by other Trentonians even though he could not mimic all their habits.

In general, many social customs had to be learned from scratch when migrants and immigrants arrived in a city like Trenton. For example, the Malloy family's "southern politeness" seemed old-fashioned in their new city. Tom had to continually relearn etiquette among elementary school and high school friends. "I learned to simply say 'no!' and 'yes' instead of the 'no sirs,' and 'yes ma'ams' that flowered southern dialect," he recounts.

Tom especially relished the games and pastimes Trenton had to offer. He would run into the streets with his siblings and friends to buy five-cent ice cream from vendors in horse-drawn wagons.[22] From elementary school until early adulthood, Tom enjoyed playing stickball in front of row houses and on empty city streets. However, Tom did not date much in high school due to his keen interest in his studies and in art. He was much more prone to tag along to a lecture outside of class than to attend a party or to seek romance. He remained rather shy and inexperienced with girls for many years while his peers dated often. He now confides, "I had never had a girlfriend by the end of high school."

NORTHERN RACE RELATIONS PROVE DIFFICULT

The Malloys and other migrant families from the South faced new racial situations in Trenton. Sometimes the Malloys were extremely surprised at the way that white and black people interacted in northern cities. For instance, Tom was amazed when he heard his father called "Mister" by a white person for the first time. Even he himself was called "Mister" when being addressed by Trenton's street vendors, despite the fact that he was a young boy. This type of conduct was unheard-of back in Dillon, South Carolina. "Grown black men were usually called 'boy' by white men in the South," Tom explains. "If they were lucky," he adds, "they might be referred to by their first name at best." Yet dealing with overt racism in the 1920s was inevitably part of Tom's life in Trenton. He asserts:

> People like to think blacks and whites were living in harmony in the North at that time, but that was not the case. It used to be a black man's versus a white man's world. At one time, all a black man could do for the president of the United States was be his servant.

Tom remembers the ongoing Ku Klux Klan demonstrations in Hamilton and in the urban section he calls Old Trenton. There, he explains, crosses were burned and blacks were warned to "stay out." In

addition to this frightening spectacle that was reminiscent of southern racism, there were also more subtle forms of discrimination in integrated areas and activities. "Jesse Goss, a black boxer, was pressured to lose his fight and was beaten up," Tom recollects. "This sent the word out that no blacks should come in." [23]

Unfortunately, the fear that Tom and other Trentonian blacks felt usually went unaddressed. Tom points out that most of the crime against blacks by Chambersburg gangs "wasn't prosecuted because no one person was identified as the assailant and no one talked!" Tom and his black friends and neighbors therefore "stuck together" when necessary.

Tom and his black peers chose different strategies instead of forming gangs to oppose Chambersburg posses. Tom defines a gang as "a group focused on perpetuation and reign." He explains that black neighborhoods simply banded together in religious and social circles to find their strength. "They corrected a problem, then left it alone," he declares. Luckily Tom's racial interactions in school were not wholly negative. For the most part, Tom muses, "The white students were nice. They knew we were all there to learn." The economic gap was also closing between black and white students, which gave them even more common ground. As the Great Depression neared,[24] during the middle and late 1920s, Tom watched the lifestyle of the white students change to resemble the lifestyles of blacks. He recalls with a laugh: "In the early days when I first came to Trenton High, here those white kids would come chauffeured! But later, they were begging for any kind of job."

Racist incidents at the Trenton High of the 1920s did occur, however. This was always horrifying to Tom. Several racist practices were particularly grim. Tom confides, "If you were a black male student, a white boy would often take his finger and goose you to make the monkey dance. They thought goosing a black man gave them good luck." This cruel, painful physical practice called "goosing" involved white boys sneaking up on a black boy and placing their fingers in a very indiscreet place to humiliate him.

Luckily, bravery and pride protected Tom from such insulting attacks. Tom recalls how he confronted a white boy who once approached him with the intention of "goosing" him: "I looked him straight in the face and said, 'You tell all your friends I don't play that game! I demand the same respect.'"

Tom adds that the quick and outrageous "goosing" attacks were not uncommon in the factory as well. Such injustices and abuse appeared wherever black and white men interacted. Tom also once had to defend his brother from a "goosing," as well. "I'll never forget the 'goosing' of my brother John," Tom begins. "It was when I first started going to the factory. I don't know where I got that courage. But I said, 'Do I do that to you? You tell all your white friends when they allow me to [do the same]. . .!'" Tom notes that his outrage even caused him to shake at the time. "I got my bad temper from Ida's side of the family!" he reflects.

Unfortunately, other black men were ashamed to reveal the nature of "goosing" in their work environments. So white men were not chastised for such actions. Tom believes that "no white man would dare do that today."

DEFYING RACIAL STEREOTYPES

While Tom confronted racism in Trenton as did other black residents, his experience was particularly unique. Many people considered him to be a peculiar person in general. Tom remembers how white members of the Trenton High staff and student body did not quite know what to make of him! He was serious, highly intellectual, and articulate. He was also a black man who was vocally proud of his race. This did not fit the negative stereotype that many whites liked to maintain about black Americans.

In the days of Tom's adolescence, many whites still liked to think that blacks were unintelligent, lazy, and unworthy of equality with them. The cruel antics of Al Neushafer, the swimming coach at Trenton High, were one example of this belief.[25] Tom describes Neushafer as a "big old German man" who would sing a nonsensical song called "Ruskus, ruskus," as Tom walked down the hall. The tune "Ruskus, ruskus" poked fun at an idiotic, outlandish black man; and Neushafer sang it particularly to embarrass the proud, intelligent young Tom. Instead of allowing himself to feel uncomfortable, however, Tom simply ignored Neushafer's singing. Tom recalls that Neushafer was also prone to express his ignorant views about blacks very openly to his integrated classes. The coach had attended Rutgers with Paul Robeson and never hesitated to share stories about Robeson with his swimming class. "I never knew a nigger could be that smart!" he'd announce obnoxiously. Other teachers were similarly cruel to Tom and other black students at Trenton High School. Tom explains, "Some of those teachers would call a black child by saying 'Hey shine!. . . I'm talking to you, coon! There would also be mimicking of the way black people spoke." Black

students were also unable to participate in all the activities that white students could participate in. Tom recalls that he wanted to go to Washington, D.C. with his high school class but "Washington had no place to accommodate such a [racial] mixture" so the principal said Tom couldn't attend.

Trenton High School could be an unbearable place for black students, at times. Yet Tom's determination and intelligence helped him prove that racist assumptions about blacks were useless and wrong. He and many others proceeded with their education, despite the fact that racist remarks and abuse went unpenalized. Other issues weighed upon young Tom like a giant anchor even though racial prejudice could not dissuade him from being a strong individual.

As his family struggled after his father's death, Tom felt the need to explore new ways to support them all. He became distracted from doodling and instead grew interested in the idea of industrial work.

Tom admits that it was sometimes painful for him to pretend that he did not still long to draw dreamy cowboy scenes during the moments when he was chatting about possible jobs with other teens. Yet he was becoming more and more intrigued by "the real world" of popular careers and civic engagements as time went on. Tom thus built a hearty, positive, yet ever-imaginative character as he became a young adult in Trenton.

The lively cries of children romping through Trenton's streets had first helped make young Tom Malloy feel as if he belonged there. Roaming the industrial town and engaging in its many enticements, he became a true Trentonian. Tom began excelling in his classes while battling the racism that attempted to challenge his confidence. Despite the loss of Tom Senior, the Malloy family's trek northward had proved profitable. Time would prove that Tom Junior would make a considerable impression on Trenton by the time he reached his teenage years. This fact would have made his late father proud.

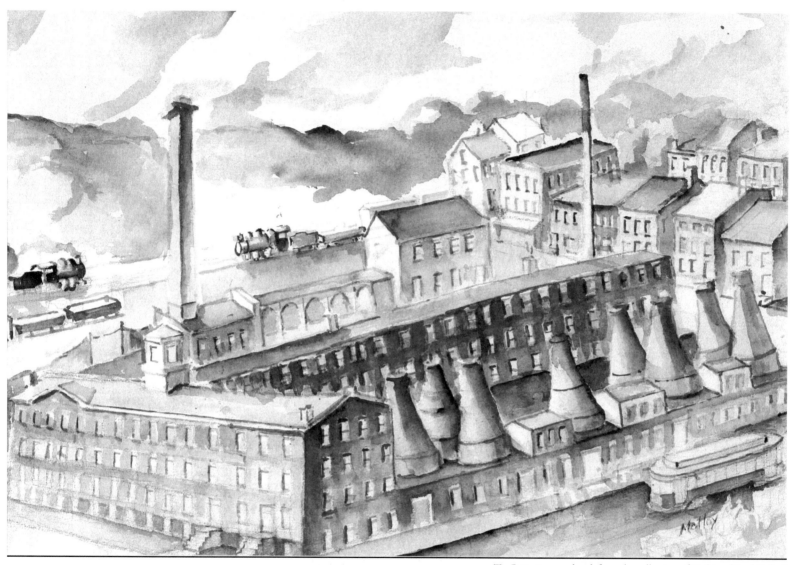

The Potteries, not dated, from the collection of Kathi and Fred Bedard

CHAPTER 3

What Trenton Makes

A keen sense of peace filled Tom Malloy's mind as he walked Trenton's busy streets as a young man. He was yet unsure where the future would take him. But the clank of metalworking in his ears and the strong smell of Trenton's factories hard at work reminded him that the sky was the limit. Observing his lively peers at school and social clubs around town, he recognized that he was different. As smoky ash-clouds puffed upward from the chimneys of Trenton's industries, Tom's lofty intellectual daydreams swirled effortlessly in his head.

Although he rarely devoted much time to his artistic interests, new opportunities would soon enable him to do so. Trenton's famous bridge boasted that "What Trenton Makes the World Takes," and Tom therefore never doubted that Trenton had an exciting journey in store for him, as well.

FINALLY A HIGH SCHOOL GRADUATE

Tom Malloy graduated from Trenton High School at a late age—21—because of the difference in academic standards in the North and South (where his schooling began). However, Tom was ambitious and enthusiastic about his future. He successfully made up several years' missed work before entering the appropriate elementary school grade levels, proved a talented student, and gained admiration from his teachers.

Of his graduation in 1934, Tom states proudly, "I finally graduated!"[1] He loved to read, still drew infrequently, and knew that his age was no sign of a lack of intelligence.

Community members like T.H. Woodley of Asbury Methodist Church pressured Tom to go to college, but Tom admits that he was "too poor to become a full [time] student." Instead, Tom decided to direct his energies toward learning through the example of those around him.

A FIRST JOB - PUBLIC SERVICE

Shortly after high school, Tom became an active, paid public servant in Trenton. His solemn studiousness, respectfulness, and swift progress in school had earned him considerable attention. He explains:

"When white middle class businessmen established the YMCA, Mr. Hilmar Jensen was chosen to lead the colored YMCA. Mr. Jensen immediately asked for my help."[2]

Tom recalls that Jensen "had an aristocratic image" due to his membership in the Episcopal Church. Although Tom was a Methodist, he asserts that "highly esteemed blacks joined the Anglican Episcopal Church back then." This church's roots in a progressive branch of the British royal family helped to give it an upper-class flair in America.[3]

Tom's positivity flourished as he worked in the colored YMCA, which was located in a building on Fowler Street, that was once the Sunlight Elks lodge hall.[4] Thinking back to his days there, Tom smiles and says, "They believed a boy was supposed to grow in spirit, mind and body." As a youth in his mid-twenties at this time, Tom considered the boys as close friends while mentoring them. He watched over the YMCA facility whenever Jensen went to recruit for members and patrons. "I counseled boys who later became outstanding men," Tom recalls, beaming with pride.

Tom actually connected with some of America's brightest future black leaders in his work at Trenton's own YMCA. A particular privilege was mentoring the late Judge A. Leon Higginbotham as a boy, before he went on to become a famous attorney, a high-ranked judge, and a Harvard professor.[5]

BATTLING RACISM WITH THE ART OF SONG

Through the YMCA, Tom also found new ways to express himself artistically. Although he did not practice his painting much at the YMCA, he became involved in the Charles Higgins Choir, a chorus that rehearsed there. Throughout his life, Tom had enjoyed expressing his feelings and his faith through song using his deep, beautiful bass voice—mostly in church. Tom feels that the Charles Higgins Choir gave him a chance to use his musical talents for the greater, public good. Tom notes that the choir was particularly responsible for enhancing the respectability of black arts and religion throughout the Trenton area.

While other racial groups may have spread misconceptions about the black community at times, the Charles Higgins Choir attempted to address this problem through cultural sharing. In Tom's opinion, "Negro spirituals enhanced black people's image more than jazz," and traditional folk groups like the Charles Higgins Choir were thus more valuable for bending the ear of conservative outsiders. Tom also sang with the original Singing Cities of Philadelphia.

Famous black personalities like Harlem Renaissance poet Countee Cullen often visited the YMCA to speak to the boys, and all these experiences maintained Tom's interests in the fine arts.[6] Through Jensen's

efforts and with Tom's youthful help, the Trenton Colored YMCA soon gained widespread recognition. "Many black doctors and lawyers joined the men's patron group," recalls Tom.

Yet the bitter hand of racism remained apparent in the broader community's response to Trenton's Colored YMCA. Despite the politeness and dignity of the black boys, Tom acknowledges, whites still "only allowed blacks into their YMCA on New Year's Day to swim."

MAKING ENDS MEET THROUGH INDUSTRY AND FOOD SERVICE

While Tom continued working at the YMCA, he bonded with other youth as a cafeteria worker in the food services division at Hamilton High West. Although the students he served were considerably younger than he was, they were in the high school environment that he had just recently left. Later, however, Tom decided to seek employment that could provide more direct income to his family. He was around age thirty, and he desired to be as supportive as possible. "I sensed that my mother was ill, and so some time before 1944, I helped her apply for assistance from the WPA in Trenton," Tom notes.

The WPA, or The Works Progress Administration, was initiated by former President Franklin D. Roosevelt and served to ease the damage of the Great Depression of the 1930s.[7] In a time of rampant unemployment in America, this program created new jobs for young men like Tom Malloy. Tom reminisces that his years serving in the WPA overlapped with the time that "The Lend-Lease Agreement started."[8] His years in the program were truly part of a very eventful time in U.S. history.

Tom recalls that WPA jobs were some of "the only work here for black men," as blacks were customarily the "last man hired and the first man fired" in times of general economic strain. The WPA focused on women who headed needy households. They could request jobs to employ their young sons, and the sons would subsequently send their salaries home. Tom speaks fondly of this program and of the late 1930s and 1940s in general. He taps his cane lightly to the floor and recalls, "Back then, I could buy a bag of groceries for $10!" Through this federal WPA program, Tom Malloy worked on many building projects that still stand throughout the Trenton area. Unfortunately, finding a fitting WPA assignment was not easy for Tom. He was a reserved, intellectual man who was not accustomed to tough labor until much later

in life. He describes his first assignment as "blue-collar work" where he joined other young men in digging part of Trenton's Stacy Park.[9]

Tom explains, "I was given a pick and shovel and a certain area of land to dig out. By noontime, you could only see our heads from ground level!" Unfortunately, Tom proved to be a very poor ditchdigger. He recalls laughingly, "I could not reach that far! So I was put in charge of watching the tools."

A second WPA assignment gave Tom and other men the task of "building Route 1 by widening the road." In this endeavor, Tom still had a minor role. He worked behind the scenes where the slabs of road were produced. "They would produce boards by steam by placing them into a slab-moving machine and I would help them remove the slabs of board," he reminisces. Slowly but surely, Tom and his companions improved the huge highway that now continues through Trenton, through other New Jersey towns, and through much of the East Coast.

RACISM ON THE JOB BUT AN OPPORTUNITY IN ART

Tom's blue-collar jobs with the WPA were brief, largely because of the racism of the Depression era. "White middle-class men needed WPA work, so many blacks were fired from blue-collar jobs," Tom remembers.

Tom also recalls that many workplace prejudices of the 1930s and 1940s were caused by political alliances. He explains:

"White people got everything because they were Democrats, and blacks lost it all. A white lady told me, 'you might get a better break if you register as a Democrat.'"

Tom was one of many blacks who changed their political party affiliation from Republican to Democrat in the late 1930s and 1940s. Tom explains:

"We had previously supported the Republican Party because it was the party of Lincoln, who emancipated black slaves. But this rationale was out of date."

Tom has remained a Democrat since making this change in his younger years. He feels that many blacks became grateful to the Democratic Party after Democratic President Roosevelt created economic programs to help their families out of the Great Depression. Tom and others grew to believe that because Roosevelt's party had helped them escape poverty, the Democratic Party was the smarter choice.

Ironically, after Tom lost his WPA job due to racism and politics, a stroke of unexpected luck brought him new employment. Tom's leadership and academic abilities landed him an even higher-paying WPA job. "They discovered that I had a little bit of brains so I got into the white- collar side of things," he explains. "First I worked in schools, supervising various programs."

Later, Tom was lucky enough to receive a WPA job in art. This was his first chance to work in the field that he had always kept hidden but secretly adored. "I taught arts and crafts," reminisces Tom. He worked in a Quaker arts program and a YMCA arts program, immensely enjoyed the undertaking. This was an assignment that working-class white men didn't necessarily fill easily. Teaching art finally gave Tom a rare chance to practice his hidden passion. Tom recalls that he was paid "a pittance. . .but at least it could keep me, if I wanted to, to go further in art education."

However, Tom did not have the time to increase his own portfolio as an artist during this time. He reflects, "I did not do much of my own work during this time because so many children wanted to do projects." Yet working with art in *any* capacity still gave Tom great joy and inspiration. Even if Tom was not creating his own original paintings, he was working with the materials and ideas that he could only dream of before.

A BOLD CHOICE TO STUDY ART

Teaching art with the WPA helped Tom expand his professional horizons. Before he knew it, his work was inciting new dreams and enthusiasm within him. "During those teaching years I would go to the Metropolitan Museum art lectures and just dream away," he confesses. Tom also began traveling to Philadelphia and New Hope more often to observe other artists. As he watched them work, he found new techniques to inspire his students and to later assist his own painting.

Tom admits that he "knew it was still just a dream" to think of a true art career during his WPA years. There were family responsibilities and obligations to consider. Yet he soon decided that he could at least begin brainstorming more often. "My drawing was doubling at home in my spare time, and sometimes I can even remember doodling on the back of a phone bill!" he chuckles.

Finally, Tom decided to test the waters of the art world more openly. After helping numerous students in the Quaker arts program, he felt that now he could at least try his hand at some artistic training. Tom

still told no one of his aspirations, but he began taking art lessons at the Trenton Industrial School of Arts on State and Willow Streets.[10]

As his appetite for art was whetted, he then branched out. "I saw an ad for a course in an art magazine. So I enrolled in a commercial art class through the mail," he explains. He notes that before this time, most of his artwork at home "was just sketches and drawings." Now, however, he could begin learning all types of artistic forms and procedures.

Tom studied art through correspondence courses sponsored by the Westport, Connecticut, Institute of Commercial Art and the Famous Artists School.[11, 12] The schools sent Tom instructions on fascinating artistic techniques, and his work brought countless hours of enjoyment at home. As he mentions the courses today, Tom's eyes dance. He pulls out a dusty instruction book that he keeps close-by even now, and he points out different examples of sketching with a broad smile. "I took a course on stippling, line drawing, hatching, and different media," he remembers excitedly.

Tom worked meticulously during these art correspondence courses. He was a man in his thirties with a hobby that few of his peers would have had. To learn, Tom first observed the sketches from his instruction books, then read about them, then sent his imitations of the sketches to the schools to be graded. Tom successfully completed the course requirements after many months. He felt a swell of personal pride, even though he only used his new knowledge to create beautiful scenes on the backs of scraps of paper at the time.

Tom could not bear to stop doodling after his correspondence courses were over. He increased his teaching hours at the Quaker arts program so he could work with art more frequently. Tom also often traveled to nearby New Hope, Pennsylvania, where for the first time in his life he made friends with a racially diverse group of artists.

Although his positive experiences in New Hope did not convince him to sell his own art yet, it provided a welcome break from his work and his life at home. Later, Tom began traveling to New York weekly to study at the Art Students League.[13,14] There, Tom was taught by various renowned artists. By 1978 Tom had studied under artists like Bradshaw, McGinness, Ed Whitney, Mario Cooper,[15] and Ranulph Bye.[16] He additionally studied under painter Edward Nee.[17]

Unfortunately, Tom's financial constraints prevented him from buying quality art supplies. He primarily used his WPA salary to assist his dependent mother and grandmother during and after the Depres-

sion. Even though his brothers were all adults by then, times were still hard for Frankie and Ida back at home.

BECOMING A FACTORY MAN

After the WPA was disbanded and the Depression had subsided,[18] Tom became interested in a vastly different field from art teaching. He decided to give factory work a try. Luckily, there were many available job opportunities. Tom also attended Trenton Normal School in order to gain more training to succeed.[19] Tom confides, however, that he doesn't know how he got in and that he was there only for a brief period of about "a year or so."

All these experiences were a far cry from the life the late Tom Senior had envisioned for Tom Junior. "I never thought I'd work in a factory before I came to Trenton!" Tom Junior now exclaims. However, Tom soon found factory work to be both challenging and remunerative.

Recalling his days in Trenton's industrial zones, Tom now states, "I wouldn't take a million dollars to change any of the experience. . .being around the machines, feeding them. . ." Tom was amazed at the abilities of the various man-made machines. He was also proud to play a role in Trenton's economic progress. As an industrial worker, Tom helped his city gain a reputation as a productive manufacturing center. Trenton was a chief supplier of goods to various cities and industries during these years, and by 1950 over 23,000 Trentonians had manufacturing jobs.[20]

Factory work wasn't all excitement, however. Remembering how he alleged that he wouldn't exchange his factory experiences for a million dollars, Tom giggles and admits, "But then again, for the experience of it, I wouldn't get it back for a million dollars either!" Tom's insightful remarks reveal the true dangers and demands that factories placed on their workers in the mid-20th century. Tom first worked eight-hour days in ammunition production during World War II.[21] "I heard they needed shells to fight the war and went to a factory in North Trenton off of Hingham Avenue which hardened the bullets," he explains. Each hour Tom worked seemed to stretch on forever because of the rigorous nature of his work.

Tom's job was to take the hardened bullets off of a wet rack with a rake after other men took them from an oven. He would then throw the bullets into a boiling vat of hardener. Tom notes that these bullets were made hard in order "to shatter flesh." While Tom endeavored to perform his industrial job well, he always held reservations. In the back

of his mind, he perceived that his work at the bullet factory was "a total contradiction of Christian beliefs." For he was technically ignoring what he knew about the evils of murder by helping to make equipment that killed. Tom's first factory job at the bullet factory was also difficult due to the "constant moving" involved in work on an assembly line. He describes how men had to neglect their own complaints and feelings, according to the rigid rationale of the industrial world:

"You learn, because you have less than one minute or else you stop the whole line and the foreman gets upset. The factory is on a contract and has a quota to make, so you're jeopardizing it if you stop the line." As if working in a bullet factory wasn't daunting enough, Tom moved on to even more dangerous work between 1943 and 1944. "I worked in the Roebling steel plant," he begins.[22] Sitting back in his wooden chair today, Tom recaptures the atmosphere of Trenton's premiere steel plant of the industrial age. He declares:

"What a noisy place it was! You had to have a note pad to communicate by writing things down. You couldn't even hear the person next to you. There was great screeching of the strand machines which made wire ropes. They made a ringing in your ears, and anyone working in such factories longer than a few years usually lost their hearing."

Various other hazards awaited the men working in Trenton's steel industry, particularly those who worked the strand machines that twisted wires together to form ropes. Their jobs resembled the perilous work in many factories across America back then. Tom warns, "If those wire ropes frayed and a piece swung forth, a grown man could get cut in two!" He and the other workers had to watch closely for the slightest sign of fraying in the ropes. If they didn't catch the frays well ahead of time, their neglect might result in the death of a fellow worker.

The men in such industries generally worked long hours from the time the whistle blew in the morning until the end of the day, taking a break only with permission of the foreman. Tom recalls that there was generally not much fraternization in the Roebling plant either, noting that

"This was a place to work. This was not a place to come together as a people and get to know each other better. . .we did not visit each other's homes. . .we are talking about a time of discrimination. You did not want to stay around too close to work. You got back to a safer haven where your own kind of people were. You did not visit [co-workers], except for those Italians that were close to you."[23]

In 1946, Tom left the steel plant and went to work at the Trenton Folding Box Company factory for twenty-four additional years.[24] This

factory was located on East State Street Extension, not very far from Tom's boyhood home.[25] "I worked in the gluing department as a sealer when the boxes were ready to be shipped," Tom recalls. Throughout their days at the gluing machines and other machinery, Tom and other workers became highly fatigued. Many of them were tense after the day was over. Some liked to relax with various sports.

"You were tired," Tom explains. "Most factory workers might drink or gamble afterwards, or go around with the women. All you hoped for was a pleasant evening afterwards. . . ."

One thing that young, unmarried Tom noticed back then was that his co-workers often sought very destructive ways of releasing their tension after work. He notes, "Many of my friends would gamble *all* their money away. Rarely was a man left with a penny in his pocket on a Monday." Watching the sad indiscretions of his factory pals made a strong impression on Tom. His disapproval of their drinking and galavanting caused him to choose a more spiritual path in his own life.

ACCOMPLISHED BROTHERS, SEPARATE LIVES

While Tom was finding steady work in Trenton's industrial world, his brothers worked elsewhere. They joined him in bringing pride to the Malloy family name through their various pursuits.

Frank and Tom remained particularly close throughout their youth and older years. Both shared their grandmother Ida's love of knowledge and vast intelligence. Tom insists, however, that "Frank was the brain of us four boys." Frank had graduated from Trenton Central High School with honors, and he later decided to try his hand at research chemistry. He was the first black graduate of Drew University's School of Liberal Arts in Madison.[26]

Not far from the factories where Tom worked, Frank became employed at a company called Merck, a company that has grown into a large pharmaceutical conglomerate today. Frank did research at Merck for several years until unemployed white workers were selected to replace him and other blacks in the 1940s, during World War II. However, Frank was as undaunted by racism as his brother Tom. Frank secured several other impressive jobs. He worked with the Signal Corps, which dealt with intelligence during World War II. Unlike Tom, Frank married early and moved away from the family home. But he later moved back to his mother's home after his divorce.

Meanwhile, Tom's brother James worked for the department store Sears Roebuck, before becoming a county file clerk and a policeman.

All of the Malloy brothers finished high school, but James had gotten off to a late start academically and was quite a miracle child. Tom confides that James "was supposed to be the dummy" and had slurred speech all through his life. His intellectual development was stunted until one day after Tom Senior had died, when a man named Reverend Cheers came to dinner.

The Reverend from Cadwalader Asbury Methodist Church had noticed young James at the dinner table and keenly asked, "You're not a dummy, are you?! If I help you James, will you prove to them you're not a dummy?" Tom remembers that James slowly responded, "Yeesss" and became set upon becoming "a phenomenal person" after that. He went from being a mail carrier to finishing Trenton State College and holding the aforementioned jobs. He was also a conscientious objector to World War II shortly before Tom joined him. After a brief bout with kidney failure, James taught junior high school and got married to a woman named Rosa along the way.

John, the fourth and final Malloy brother, was always a very serious personality who was quite adored by women. "Women loved him." Tom reminisces quietly. "He understood them and was very sensitive to women's problems and needs. He could make women [who were] feeling the blues just laugh!" Despite this fact, John remained unmarried throughout his life. He worked in construction and later worked with freight trains on the Pennsylvania Railroad.

NO USE PURSUING ART?

Tom performed his factory work at Trenton Folding Box throughout his middle-aged years although times were hard. After settling down to a work routine, he also sought out art once again as a hobby. This pastime helped him retreat from a tedious job. Ever since finishing his New Hope art course and his job as an art teacher, Tom had missed the joys of learning art. He began to ask artists about attending an art school in a larger city but was soon warned to abandon all hopes.

One fellow artist burst Tom's bubble when he cautioned, "I wouldn't advise you to go to a large city! Find a local art school." Tom attributes this man's negativity to the skepticism that many working-class artists acquired after their careers failed during the Depression and World War II. These events had decreased many people's faith in the pursuit of nonpractical jobs. With this pessimistic advice, Tom spent a short time doubting whether he should even try to keep studying art at all.

Yet Tom did manage to sell his first painting during the 1950s. He worked up the courage to attend an art show held at the Mercer

County courthouse. He once explained to a newspaper interviewer that the first painting he sold "was a rooftop scene.... I forget what I got for the picture but I know it was less than eight dollars."[27] This first sale didn't convince Tom that his artwork was of professional quality. However, the years would prove that art would remain part of Tom Malloy's life even as he pursued other adventures.

TROUBLE SEEKING A LOVE LIFE

Tom dated during his early and middle adulthood, but he confesses that he "found it difficult to find intelligent women." Many times, his interest in art actually dampened a relationship! On the rare occasion when he gained the courage to open up to a woman, "show who he was in art," and invite her to the Metropolitan Museum, she usually got bored there! Tom also became ashamed when one of his girlfriends caught him sketching for his commercial art course. This led him to believe that he should not expose his artistic interests to women in most relationships.

"Now there are women bankers," Tom asserts, "but most women I met back then were more concerned with family life than intellectual matters." Tom remembers that many women "tried to study" him to discover if he'd make a good husband. Yet he laughingly admits that he often proved a brief or boring study for many bachelorettes: "I had little money, was studious, and disapproved of drinking. Many women told me, 'You're not my type!'" Tom recalls.

Tom had also gained the reputation of being a scholar in the black Trenton community. This fact also often hindered his romantic prospects. "People would say, 'He's read too many books. Don't listen to that fool," he confesses.

Fortunately, Tom remained open-minded about the possibility for romance in his life. He was also not crippled by the prejudices that his mother tried to instill in him. Frankie's own awareness of her light skin complexion made her quite opinionated about her sons' choices in women. Tom recollects: "From the time she found some of us were beginning to look at girls, she said she had to change it. She said, 'Don't bring me no kinky-haired girls and don't bring me no coal.' Unfortunately she was raised to think of black as evil. . . 'You're black, git back' was the saying."

Tom's religious beliefs helped him dismiss his mother's animosity toward darker-skinned women. They also caused him to disregard the prejudices that he heard other people express. He explains: "When I was young, I first started believing in Jesus Christ, and the preacher said we should understand Jesus Christ better because he was Jewish. [So] When people talk about 'cheating, stingy Jews,' we must condemn that and always be reminiscent of Jesus."

Tom's loving attitude would pay off even though his dating prospects didn't blossom until much later.

TO JOIN TRENTON'S BLACK SOCIALITES?

While women may have shown only minor interest in Tom, it was Tom's turn to show disinterest when it came to joining social organizations around town. Most of Trenton's blacks belonged to at least one of the city's numerous social clubs and fraternal associations. Yet Tom did not feel like he fit in with any of those crowds. Being a self-proclaimed bookworm, Tom felt uncomfortable belonging to a club with no clear intellectual or civic purpose. Tom recalls: "In those days, one lady asked me to join her high society social club. I remember asking her, 'Tell me—what does a black high society club in this city do?' She said, 'We meet and play cards.' And I told her I was no card player!"

As Tom walked away from the woman, he made it clear that he had little interest in her club's pursuit. This incident unfortunately helped Tom create a very haughty image of himself. "She was the first and the last to try to adopt me into a social club!" Tom exclaims with a good chuckle. Tom also avoided most social organizations because he felt that the identity of such clubs was based on silly stereotypes. For example, Tom felt that the woman who invited him to join her "high society club" had begun her invitation with an inappropriate comment. She had approached him saying, "'Although you live in East Trenton, you're like us people from West Trenton. We want to invite you to be a part of our black society in West Trenton!'"

Tom was offended because the woman spoke as if she considered most East Trentonians to be beneath her. He felt that it was ridiculous to think the location of a person's house had something to do with their character. "It was as if she didn't believe anyone could be good if they came from East Trenton!" he exclaims with an incredulous look on his face. "It was as silly as it was way back in the Bible when the Jewish Sadducees said, 'What good can come out of Nazareth?' just because they heard that Jesus came from the small town of Nazareth," he continues.

Although Tom rejected Trenton's purely social organizations, he still found plenty of enjoyment and fellowship. He had been elected as vice-president of the Trenton Chapter of the National Association for the Advancement of Colored People (the NAACP) as a fresh-faced

high school graduate.[28] He attended various meetings and lectures in that capacity, as well as through his church. "I filled my days with free lectures at local colleges and forums instead," he remarks. Tom usually attended scholarly events alone although he was not a college student, and he always made new friends.

TRAGEDY STRIKES AGAIN

The death of Tom's father was far from the last misfortune facing the Malloys. Tom's life was later stricken with grief at the loss of three family members all in the same decade. Tom sighs sadly when recalling the rapid sequence of deaths in his family in the late 1940s and 1950. His mother died in 1946, his grandmother died in 1949, his brother John died in 1950.[29] While such hardships made things rough for Tom, he continued to expand his own journey while finding ways to cope.

Tom Malloy today grips a curvaceous, dark auburn wooden cane that a friend brought to him from Kenya. He tilts the cane slightly and speaks fondly of his adventures in Trenton's factories, around town, and in the school where he once taught art. One can see the giftedness emanating from within him through the enthusiastic sparkle in his eye. As he explains it, he had lived out his young adulthood answering calls to duty from both his family and society. Trenton had helped to make him a well-rounded, God-fearing citizen, and he took advantage of the ample opportunities it afforded him.

Yet another dimension of Tom's life remains unexplained in this narrative up until now. Tom had continually felt the tug of Christian values. He had always sensed a call to preach, which accompanied his civic lifestyle and his steady path toward various careers. One can imagine this constant, fateful religious thread through Tom's life as a deep, royal purple billowing in vivid strokes upon the canvas of his watercolor life and making Tom himself a regal and exemplary figure in both personal and civic life.

Street Scene, (1979), from the collection of Brian and Linda Hill

CHAPTER 4

The Spirit Always Calls

St. Mary's Cathedral, early Tom Malloy Painting, courtesy of Mr. and Mrs. Josef Teti, Triangle

Tom answers the phone during one of our many interviews for this biography. He calmly listens to the caller on the other end of the line. He has a pressing schedule for the day, and I myself feel this urgency as I gaze at his teeming piles of unfinished sketches, finished paintings to be sold, and the art supplies scattered around his studio. Yet Tom nods respectfully as the caller drones on for several minutes. After some time, a small smile creeps upon Tom's auburn lips.

"Yes. I thank your organization sincerely for its noble work. I will sustain my pledge from last year," Tom assures the caller.

As he hangs up the phone, he patiently explains to me, "It is the Police Athletic League. I believe that they are one of the more worthy organizations that call, and so I chose to give to their fundraiser."

Many professionals find little tolerance for telephone fundraisers and social service. But a boundless benevolence guides Tom Malloy in this typical episode and every day. He gives of his time and money with his whole heart. This quality is the result of a spiritual base that has guided his artfully diverse life and his style of painting.

Feeling an obligation to spread God's goodness to others, Tom has always allowed his life to turn in multiple directions. Yet all the roads he has taken began with the soulful ideals from his Southern roots. Whether he is working with youth, instructing the church, or enchanting the world with his art, Tom uses his long-standing spirituality to show that one's actions can be a colorful form of service to the Lord.

A PREACHER FROM BIRTH

Becoming a spiritual man was always Tom Malloy's destiny. His spiritual life has a story all its own. This chapter is the story of that spiritual life, which deserves a special focus. Throughout his work on his boyhood farm in Dillon, in Trenton's factories, and in many other places, Tom was abiding by spiritual principles.

Tom's spirituality always corresponded with his other activities. He begins the story of his religious journey by proudly announcing, "When I first came into the world, my grandmother Ida told my father and mother, 'I'm gon' educate this man to be a preacher!'" As Tom grew, there was no question in the mind of Ida and other Malloys that

Tom also had innate preaching talent. Tom continues, "They saw me as a gift from God in preaching when I was a child."

Tom's grandmother Ida had a spiritual spark that was nurtured by her mother. Ida's mother was a devout slave called Shoutin' Easter Farley. Easter was famous around South Carolina in her day because her kind heart, lively religious dancing, and beautiful singing earned her a reputation. In the eyes of family and friends, Tom recalls, Ida was also considered to be "a gem of a woman."

Ida taught her family important religious lessons in addition to teaching the etiquette of whites in the Big House. Tom remembers that she always scolded, "'You cannot raise kings and queens with a noble purpose and high esteem if you're doing the devil's work!'"

Ida was thus a large influence on her grandson Tom Junior's spirituality. She demanded that all the Malloys "had to have principles." She spoke of "getting right with God" at every possible opportunity. Ida was also constantly on a mission to hear the wisdom of great preachers and activists. She hoped that such speakers would rub off on her intelligent grandson Tom. As Ida trekked to meet countless luminaries such as Walter White and Mary McLeod Bethune, Tom could not help but notice how these speakers' inspiring words edified his grandmother's soul.

LIFE IN THE SOUTHERN CHURCH

A large portion of the black southern population was Baptist in the early 1900s.[1] But Ida Malloy taught her family to worship under the more reserved, scholarly Methodist religion. As Tom notes, the Methodists believed that "anyone who reached worthiness as a preacher first had to be educated."

As a Methodist, Tom learned numerous stories about John Wesley, the founder of his religion. Wesley was educated in England at Oxford.[2] Wesley was a model of scholarship and faith whom Ida encouraged Tom to follow. The Malloys were faithful members of St. Stephen's Methodist Episcopal Church in Dillon. Little Tom attended services there every week until he moved to Trenton. Tom speaks excitedly about memories of his old southern church. He proclaims, "Church on Sunday was one day when we really got to talking about what a good time we had in the Lord!" Tom remembers how other southern men customarily snuck into the woods to "drink moonshine and corn whiskey out of tin cups." Yet things were quite different for the men of his household.

As a rule, Tom's father, his family, and all their Methodist friends had to abstain from liquor. They avoided such intoxicating substances

because ingesting them would create extreme pleasure here on earth. "Methodists believe this world is not our home," Tom clarifies. "Methodists know we are all sinners, but we use our *minds* to live this secular life." However, the Malloys and other South Carolina Methodists shared many hymns and other lessons with Baptists, Pentecostals, and other Christians. Tom fondly recalls the lessons of his pastor at St. Stephen's:

> We were always taught that God knows best, and that there can always be hard times. So we were to be thankful for what we did have. And in church, the preacher would say, 'By and by, when the morning comes, we'll understand it better by and by.' Just about every time you went to church, you were reminded that God is preparing you.

While reciting the words of his childhood pastor today, Tom articulates the words slowly and fervently. It is as if he truly feels the meaning of these words within his soul. His voice rises at the end of each phrase, and he shakes his head and smiles triumphantly while speaking. Real joy seems to be reaching deep into his heart. Tom continues reminiscing and reciting portions of sermons with his eyes closed. He envisions himself back there in that old church pew even now: "This world is not our home. I am just a traveler, a sojourner! But by and by, when the morning comes, we'll tell the story! Roll Jo'dan roll. . .'"

A NEW CHURCH HOME AND RELIGIOUS POLITICS IN TRENTON

When Tom moved to Trenton at age ten, he became a member of Mt. Zion African Methodist Episcopal Zion (AME Zion) Church. He recalls those peculiar days of segregation. Racial struggles over religion were particularly important back then.

"We Methodists thought we were better than the African Methodist Episcopals because our church was not totally segregated," he asserts. Ironically, Tom also remembers that "black Methodists were not fully accepted" by white Methodists who shared their own religion. After searching for purely Methodist churches that were their first choice, Tom's family finally settled upon an AME Zion sanctuary instead.

Ida felt that Mt. Zion's rich history somewhat compensated for its racial isolation from the traditional Methodist faith. "Mt. Zion was one of the oldest AME Churches where Richard Allen himself set foot," Tom explains. Tom still values the privilege of worshipping where Allen, a former Philadelphia slave, once visited. Allen founded the AME faith in 1787 and now has a legacy in churches all across the nation.[3] In Ida Malloy's opinion, women in elaborate hats and ushers in "swallowtail

morning coats" made Mt. Zion a snobby, "seditty church." Ida was more accustomed to simple southern Methodist worship, and she felt that such ornate clothes distracted from the spiritual focus of a church.

Luckily, Mt. Zion generally upheld the same conservative morals that Malloys had learned from St. Stephen's Church in South Carolina. Tom asserts that in the 1920s, Mt. Zion was a place where "women actually boasted that their husbands had never seen them naked!" These devout wives made this claim "whether it was true or not because they believed it was immodest to show their bodies."

At Mt. Zion, black Trentonians also honored the patriarchal model of the family. They emphasized that a father's rule over his home was key, and the Malloys therefore felt right at home, having learned this idea from southern customs.

Tom recalls that members of Mt. Zion also "practiced good manners." They were taught to refrain from swearing and drinking at all times. Worshippers even substituted juice for communion wine due to their roots in sober Methodism.

According to Tom, John Wesley had first decided that American Methodists shouldn't drink alcohol because he felt his homeland of England had become "a nation of drunkards." Mt. Zion members likewise lived by the philosophy, "No gambling or else no good!" as Tom explains it. For the Malloys and their church associates, old-fashioned values prevailed wherever they lived.

HELPING FOUND A CHURCH

The Malloys remained at Mt. Zion AME Zion Church for only a few years. They truly missed the liveliness of the Methodist services they had participated in down South. After some soul-searching, the Malloys chose a Methodist Church that was more animated and humble. Their new church was so simple and modest that it did not even have a building!

"We went to Asbury Methodist,[4] where people were struggling," Tom recalls. In contrast to the "quiet" congregation at Mt. Zion, Asbury's members weren't too uppity to catch the spirit and dance in praise of the Lord. Asbury prided itself on being a part of the tradition of lively, "shoutin' Methodists," Tom notes. The new church's high energy and unadorned services immediately made the Malloys feel more comfortable.

Tom is still quick to point out the differences between Methodism and other Christian denominations, however. "Physically we have a difference. We believe in the Holy Spirit but we don't interpret it as

the Pentecostals do," he explains. Tom notes that speaking in tongues is rarely seen in a Methodist Church. He compares that reality with the fact that "Some [Pentecostals] feel that if you can't speak in tongues, the Holy Spirit hasn't reached you."

Asbury Methodist Church resembled St. Stephen's church in many other ways. Until the congregation found an actual church building, they met in remote places. This reminded the Malloys of the practice of rural churches in the south. "One Sunday, Asbury even met in a livery station where horses were kept!" Tom chuckles.

The Malloy family was not bothered by the insecure location of their new church. They knew that Methodism encouraged worship anywhere. They were taught that a church existed wherever God's followers united. Tom quotes an old Methodist hymn that demonstrates this fact, singing, "Ooh, come to the church in the wildwood. Oh come, come, come to the dale!"

Other members of Asbury were likewise eager to praise God in any location. They enjoyed their services and maintained faith in the potential of their institution. "They were determined that one day their congregation would become a formal church approved by the national Methodist leadership," Tom recalls. In the meantime, they stayed strong and worshipped as a group.

Tom feels that the church's name was especially indicative of the congregation's hopefulness and conviction. Although they had humble beginnings, they named themselves after Francis Asbury, who "was a great leader and [early] bishop of the Methodist Church in the United States."[5]

True to the faith of its membership, the Malloys' new church finally triumphed. Tom proudly explains that the church formally became approved as Asbury Methodist Church in the late 1920s. The congregation then began meeting at the site of a future Colored YWCA while their church building was being completed. They met there until the YWCA's staff moved in.

The Malloys joined other Asbury members in dedicating their first church building. They became involved in various programs there. Tom reminisces, "This first church building is still on Montgomery Street near Revere School, or the New Lincoln School."

Although the first Asbury Methodist Church was small, the group felt fortunate to have a stable meeting place. Later, their luck increased when they found another building on 533 Perry Street.[6] "It was a store-front which was a German bakery. It was torn down only two years ago," notes Tom. Tom's heart remains close to Trenton's Asbury Methodist

Church today. His grandmother Ida played a particularly important role in helping them move from the Perry Street storefront to the splendid building on Stuyvesant Avenue and Oak Lane, which stands as one of Trenton's most historic churches.[7] Tom explains that the happy congregation renamed itself Cadwalader Asbury United Methodist Church "because that region was known as Cadwalader Heights."

Once a faithful group worshipping among horses' saddles, the members of Cadwalader Asbury went on to become pillars of the West Trenton community. Tom is one of its oldest members. He enjoys recalling the first time he roamed the church's great halls as a young man. "My grandmother cut the ribbon at the dedicating ceremony around the time when Hitler invaded Poland," he boasts.

Tom Malloy remains concerned about the future of the Methodist denomination. He points out that the Pentecostal faith "is the fastest growing Christian body, whereas my denomination, Methodism, has lost, in a relatively short period of time, two million of its members. A lot of the members that we lost joined with the Pentecostals."

Tom feels that one reason for the decline in Methodist membership may be due to Pentecostals' lack of old-fashioned formality. He explains:

> You don't have to dress like. . .'in the nines.' The Bible says you can come as you are, and that is the Pentecostal approach. If you have the curls in your hair or you have the dreadlocks or whatever it is, come as you are. Just come with a repentant heart. [Pentecostals] have a more open door.[8]

GROWING CLOSE TO GOD AS A YOUNGSTER

The temptations of urban life "in the roaring twenties" were largely unknown to Tom. He knew very little about "the world of flappers and smoking" because his family encouraged him to seek God instead. The Malloys also supported the Women's Christian Temperance Movement, which sought to outlaw alcohol in America to promote a more moral society. These ideas resonated with Tom as his reasoning abilities grew, and he became a conservative young man. A new, powerful mentor also sensed extraordinary potential in Tom. Tom admits that even before he showed an interest in spiritual leadership, he "was always treated special" by Asbury's pastor, R.W. Cheers. "He knew that I was unusual. That I had a way of understanding. That I was not an ordinary boy," Tom admits. Cheers helped to guide Tom's adolescent behavior.

Tom reminisces: "Even as a dirty little boy, the pastor invited me to hear speeches. He would come sometimes and find me out in the street

playing and say, 'Come and go with me, Thomas.' And we would be the only black people there." Tom also gained the attention of Reverend Cheers and others as a young boy because he had the uncanny ability to recite the minister's Sunday sermon almost verbatim after the service.

Cheers' kindness meant a lot to Tom because some of the more affluent blacks degraded him and other poor migrants from the South. As Pastor Cheers went out of his way to befriend Tom, he gave the intelligent boy unexpected chances to succeed.

Reverend Cheers' good faith in Tom consequently had a large influence on the boy's life and image. As Cheers encouraged Tom's leadership in church services and activities, other church members gradually noticed the boy's calm, steady approach to any problem that came his way. Tom was made "Junior Class Leader." For Cheers recognized Tom's ability to grasp and teach spiritual concepts.

While many of Tom's high school friends played in a band or practiced team sports, Tom focused on assisting his church. "I supervised no more than twelve people and saw to their spiritual state in my Class Leadership position," he remarks.

Looking back on his youth, Tom admits that his conservatism cost him many exciting adolescent adventures. "In a sense, I never reached [typical] manhood," he muses. A sturdy masculinity in the 1920s was "proved by smoking, drinking and betting with the fellows on the corner on who's gonna get a girl first," he explains. And such ideas were always foreign to Tom.

Yet Tom enjoyed the more challenging strain of manhood. He expressed himself in a deeply spiritual, serious way. He felt that disrespecting and tricking women was simply unacceptable, and he refused to join that type of behavior. He recalls, "I would talk to the minister about it instead. I never felt left out then. I became bookish, fascinated in other things."

Because of his Methodist tradition, Tom combined biblical study and academic study. He grew more and more studious as the years went by. "I was always seeking knowledge of God," he explains. Tom's grandmother Ida also continued to influence his morality as he reached young adulthood. "She would say, 'books and girls don't mix!,' and I happily took her word for it," Tom recollects.

Throughout his studies, his quiet chats with Reverend Cheers, and his active life as a youth leader, Tom was able to avoid the dangerous places where many of his urban counterparts gathered each night.

GAINING COMPASSION FOR THE UNKNOWN

As Tom grew older, he gained a deeper understanding of morality. He began to recognize that faith was more than simply learning from his pastor, congregation, and family. He was soon able to see the pitfalls of immoral life with his own, discerning eyes. He recalls watching many of his friends "get sick as dogs" at bars and brothels day after day. Tom could not help but to feel sorry for them, as he realized that they were desperately seeking what they thought was true happiness.

The plight of Tom's friends also made him personally disinterested in women who "overdrank." Such women commonly approached Tom during his youth in the 1920s. This was a decade when sexual liberation and bootlegged liquor were spreading across America.[9] Yet Tom immersed himself in "profound religious thought, human relations, and world affairs" instead. Tom believed that immoral romps with girlfriends would only bring him illness and desperation. Unafraid to stand apart from a crowd, Tom sought to help his wayward peers.

Pondering the 1920s social climate, Tom now exclaims, "But for the grace of God our nation came out of those times!" Back then, many of Tom's friends did not see a way out of despair. Tom feels that the black church in general had a profound effect of "eas[ing] the agony, pain and suffering, emphasizing that this world is not our home."[10]

Tom was especially inspired by his church leaders' kind acceptance of sinners. He explains that disobedient "gamblers in the church would say 'I'm gonna do something for your church.'" Tom remembers that although "some people would say 'We don't want that money,' the preacher said 'That money came from the lord!'" Tom was likewise impressed when "Hoboes would stop by [his] church" and were never turned away. Ministers of Tom's church took the time to extend love to those who felt downtrodden. Their compassion weighed in Tom's mind as a model of exemplary Christian behavior.

Yet Tom notes that liquor still "destroyed poor people, white and black, especially women" in those days. The mature moral observations that Tom made as a young man ultimately led him to consider the ministry. He felt he could not stand by and watch so many people's lives crumble further.

For a long time, Tom remained unsure of how he could best spread his ideals to a rowdy society. Even though he knew he could become a minister, he felt self-conscious. He knew he seemed to stick out as an unusual, somewhat unstylish young man. Even his mother Frankie worried that her son was a bit too serious for his own good. "My mother always said, 'You're a strange son,'" Tom recalls. Frankie wasn't

shy about urging her son toward the career path she thought he was best suited for, however. "She said to me, 'You're a born preacher. Those doodles and sketches won't get you a loaf of bread!'" Tom laughs.

A SURROGATE GODFATHER AFTER TRAGEDY

Tom Malloy Junior lost his father when he was only thirteen years old. He was therefore honored when Pastor Cheers requested to "become a surrogate father" to him. Tom admits that he seemed to be a "strange," stuffy young man to some people. But he remembers that Cheers had always perceived his need for belonging and guidance. Throughout his teen years and beyond, Tom spent an increasing amount of time at Cadwalader Asbury talking to Pastor Cheers. They soon became close confidantes. As Tom matured, the two religious men cultivated a strong bond. They discussed everything from politics to church philosophy.

Tom remained cautious about becoming overly dependent on Cheers, however. He felt extremely honored and grateful for all the many things Cheers had done throughout the years, and he did not want to overburden him. Tom confides, "I never asked for much advice because I'd been given so much by him along the way already."

The other Malloy boys were suspicious of Tom's close friendship with Reverend Cheers. They suspected that the friendship was "forced" by the pastor. Yet Tom stresses that this was not the case. Tom was humble and cautious out of respect, but he always rejoiced when the preacher freely lent him knowledge and time.

Tom's scholastic interests also increased as he learned more about his surrogate father. Upon discovering that Cheers was a graduate of the esteemed Boston University, Tom's admiration for him grew.[11] Cheers was also a relative of the McLeods—the same family that produced the famous educator Mary McLeod Bethune. As Tom recognized that educational success made Cheers and his family astute, confident, and spiritual, Tom longed to stretch his own mind in a similar fashion. Tom also became more comfortable exposing his lovely singing voice to other members of his church and family during this stage of his life.

A RELIGIOUS REVELATION

After serving as Junior Class Leader for several years and bonding with his pastor, Tom finally experienced the spiritual encounter that would shape the rest of his life. Around 1934, when 21-year-old Tom was preparing to graduate from high school, he felt an increasing desire to become more active in the church. He explains:

"I had this desire to do something creative in the church, like when creating things I'd visualized with my eyes onto paper," Tom reflects. "A time came when I began thinking, 'I'd like to preach that sermon!' each time I sat on a church pew."

Finally, one particular day arrived when Tom's whole heart and mind became focused on the ministry. Tom recalls this decisive feeling as "a sensation I can't exactly describe." He ponders, "I can't explain it. . . . One day I was thinking and I found myself *preaching. But* I was alone. I felt this warmth and realized God had something for me to do. . . . To tell the Good News."

Tom had never felt the special light of God shining on him so strongly before. He had never found himself speaking and not knowing why. He knew that this was a historic moment in his life. God seemed to be singling him out all of a sudden, for a reason. "From then on, I became devoted to speaking about the evils of warfare as a follower of Jesus Christ," Tom proclaims.

This special moment of revelation solidified Tom's confidence. He became more serious about the idea of being a real religious leader—an idea that others had often suggested to him. Although many people had told Tom he "was a gifted orator," he had never really fancied himself a preacher. Now, however, Tom stopped doubting his preaching abilities. Perhaps his grandmother had been correct to claim he was a preacher on the day of his birth.

Today, Tom lifts a wrinkled brown hand that clutches a pencil. He shakes it up to the sky as he recalls his spiritual revelation. It is as if he is truly preaching even now. He notes that his unexpected awakening-day was probably the "personal encounter with God" that all Methodists believe in. "Every religious person must have one," he asserts. "It may inspire *you,* but it was *my* experience."

After this extraordinary encounter, young Tom finally decided to dedicate more time to becoming a church leader and instructor. He first became a deacon.[12] Later, his faith pushed him even further upward. "I had to accept an offer from my pastor to begin studying as a local minister. Preaching was something I had to do," he explains.

ANSWERING THE MINISTRY'S CALL AMID OTHER JOURNEYS

Tom recalls that his preaching career blossomed during the period when "three Methodist groups came together." This gathering, which was formally called the Fourth Quarter Methodist Conference, was

a meeting of various district superintendents and preachers. Tom felt privileged to simply attend the conference along with Cadwalader Asbury's leaders. He attended in order to represent his church's Junior Class. Yet he was eager to stretch beyond simple participation and become a member of the clergy.

Tom recalls this day as clearly as if it was yesterday. He explains, "At every Conference, there came a time when the Conference's overseers asked, 'Are there any candidates for ministry of any sort at this Conference?'" During this portion of the Fourth Quarter Conference, Tom Malloy stood proudly. He was in his mid twenties when he introduced himself as a candidate for the ministry.

"They were glad when I answered the call," Tom remembers. Many Methodist leaders had been watching him closely. They knew that this young, studious man would be an excellent preacher. They had hoped he would decide to join the clergy, and he had finally accepted the challenge. After graduating from high school, while working at the YWCA and Hamilton High West, Tom began simultaneously preparing for the ministry.

The curriculum for Methodist ministerial candidates was rigorous. Tom notes, "I studied introductory psychology, church history, and the Bible from cover to cover." These topics comprised a course that the Methodist Board of Education administered through the mail.

As a working-class man with two jobs, Tom had neither the time nor the money to attend a seminary course at a college. After toiling over his books for the mail course, Tom was ready for his final exams. "I went up before a board of preachers who decided that I had passed the exams to their satisfaction," he reminisces.

Difficult classes were only the beginning of Tom's journey into the ministry. After his written exams, Tom was required to go before another board of ministers who examined him more personally. This step would determine whether Tom had the character traits necessary to lead a congregation.

"A minister's conscience couldn't be flawed. The Methodists believe that the call to preach is the loftiest concept and the pinnacle of mortal life. Preaching is the highest honor for people on earth and it must be earned," Tom explains reverently. After being asked numerous questions about his personal life and family relationships, Tom "passed" the personal exam "with flying colors."

Tom recounts this fact with a firm, pleasant nod of his head. He continues chuckling, "I was so pure I wouldn't take a fellow's girl out even if she admitted she was more interested in me than her boyfriend!" Such decency enabled Tom to gain recommendations from all the ministers on the board. All the churchgoers who knew him could easily vouch for his high morals, as well.

SELECTING THE LAY MINISTRY

Once Tom passed the necessary requirements to become a local minister, several opportunities appeared. Choosing a certain type of ministry was not an easy decision for him. He sought to put the teachings of his religion to good use, but he knew that there were endless possibilities. He was only certain of his desire to relate to church members with the utmost generosity and closeness.

"The more I grew older, the more I understood. . .if you're doing what is right, you're going to treat your neighbors right. For a long time, my philosophy has been that of an altruist. The whole basis is being someone who thinks not of himself but of others," Tom proclaims.

With firm faith and kindness, young Tom pondered the ways to serve his congregation. He finally chose to become a lay minister. Tom chose this role instead of seeking to become fully ordained because he thought more difficulties faced ordained pastors in the Methodist religion. He knew that leadership councils oversaw local Methodist procedures, and he felt that this often made things tougher for ordained preachers.

"I saw the behind-the-scenes politics and knew I couldn't be independent as a minister," Tom recollects candidly. "I would have to listen to my bosses." Tom never regretted his choice to become a lay minister. For forty years, he served his church as a deacon and lay minister, doing "just about everything short of being an ordained minister."[13] He now recalls that "it was equivalent to being an assistant pastor. If something happened, the lay minister is minister up until the next annual conference." Today Tom is certain that being a lay minister was his special gift. In general, Tom believes that everyone has a particular, innate gift to utilize in their life as Christians. He explains:

When Saint Paul speaks about the gifts, he says when you become the new person you have the Body of Christ as a part of you. But then he divides [the Body of Christ] in a great number of divisions, like the body parts, but all are one in Christ Jesus. With this oneness, you might have a great voice, or be a great intellectual. And that's the gift of the Spirit that God has given you. Everyone has a gift, but we are all one.

CONFLICTS WITH THE CHURCH

Tom knows that his superiors at Cadwalader Asbury may have noticed his negative attitude toward church bureaucracy. Although he always tried to be respectful, it was also clear that he did not always support the questionable conduct of his fellow ministers.

"I became discouraged after seeing the womanizing of preachers. And I was never political enough to get elected to any high conferences," he admits. Tom explains that only a portion of Methodist preachers ever appeared to act improperly toward women. Yet the hypocrisy was enough to upset him. "Usually the bishop would pull the womanizing preachers in line," he adds.

TEMPTATION COMES KNOCKING

Ironically, Tom's call to the ministry is what finally introduced him into the romantic social scene in Trenton. Tom had been a hardworking, polite man before joining the ministry. Yet few church women had approached him. He suggests that "no one dared before" because women found his bookishness either "intimidating or boring."

"But ladies became heavily interested in a preacher!" Tom exclaims. Women now realized that Tom could put his bookish mind to practical use as a leader, in addition to keeping a dependable factory job. Numerous young ladies now surrounded Tom and he finally had his pick.

"Women did everything but say 'I want to go to bed with you!'" Tom confesses in a shocked voice. He does not pretend that it was easy to resist temptation. He muses: "I probably do have a devil in me.... Each good-looking woman and you'd instantly *think!* Every living male is vulnerable. I've lusted after other women while in relationships. But I had to resist."

Tom chose to uphold his belief in chastity throughout his life, both before and after becoming a lay minister. Despite his sudden appeal to many women whom he admired, he treated females respectfully both inside and outside of the church.

SERVING TRENTON THROUGH THE MINISTRY

Tom was kept busy with many practical duties throughout his years in the lay ministry. One of his most enjoyable experiences was serving as a counselor to Cadwalader Asbury members. Tom points out that "long before psychologists were used popularly, people went to a preacher." When he joined the ministry in the 1930s, most of Trenton's neighborhoods still turned to religious leaders for both personal and spiritual guidance.

"Most people back then reasoned, 'He's a man of God. He'll tell me what's wrong!'" Tom explains. This rationale now leads people to a variety of preachers, counselors, psychologists, and relationship experts today. Yet Tom and other lay and ordained ministers once earned the utmost respect for their advising abilities.

Tom sees many differences between the advice experts of today and the ministers of the past and present: "Psychologists today don't say much!" he laughs. "Psychologists might give lead questions. But that was the preacher's role before. *Also*, the preacher would say, 'Do you pray? That might be the source of your problems.'"

Tom suggests that today's counseling field is missing a crucial element: the ability of counselors to find solid solutions to problems. Unlike psychologists, preachers never feared to tell their advisees if they were acting immorally. They were also unafraid to prescribe a certain course of action. Over the years, Cadwalader Asbury's congregation grew closer to Tom Malloy as he listened to them and encouraged them to seek personal healing and prayer.

Administrative duties were also part of Tom's ministerial role. Tom notes that "pastors come and go in the Methodist Church" because their assignments from the bishops may change spontaneously. Lay leaders are therefore used as a continuous source of leadership in each church. They serve "to make things relevant to the pastors." When a new pastor or administrator arrived, Tom would familiarize him with the church. Tom soon acquired "full knowledge of church history, the nature of the membership and its opinions."

Conflict resolution was another responsibility that Tom had to fulfill in his church. "I was sometimes interpreting between the minister and the membership when there was a problem," he reminisces. Tom's sense of fairness was particularly vital during his years of church service. He spent many years "measuring the behavior of trustees and church officers against church law" when disciplinary action was necessary.

PREACHER YESTERDAY, TODAY AND TOMORROW

Only the gentle light of fondness can be seen in Tom's eyes as he speaks of his nineteen years as a Methodist lay preacher and his over sixty years of total church service.[14] Tom treasures those long years making speaking engagements all over the tristate area. He proudly asserts, "I used to preach 50 times a year! There was only one man they thought was better than me—S. Howard Woodson."

Tom here reveals that Trentonians once thought very highly of his preaching. For they compared him to the noted Shiloh Baptist Church pastor and politician S. Howard Woodson. Woodson was a dynamic speaker until his death in 1999.[15]

Today, Tom retains his role as a minister even though he no longer holds a formal church office. "People always tell me I am a born preacher. . .I'm preaching every day," he remarks. This is only too true, for it is rare to come in contact with Tom for more than a few minutes without his instructing one on spiritual lessons or on lofty intellectual ideas. He is regarded by many as a spiritual mentor, and one of his colleagues even noted that "Tom is everyone's grandfather."[16]

Tom's longtime mentee Larry Hilton reiterates the effect that Tom's strength and optimism have upon others. "He's always saying things positively and he never has anything bad to say about anyone."[17] Hilton has been deeply influenced by Tom's exemplary attitude over the years and is a pillar of Trenton's artistic community himself.

Tom is eager to share the spiritual secret for living a happy life that can be speckled with diverse jobs, journeys, and discoveries. He once told a journalist his creed and recipe for staying experimental yet grounded:

> Endure hardship, serve the Lord, be good and love one another. Whatever task is assigned to our hands, we are supposed to do it with joy and not with anger. For God in His own time will relieve us. He will bring deliverance, as he brought deliverance to our forefathers from slavery.[18]

Tom's spirituality is the reason for his amazingly colorful journey through various jobs and struggles. He accepts whatever new opportunity comes his way as a chance to learn and grow. He bellows soulful hymns and anthems in his melodious singing voice whenever the spirit moves him, often in front of visitors and friends. Whether using a paintbrush or story and song to illustrate his faith and admiration for God's glory, Tom praises the Lord.

Never tiring of religious inspiration, Tom always seeks to learn more about God. He keeps up with current events in his church and comments about one of the newest battles facing his church:

"We [Methodists] are split over the question of whether gays and lesbians should be ordained as preachers." Tom adds that the church would be silly to deny that gays have already been an active part of the ministry, "especially in music," although they may not have been outspoken before. Still, he concedes that "it's such a sensitive issue."

Even the Bible presents new adventures to Tom while he is in his nineties. Tom describes his newest religious endeavor as a close reading of John's Gospel each night. He notes with a serene grin, "I do the reading in my raggedy Schofield Bible."

Tom feels especially lucky to have been a member of Cadwalader Asbury United Methodist Church throughout the ages. He has ushered the church into the 21st century, offered leadership to its congregation, and is now one of its oldest members. He proclaims with a firm nod, "My church has been kind to me."

The sound of each soulful voice joining in hearty song resounds into an almost eerie, earthy hum. The church's walls even vibrate slightly as the notes sift off into the high ceilings of the sanctuary. One can almost see the musical notes floating upward, telling a tale of Negro slaves in bondage, of rural workers holding fast to dreams, and of faith-filled urban settlers staking their claim in city churches at last. Pale light seeps through brilliantly colored stained-glass windows. And this light shares the promise of a bright, sunny day outside in Trenton.

Small children's eyes dart around the sanctuary as adults grasp hymnals and sway their sturdy hips in the pews. This Sunday at Cadwalader Asbury United Methodist Church is not unlike most others. And Tom Malloy, as always, is among the members singing. However, his almond-shaped eyes are closed now. For he knows this tune by heart.

Life has given Tom a remarkable gift of preaching. He has a deep compassion for his fellow churchgoers and for those suffering in even the outermost regions of the world. After using his gift for many years as a Methodist lay minister, Tom remains a philanthropist and a source of kind words in his elderly years.

Yet Tom's life story does not end with his adventures in the ministry. Tom's religious life may comprise a pleasing streak of royal purple hue upon the canvas of Tom's life, but it was only a portion of his potential and passion. In his early adulthood, Tom still dreamed of swirling colorful paints upon a real blank canvas, of further developing his career path, and of cultivating a romance if fate could bring such luck

"An Inner City Church Striving To Serve Its People"

1976 Cadwalader-Asbury 1986

Sketch of Cadwalader-Asbury Church

St. Michael's Church, (1979), courtesy of Ted and Jane Boyer

CHAPTER 5

Love, New York and War

It felt like the members of a large colony of butterflies were happily testing their gossamer wings in preparation for an exodus, all inside of Tom's stomach. He tried to keep his hands from sweating as he combed his hair in the mirror, but the moisture just kept appearing, both in his palms and in seemingly innocuous beads on his forehead. He tried his best to make himself look dapper, and he prayed a simple prayer that God would help him remain calm. Although he was well into his thirties, this was the first time that Tom had ever prepared for date with a prospective girlfriend. And Consuela Dare was quite a catch!

While Tom's relationship with his first girlfriend, Consuela Dare would soon prove fleeting, Tom's commitment to his faith, his career development, and his many intellectual pursuits continued to lead him toward new adventures in love, work, and scholarship. While dating became routine after a while, Tom still experienced a thrill akin to the dance of the first-date-stomach-butterflies for years to come, whenever he approached a famous lecturer to shake hands or ask a question.

A FIRST ROMANCE AT LAST

After a short time in the ministry, Tom finally landed his first serious girlfriend. He was a man in his thirties by now and had lived his entire life without a love interest. One weekend, Cadwalader Asbury's ministerial staff asked Tom to speak to the youth at Tindley Temple United Methodist Church in Pennsylvania.[1] There, a true romantic relationship finally found its way toward Tom.

A pretty Tindley church member approached Tom with confidence and grace after his presentation. She had listened attentively and had questions. Young Consuela Dare was the woman who sought to clarify Tom's remarks. She proved to be an intelligent and fascinating person.

"I was speaking to the Tindley youth about marrying for love versus for companionship," Tom remembers. In his speech, Tom had suggested that although many adults of the 1930s thought "love marriage makes trouble," he personally considered "love marriage" a far wiser idea than simply marrying out of a social obligation to find a companion and begin a family. Consuela was intrigued by Tom's words. Tom vividly recalls their first conversation:

"She asked me about my views on platonic relationships, and I was enticed because she was interested in such a complex topic." They then proceeded to talk long after most of the other young people had exited the church.

Tom soon became impressed by Consuela's virtue as well as her astuteness. He finally found himself smitten by cupid's arrow after many years of single life. He and Consuela had much in common, exchanged ideas often, and later began what Tom calls "a pretty serious relationship." Their romance lasted several years and filled Tom's studious spirit with new wonder, joy, and peace.

A SHIFT STANDING GUARD AND A STAND AGAINST WAR

In 1940, six years after Tom graduated from high school, he enlisted with the National Guard. He made this decision because back then, "Men were told, 'Until you've had a military experience you're not a man'. . .that there's something about a soldier." Tom was assigned a post guarding the New Jersey governor's summer home at Sea Girt. He fulfilled this post after completing his WPA jobs, while he was a minister at Cadwalader Asbury, and before beginning factory work.

Yet this National Guard experience persuaded Tom that military jobs clashed with his personality. He remembers one particularly frightening encounter with his superior:

> The officer of the day said, 'Private Malloy! Wake up!' He was shaking my rifle in my face and said 'See this rifle? Why do I have it?' I said 'I don't know!' He said, 'Because you went to sleep on guard. That's why I have it. If this was war and I'd have been the enemy, I'd shoot you right here. Everyone in this camp would be in jeopardy. You're supposed to say "Halt! Who goes there?" Then "Friend or foe?" Then "Advance" or "Do not advance."'

After his superior's lecture, Tom recognized that his lack of fortitude revealed a deeper weakness. "I didn't believe in killing people in the first place!" he admits. "I knew I had to find a better way to serve my country."

During the 1940s, when World War II began, Tom therefore took a strong, independent stance against the War. Tom could only think of the contradiction between war and his deep spirituality. His position as a minister inspired him to voice his objections.

"The Bible said 'Thou shalt not kill,'" Tom states frankly. His belief in this Commandment led him to become a formal "conscientious objector" during World War II. Tom bravely notified military officials that it was against his religion to kill others. He also urged fellow churchgoers to do the same.

Tom proudly boasts that during World War II, "Methodists produced more conscientious objectors than any other religion."[2] While many of his friends from outside of the church went on to fight overseas, Tom pursued other occupations. Luckily, Tom's loved ones all supported his choice not to accept the draft.

As a young minister, Tom often found himself drowning in deep thought whenever he heard President Roosevelt's "Fireside Chats" on the radio. These "Chats" discussed America's decision to enter the war. These radio programs also brought anger and frustration into Tom's religious home. Members of his immediate family were pacifists who strongly opposed American involvement in World War II at the time.

"My mother used to cuss Roosevelt out to the daylights when he said 'Your sons and daughters will never fight on foreign soil' and then later contradicted himself!" Tom recalls. Frankie Malloy had been skeptical of Roosevelt's promises long before the draft. Her expectations proved correct when the American draft finally began.

Today, Tom speaks of the World War II era with a twinge of regret in his voice. He still feels that all wars are essentially unfortunate. He clearly remembers the day when England's Winston Churchill and American Ambassador Joe Kennedy asked President Roosevelt to join the war. Tom explains that they made their decision because "They thought that England could not withstand by itself."

ROMANCE ON THE ROCKS

Unfortunately, Tom's stance against the War caused trouble with his first girlfriend Consuela. Although she was religious, Consuela was not on the same side of the World War II debate as Tom and the Malloys. Like Tom, Consuela was a pensive person. She often lost herself in currents of thought and worry which she shared with few other people. Consuela mulled over her disagreement about Tom's draft objection for some time. Finally, she concluded that she could not accept Tom's actions.

Tom and Consuela's relationship became even rockier when Consuela began avoiding conversations with Tom. Tom feels that she became more distant due to their differing opinions about the war. Tom explains, "I had tried to do everything I could, and I would ask her what was wrong and she would say, 'nothing is wrong with you, but I feel uncomfortable now.'" He now reflects, "It was for the best that we separated if she was uncomfortable. Some of life's relationships just turn out empty." At the time, however, Tom took his breakup with Consuela very hard. Their split made him seriously question his self-esteem. Consuela ultimately left Tom for a more patriotic gentleman in the ROTC at Cheyney State College in Pennsylvania. Tom suffered considerably when he learned details about her new choice in men.

He describes this rival for Consuela's affection as "tall, dark, and handsome. What women wanted then." Consuela's new, burly boyfriend made Tom feel self-conscious about his own looks and virility. He regretted not being the valiant, muscular man she wanted to be with.

Tom now asserts that women of the 1940s held many "silly ways of thinking" about men's physical appearances. He himself had always taken the opposite approach when searching for female companionship. Instead of desiring a woman purely for her physical attractiveness, Tom sought other qualities like good personality and intelligence. "I was ahead of my time in terms of desiring a partner for the right reasons, not looks," Tom asserts.

Tom admits that it took a long time for him to recover from the blow that Consuela's rejection had dealt to his confidence. In the meantime, he chose to concentrate on expanding his interests. His heart slowly healed as he threw his energy into other pursuits. "Once I got over her, I got into more community causes," he notes.

NEW LOVE CASTS A COMPLEX SPELL

After several years, Tom finally found another girlfriend to hold his interest. This sultry young woman was named Mildred. Tom reminisces fondly that Mildred "had Indian features and an *Ipana* smile that melted a man with charm just like the toothpaste!"

Tom here jokingly compares Mildred's smile to *Ipana* toothpaste ads because they always featured beautiful people who supposedly turned heads with their smiles. Tom recalls that Mildred's good looks and appeal caused many men to fall hopelessly in love with her. He was but one of her countless suitors.

Tom remembers Mildred as a vixen who could wrap men around her little finger. He asserts that although "many men tried to bring Mildred down so she couldn't [lure them in] with her power, she knew how to use her physical attractiveness wisely." Unfortunately, Tom proved no match for Mildred's feminine wiles. He was fated to be one of the hapless men who fell under her spell from the moment that he developed a close friendship with her.

Mildred was particularly interested in Tom because of his position as a minister. He recalls that she claimed to be "looking for someone

strong enough to help her develop her personal and moral sensibility." Mildred befriended Tom because he was a lay preacher with morals that she sought to emulate. They spoke often and grew to respect each other immensely.

Later on, Tom and Mildred dated until Mildred ended the relationship. Although the romance did not last, Mildred did not release her hold on poor Tom. She was determined to keep him on the back burner as a potential rebound partner after growing weary of other relationships. She therefore pursued him continually for several years, no matter who else she was involved with.

"After she married," Tom declares, "she told me of her disappointment. She said the brother of her husband wanted to be with her. She lured me into this emotional problem and wanted me to comfort her." It was not easy for Tom to resist becoming involved with Mildred when she appeared helpless. She fled to him for support long after their breakup. "Many preachers become part of a woman's problems as a normal part of their role as counselors," Tom explains. As a sensitive, compassionate lay minister, Tom was no exception. He commonly preoccupied himself with others' problems. And Mildred had a particularly beautiful allure to accompany her distressed spirit.

Mildred sought Tom's "good advice" time after time. During their conversations, she often hinted at her hopes of beginning another romantic relationship with him. She even fled to Tom's church when it became unbearable to live with her husband and his brother—both of whom knew Tom.

Eventually, Mildred realized that Tom would not renew a romantic relationship with her. Although he was tempted, Tom refused to stray from his role as a concerned religious advisor. In desperation, Mildred finally claimed that she was hopelessly in love with Tom. This attempt to regain his affections occurred long after she had originally left Tom and married another man.

Yet Tom was determined to keep his professionalism. He knew better than to fall for Mildred again. "She was incapable of loving any man because no one could handle her," he alleges. Whether Tom's assertion was correct or not, it proved wise for him to maintain his distance.

Throughout her life, Mildred continued following feisty urges to be unfaithful to both her husband and her other lovers. Tom candidly recalls, "They'd have a competition, she and her girlfriend Bertha! She would knock on my door and say her other romances were over." Tom alleges that Mildred and Bertha would actually play a game to see how many men they could trick into falling in love with them. Tom luckily resisted Mildred's physical advances at his doorstep. He knew it wasn't uncommon for Mildred to leave town with a new man on a regular basis.

Mildred ended up staying romantically involved with both her husband and his brother for five years. Tom believes that she remained truly tormented deep within her soul. "She flip-flopped between the brothers and she initiated it," he states.

As Tom notes, Mildred did admit later on that her behavior with her husband and his brother was improper and "incestuous." However, by then it was too late for her to undo the damage to her life. Tom fortunately escaped from his friendship with Mildred with greater insight about both counseling and romance. He had survived his second ordeal in love without the pain of an irreparably broken heart.

CAUGHT IN A WEB OF CONFUSION

Throughout Tom's years in the lay ministry, he continued living a faithful and fulfilling life. Although many young ministers met their future wives through the church, Tom seemed destined for more bad luck in love. Tom's friend Phillip introduced him to his next girlfriend, Nora.

Phillip was a fellow minister from Philadelphia whom Tom had met at an annual ministers' conference. Tom recalls that at the time he began dating Nora, he was "less than forty years old." Unfortunately, both Phillip and Nora soon brought ample servings of trouble to Tom's plate.

Directness was quite natural for Nora. Tom recalls that upon meeting him, she promptly told him, "I want to learn more about you!" Once Nora let Tom walk her home the day they met, he became likewise intrigued. He describes her as a "lovely" and "outstanding" woman who was a secretary to the prominent lawyer and activist, Raymond Pace Alexander. He remembers many days when she could not socialize with him because she had to prepare briefs and legal documents.[3] Unfortunately, Tom was so innocent and trusting that he was unaware of the strangeness of his and Nora's relationship. He simply followed her lead, considering them to be quite a good romantic pair. Looking back, however, Tom can now piece together many clues that he should have picked up from the beginning. "The first time I was at her home, I saw Phillip cooking," he explains. Yet Tom did not think much of this coincidence way back then.

Tom simply figured that Phillip was Nora's good friend. He did not become suspicious of Phillip and Nora's relationship at all. Tom likewise assumed that he and Nora would miss Phillip's friendship in a similar way "when Phillip said he was going back to school."

After Phillip left, Tom and Nora went to the orchestra and "all the great places" together. Confident that he and Nora were a wonderful couple, Tom appreciated Phillip's kind introduction. Soon, Tom was deeply in love. He quietly admits that he and Nora "had a hot romance going."

Sadly, Tom was destined for another heartbreak. During his relationship with Nora, he found out a shocking secret that neither Phillip nor Nora had bothered to share with him: "Neither said they were *engaged*!" Tom explains this fact with an apparent twinge of hurt in his eyes. He was stunned at this discovery, to say the least. He was outraged that Nora "went so far without telling" him about her longtime engagement to Phillip. He felt betrayed by both a girlfriend and a male friend.

After Tom learned of Nora and Phillip's long engagement, all the previous coincidences finally made sense. This was why he saw Phillip cooking dinner at Nora's house! This was why Nora's interest in him intensified after Phillip had left for school! Tom had unknowingly become caught in a web of lies that Nora had created to gain his affection on the side. By the time he learned the truth, Tom was unfortunately quite smitten by Nora. He therefore believed her when she professed to love him wholeheartedly.

As with Tom's earlier romances, problems abounded. Nora was quite unfaithful and caused Tom pain throughout the years. He reminisces, "She would behave and be with me for a year or so. Then she'd leave. But then, she tells me she likes me over Phillip..." Tom also remembers a letter Nora wrote him after she'd been "acting unusually strange":

"She wrote me a letter. She said that had she met me first, I would be the only man. And at the same time she's telling me that she's going to marry Phillip! She said, 'Is it possible for a woman to love two men?'"

Tom recalls one particularly difficult moment when a youngster in Nora's church brought attention to her unfaithfulness. All of the youth in Nora's Philadelphia church "loved her and loved Phillip" due to their involvement with church programs. Tom recounts, "[Nora] was working with the young people and one little girl said to her, 'Nora, I don't like what you're doing to Phillip!'"

Tom was present on that day and notes that the girl's comments "hit [him] very strong." From that moment on, Tom became certain that their relationship had to change. After that day, Nora also felt more conscientious about her affairs. She realized that her behavior was influencing her reputation, in addition to causing pain to many people.

Tom finally decided to resist Nora's games after his feelings and dignity were stomped on for nearly three more years. He forced Nora to make a choice one day after she had gone back to Phillip, then left Phillip and told Tom she wanted him again. Faced with an ultimatum, Nora ended the relationship with Tom. She soon "married Phillip to fulfill her first promise."

Because Tom was a religious man, it was difficult for him to abandon his fervent love for Nora over the following years. Tom confesses that the forgiving, sentimental "preacher" in him helped him understand and love Nora "deeply, despite her weakness and her lies."

SEARCHING FOR A CHANGE OF HEART

Tragedy compelled Tom to resurrect his feelings for Nora not long after their final breakup. Soon after Nora and Phillip married, Tom was forced to remember her with sadness and love. He could only cry when he heard the dreadful news that that she had been shot twice.

Nora had been a peacemaker and a kind soul in spite of her infidelities. One day she had run outside to investigate an argument between a maid and an unidentified man. This argument occurred at the Colored YMCA, where she had recently gained a new job. Unfortunately, Nora's innocent interruption prompted an altercation and incited the irate man to shoot.

After hearing of Nora's death, Tom became deeply grim. He decided to make a new start in love: "I promised next time I would keep a vow without recalling these other women, and I would try to find a woman to do the same," Tom explains. He swore to give and accept only faithfulness and honesty in his future romances. He hoped that this promise would bring him better luck in love. Still, many years would pass before Tom's pledge would be fulfilled. He remained single until his early fifties—long after most of his peers were married.

PROTECTING GOD'S PEOPLE IN THE MENTAL HEALTH FIELD

During the years when Tom's romances blossomed, when he was in his thirties, he was also quite busy with civic responsibilities. After performing cafeteria work, social services at the YMCA, and various WPA jobs before World War II, Tom became a health care worker after

the war began. He felt this was a way to help lessen the suffering that the war caused to others.

Tom began working at a mental hospital in Concord, New Hampshire, as part of the Selective Service. [d] This was a work program for conscientious objectors. Tom remembers that "instead of chopping wood there"—like most other Selective Service workers at the hospital—he sought to use his mind and compassion more directly. He soon found ample opportunity to do so in the hospital, as his Selective Service program was run by compassionate Quakers.

"Back in those days, I was concerned about the treatment of people in asylums," Tom reflects. He carefully scrutinized the practices involved in treating the hospital's mentally ill patients. Tom soon decided that the common procedures were quite unfair. "They would take off the patients' clothes and put them in a bare room," he explains sympathetically. Tom and several other conscientious objectors finally took the initiative to try to improve the treatment of mentally ill Americans. They became part of a small national program that enabled them to perform invaluable service in hospitals.

"We were assigned to tasks in the hospitals and suggested medication as more humane treatment," Tom states. Their efforts were part of a new movement toward humanizing the plight of the mentally ill. This movement still exists and has gained widespread support since Tom and his friends first participated in it nearly half a century ago.

Tom's only regret is that work in the psychiatric field took a serious toll upon him. "It started working on me and I got stress," he recalls. He continues, "what I went through in that experience as a conscientious objector…I wouldn't go through it [again] for a million dollars!" The anxiety from working in the New Hampshire mental hospital led Tom to quit working in the mental health field soon after he began. He was dismissed from the Selective Service and then began working at Trenton's bullet factory off of Hingham Avenue.

A STINT WITH THE FBI?

Ironically, Tom's objections to World War II and his participation in the Selective Service increased his reputation as a pure, nonreligious patriot where the government was concerned. Many members of the white community mistook his strict Methodism for a belief in nothing at all!

"I was approached by the FBI because I was reputed to belong to no symbolic organization," Tom recalls. "People knew I didn't believe in Masons, in Father Divine,[5] or in Communists." Tom's lack of involvement in such strong ideological groups and fraternal orders made him a prime candidate for FBI work. At that time, the FBI sought to employ intelligent men who opposed Communist associations and rejected symbolic groups.

Tom was offered a well-paying job at the FBI, but he declined it. He admits that he was highly suspicious of their motives and integrity. "They do everything for you until you are caught in their work and you take the consequences of their actions," he sternly asserts.

MINISTRY BRINGS FAMOUS COMPANY

Tom's preaching experience and his continued interest in social justice also helped him meet renowned historical figures. "I'd travel as a lay leader in my local church," he begins. "When I heard some scholar would be lecturing at Princeton, I would go there." Tom often received news about intellectual gatherings in other surrounding regions. Even as a grown man, he still "liked to hear stories" from intriguing new individuals. Tom met the black former U.S. Congressman Adam Clayton Powell in the late 1930s. At that time, Powell was minister of Abyssinian Baptist Church in New York, before he was elected to Congress. At a religious meeting in Philadelphia, Tom also met Benjamin Mays. Mays had been president of Morehouse College and the only black president of the National Council of Churches. Tom was especially touched by Mays' speech and still recalls it today: "Benjamin said, 'If it wasn't for the Lord, I would not be here at all!'" Tom quotes Mays in a hearty voice with the gleam of admiration shining through his proud smile. Much of Tom's contact with important intellectuals can be attributed to his grandmother Ida's encouragement. "My grandmother would make provisions for me to go to a higher level," he comments. "She believed that exposure to scholars and pious men was the best way for me to advance, since I was not highly educated."

Gaining inspiration from Ida, Tom became determined to meet "whoever came to town" and also traveled to expand his horizons. He met Kwame Nkrumah, president of postcolonial Ghana from 1960 to 1966, in Philadelphia's Fairmount Park. He also befriended Dr. Harry Emerson Fosdick, minister of the impressive Riverside Church in New York City. On another occasion, Tom was particularly proud to meet Bishop Barry, the first black bishop elected to the national Methodist conference. All these encounters reinforced Tom's belief that elevating the mind was a lifelong task.[6] Tom was also sent to regional NAACP conferences before and after he was vice president of the organization's

Trenton Chapter. He went to see former NAACP Director Julian Bond whenever Bond came near Trenton. Tom also remembers seeing black dignitary Everett Scott "in the flesh" at Bordentown and absorbing his wise words.[7] The boundaries of race and gender did not narrow Tom's intellectual and spiritual curiosity. Tom remembers the time he sat in the audience to hear Admiral Richard Byrd speak.[8] "There were no blacks there but me!" he exclaims. Tom recalls hanging eagerly on to every word of this fascinating white explorer who had traveled to the South Pole. "I was thrilled to hear him," he remarks. Tom did not feel the least bit uncomfortable amid the sea of white faces in the audience. Although he attended the talk during an era of segregation, he knew that the thirst for knowledge could unite all members of society.

Tom also boasts of being in the audience when First Lady Eleanor Roosevelt "spoke out for children." He took her message to heart when she suggested that "everything we do is for our children." Mrs. Roosevelt made an especially strong impression on Tom because she reiterated the values of humility and charity, which he learned during his childhood. "I wasn't raised on 'me, me, me!' Life isn't that way," he explains.

Tom's quest for intellectual growth, culture, and spiritual insight eventually helped him meet the man who made the strongest impression upon him. Tom proclaims that Walter White was, by far, the most spiritual man he ever met. White was the leader of the NAACP whom Tom had the pleasure of meeting at a gathering in Philadelphia. "It was in the roaring twenties, a little before the Depression," he ponders.

"Walter White and [W.E.B.] DuBois started the National Association for the Advancement of Colored People. The two men met at a meeting in Niagara Falls," Tom begins. "Walter White saw a way to solve the black situation through the intellectual approach. He said, 'We've got to go where the problem is;' at that time most of the blacks were in the south."

Walter White's humor, candidness, and reverence were extraordinary to Tom. "He would entertain his audience every time he spoke and he would relate most dramatically. . .the story," Tom explains. White often reported how he "traveled endlessly in the South to see things for himself." A man of mixed-race heritage who "looked white," White also had the advantage of hearing how whites felt about blacks. He was brave enough to fight for justice and educate those who were both dark-skinned and light-skinned.

One memorable story of White's taught Tom more about the ignorance of southern racists. At the meeting Tom attended, White recounted how he "got on the train and a white man said, 'there's a nigger down here. They're looking for that nigger. I know what they're gonna do if they find him! I know there's a lotta them niggers that pass for white, but I know a nigger! A nigger couldn't fool me!'"

White told the audience that he boldly asked the man a question despite the danger of being lynched. White inquired, "How could you tell that a nigger couldn't fool you?," at which point the man said, "Give me your hand! Niggers have moons that a white man doesn't have. But I don't see no moons in your hand so you must be white!"

Tom gleefully remembers that White's story "brought the house down" with laughter and applause. White had successfully fooled an ignorant racist without ever claiming to be nonblack. Tom and others saw White as a valiant activist who put himself in the line of fire time and time again. This encounter touched Tom's life deeply for years to come.

The late W.E.B. DuBois is one of the most famous historical figures that Tom met in his ministerial travels. Tom saw this monumental scholar and black leader in the early 1960s, after DuBois had returned to the United States from Ghana, before the civil rights movement. "He was up in age then, but he was a solid person. "I saw him from a distance," Tom recalls.

Tom was fascinated that this intellectual legend had grown old yet remained committed to new methods of improving his race. Tom was particularly impressed by "pan-Africanism," which was DuBois' idea of uniting the world's black population in spirit, financial enterprise and even location.[9]

As he neared age forty, Tom grew astute in the ways of the heart and those of the mind. He had weathered several failed love affairs, worked in the Selective Service, and rubbed shoulders with intellectual giants. The canvas that was Tom's life was growing more colorful and intriguing every day. Yet the image on the canvas had yet to be completed. Tom grew more and more certain that the shadow of racism that had darkened his world since boyhood was an unnecessary injustice. He sought to help his community and nation create a brighter future, and his work toward a vision of social justice continues to add brilliant strokes of achievement to his watercolor life.

CHAPTER 6

Fighting For Social Justice

Trenton Battle Monument, (1988), courtesy of Dr. Risa C. Smith

Tensions were high and many fists were clenched. A school board official and various town civic leaders sat stoically in chairs around the dimly lit room. The air was thick and many eyes were narrowed. This was an important day in the history of Trenton and the nation.

Tom Malloy sat amid these important individuals. He was an organizer himself who was bent on achieving true change. This same man who as a boy once romped through billowy cotton fields in Dillon, South Carolina, sat calmly now. He knew the strength of his southern ancestors was with him on this momentous day.

The enjoyable hobby of sketching long country roads and quaint city storefronts was far from Tom Malloy's mind that evening when he met with Trenton's NAACP and a member of the segregated school board. He knew that the future of a town rested upon his energies and understanding.

Tom's talent for making use of all life's opportunities would help him in this situation. He'd always had a knack for mixing life's colors into a special blend whenever a new job or encounter confronted him. Now he was eager to help people of all colors work together in a new age of civil rights. If fate was on his side, they would all learn that faith and collaboration could create a masterpiece.

CHURCH ADVISING AND QUIET CIVIL RIGHTS SUPPORT

Tom met countless black leaders during his years in the Methodist lay ministry. Yet he himself became a visible leader in his own right during the civil rights movement.

Tom first began advising his pastor on civil rights issues due to his exemplary sensitivity as a lay counselor. He had a unique willingness to reach out to the community and to understand all sides of a complex debate. "I was appointed as an advisor by the Church Conference after being nominated by a committee," Tom remembers proudly.

During the civil rights era of the 1950s and 1960s, Tom chose a distinct method of expressing his support for integration. He quietly backed worthy causes and activists. "I did not participate in marches," he explains. "I am not a loud confrontationalist. I gave money and my voice. I challenged segregation."

Nonviolence and nonconfrontation were Tom's preferred method of activism, particularly because of his involvement with the Quaker community. In addition to his Methodist roots, Tom was associated with the Friends Society, a religious group that believed in peace above all things. "I was at the place that converted Martin Luther King to nonviolence before *he* was," Tom boasts. "It was a place run by the Friends called Pendle Hill. I don't know if it's yet there. That's where they [Friends] trained their workers that they could send all over the world. It's in the suburbs of Philadelphia."[1]

Tom is especially proud of the accomplishments of the civil rights era when he contrasts it to the harsher, more blatant racial iniquities of his sharecropping days. He reminisces, "Martin Luther King is remembered so reverently because he fought for the universal franchise." Back when Tom was a youngster, few blacks in the South could vote because of reading tests and other difficult rules designed to keep them away from the polls.

Tom feels that in his determined, calm efforts he truly helped bring about social change. He notes that finding one's true self is an essential part of any civil rights struggle. He provides the example of black activists like Leroy Jones, who "won a prize as LeRoi Jones but became a seeker for his true name. . .Amiri Baraka."[2] Although Tom kept his Christian name of Thomas Malloy, he gained a new sense of self-determination and black pride as an activist.

FOLLOWING ROBESON'S LEAD

Encounters with the great black orator and activist Paul Robeson helped shape Tom Malloy's ideas about identity and activism. "Paul Robeson spoke for us with dignity and skill. He was a scholar and a forceful speaker. He was warm to everyone he met. He had integrity and honesty," Tom proclaims.

Tom recalls that Robeson had a calm, noble manner of acknowledging the pitfalls of racism. This stood out in Tom's mind as truly exemplary behavior. Tom therefore attempted to learn from this leader's demeanor at every possible opportunity. He grew extremely fond of Robeson. "I once even told a white man, 'I am a Robeson by adoption,'" Tom confides with a wide-eyed, mischievous look upon his face.

Tom found Robeson's views on the basis of social justice to be particularly rational:

He believed that you were a member of the human race before you were black. When you meet people in the world, we begin to see that we are all the same. Robeson was considered radical. He was prolabor, problack, for the poor.

Robeson's mature yet solid defense of civil rights became a model for Tom's own behavior throughout the 1950s and 1960s. In addition to admiring Robeson's views and personality, Tom was also awed by the man's "rich voice." He loved to hear him sing in his famous, booming bass style. Tom boasts that Robeson gained fame and respect in both the United States and England for his talent and social activism.[3]

Tilting his head upward and shaking it firmly with his eyes gleaming, Tom now imagines himself back in Robeson's times. "This takes me back to those unbelievable days!" he exclaims. Without warning, Tom is overwhelmed with excitement. His hand brings his curved cane crashing down to the floor. It is evident that Tom is still infused with a passion for racial justice and inspired by memories of Robeson's charismatic leadership. One can almost imagine a young Tom forty years earlier standing before Robeson with the same fervor and energy.

STEPPING UP IN CIVIC LEADERSHIP ROLES

Tom's leadership abilities were put to a crucial test when Mercer County's black Methodists decided to formally integrate their churches. "There was discomfort, so they called on me to help smooth things over," he explains.

Resisting segregation in Princeton later proved to be another grueling task. Tom recalls that in the 1950s and 1960s, Princeton was a "highly racist" portion of Mercer. "It was controlled by Wall Street although the people were of Calvinist stock," he alleges.

Tom found that by and large, blacks were hardly ever welcomed in Princeton. "The only way into the university was to work there. The black man only had Greg's Place, a restaurant in poor man's Princeton," he adds. While universities like Harvard and Yale accepted black students before the civil rights era, Princeton did not allow them to enter until much later. Tom's role as a spokesperson for Princeton's potential black community was inevitable for two reasons. First, he was a minister who was well informed about the issues affecting the black community on a daily basis. Second, although he lacked a college education, his superior public speaking skills and well-rounded intellect made him a remarkably articulate man.

At a time when it was becoming increasingly difficult for blacks to develop a positive political rapport with whites, Tom's conscience compelled him to use his easygoing demeanor to ease local race relations. He soon gained the confidence of local black leaders. His eloquence, insight, and solid work ethic were exactly what black activists needed in a young mediator. Tom had already been elected vice president of the Trenton Branch of the NAACP at age 25, a few years after he graduated from high school. He continued to hold various NAACP posts and assisted the organization through his adult years while simultaneously holding several full-time jobs.

Reminiscing about working with the NAACP is highly sentimental to Tom. He thoughtfully recounts the organization's history, commenting: "When it started becoming political, it started as the Niagara Movement. These intellectuals and other black people met in a conference in Niagara Falls and decided it was time to set up a different organization."[4]

NEGOTIATING FOR INTEGRATION IN TRENTON SCHOOLS

Tom's most outstanding contribution to Trenton's civil rights struggle was in the fight for school integration. As a former art teacher and Trenton student, Tom had an inside understanding of the Trenton school system. He sought to aid the NAACP in expanding Trenton's educational goals for both races. Tom encouraged his beloved school system to change with the times. "I helped with the art school expansion program and got it off the ground as an NAACP person," he explains. When a white school official's bias threatened to keep Trenton from the promise of full integration, Tom was a particularly effective mediator. He used his talent for communication and his passion for fairness to urge blacks and whites to unite. He pleaded with them to persevere with group discussions so that they could compromise for the benefit of all students. Tom was particularly determined to help the NAACP achieve integration in *all* Trenton Public Schools, not just Trenton High. Thinking back, Tom recalls:

The NAACP played a significant role in integrating the public schools.[5] The mayor had appointed a new man—Dr. Urbaniak,[6] who was Hungarian or Polish. He had a background in orthopedic medicine but was chosen to advise Trenton in developing school programs. When Urbaniak attended one of the first school board meetings, he listened to arguments for and against integration. And he said, 'Perhaps the blacks are not ready for integration. . . but I'm

just appointed to the board and don't really know the situation!'
Well that made all the Negroes *fighting* mad!

After the black community arose in an uproar against Urbaniak and his controversial comments, the NAACP requested Tom's help. "A friend of mine went to Urbaniak and Urbaniak said, 'I'm surprised at the black reaction to the board meeting,'" Tom explains. Tom's friend realized that Urbaniak had misunderstood Trenton's blacks. She sought to decrease resentment against Urbaniak with Tom's help, while simultaneously assisting Urbaniak's dilemma.

Tom's friend therefore told Urbaniak, "'I think I know somebody who perhaps wasn't at that meeting but he holds an office.'" She had faith in Tom's sensitive, yet firm manner of negotiating. Her good faith in Tom's ability to ease tensions soon proved crucial.

In a private meeting with Tom, Urbaniak felt comfortable enough to disclose his confusion and concern. Tom recalls how Urbaniak admitted, "'I can see the anger, and I didn't take my position to antagonize anybody. I want to do the right thing and segregation is wrong. Is there any way I can talk to the heads of the local NAACP?'"

A born diplomat, Tom assured Urbaniak that he had done the right thing in confiding in him. He invited Urbaniak to the next NAACP executive board meeting so that the school officials could clear the air and begin cooperating with black leaders. Tom now laughs when he thinks about how naïve he was back then. He'd had the impression that racial reconciliation between Urbaniak and the NAACP could be achieved quite rapidly. Naturally, the meeting did not go as smoothly as Tom had imagined. "Before the NAACP even arrived, they were ready to hang me, tar and feather me, and ride me on a rail out of town!" Tom exclaims.

Tom's fellow NAACP board members were furious that he had invited the white official to a private organizational meeting. They scolded, "'You bring that man to an executive meeting? I thought you had more sense than that!'" Yet Tom maintained his composure. Above all things, he had faith in the reconciliation process. Tom was determined to see that both Urbaniak and the black leaders got a fair hearing in the end. Luckily, at least one other well-respected individual believed in Tom's plan for a mediation between Urbaniak and the NAACP. Tom recalls that a young white woman named Mrs. Yard[7] played a strong role in the situation. She was a member of the NAACP and was highly regarded by both black and white Trentonians for her knowledge of and work in peacemaking and racial justice:

Mrs. Yard had been hired to prevent tension after southern soldiers at Fort Dix caused problems as racists. In those days, there were rumors that the Fort Dix soldiers might imitate Detroit soldiers who claimed to have 'thrown a nigger into the Detroit River' during the 1945 Detroit riots. Mrs. Yard was appointed to prevent violence. She helped prevent the Fort Dix soldiers from coming to Trenton because we feared they would increase hostilities in our racially mixed city."

To Tom's delight, Mrs. Yard was particularly impressed with his plans for Urbaniak and the NAACP. She soon proved invaluable to Tom's mission, and they sought to fulfill the same goal.

However, Tom's suggestion for an NAACP meeting seemed to be a daring milestone even in the eyes of the noted Mrs. Yard. She had never considered the value of a one-on-one meeting between black and white leaders before. She excitedly yelped, "'*This* is what we were looking for!'" when Tom first explained his plans to her. However, even after Tom could count Mrs. Yard as his chief supporter, he still faced widespread opposition.

One female NAACP member warned Mrs. Yard that Tom's ideas were trouble. This woman boldly cautioned, "For your sake Mrs. Yard, just say you weren't here when Tom insulted us by inviting this man to our meeting!" When Tom strolled into the next NAACP executive meeting with Urbaniak, however, he was as calm as a mountain lake. He was sure that everyone present could benefit from hearing one another's opinions. He hoped to both clarify and alter Urbaniak's intentions.

At Tom's urging, Trenton's NAACP executive board and Urbaniak slowly began seeing eye to eye. Urbaniak confessed that he was "'trying to do it all at one time'" and that he felt completely overwhelmed. He was a school administrator, yet he knew very little about the inner workings of a school. He also confessed that he knew very little about race relations. Urbaniak further admitted that his lack of knowledge may have led him to make an inappropriate suggestion—that Trenton's blacks may not have been prepared for integration. He told the NAACP that he'd already notified the school board that his suggestion may have been improper.

Urbaniak had surely made incorrect assumptions, but he was willing to change his view. This was music to the ears of the NAACP. Without Tom Malloy's insistence, however, this monumental meeting may never have occurred. When asked if he was personally offended

by Urbaniak's statement, Tom comments, "This man was trying to understand our people as a new member of the Board of Education. He wanted to meet people and to learn."

Fortunately for Trenton, Tom was able to see potential in Urbaniak. He saw past the official's words of misunderstanding, straight through to a day of reconciliation for all. As a result of Tom's faith, the meeting resulted in a groundbreaking resolution.

Urbaniak suggested to NAACP leaders, "'Why don't you talk to the teachers first and see how they feel about integration?'" The NAACP agreed that preparing Trenton's teachers should be the first focus of the integration process, but they also hoped Urbaniak would take a more aggressive approach.

At last, both sides agreed to actively "educate the faculty first" in order to prepare them for integration on a larger scale. As Tom recounts, everyone finally agreed that "if faculty can get along with the concept of ending segregation, then we can do so in the whole city."

VOCAL OPPOSITION TO TOM

Interestingly, Tom remembers that several upper-class blacks were offended by the decision to educate Trenton's teachers about race relations. Many even opposed the idea of a racially mixed group of teachers. Tom attributes this lack of support to distrust within the black community. He alleges that many haughty blacks feared the influence of other, less affluent black people.

"They said, 'we don't ever trust a Nigger'" Tom recalls sadly. These blacks therefore argued alongside prejudiced whites to maintain the status quo of segregation.

Despite such negativity, Tom, the NAACP, Urbaniak, and others sought to bring a fully integrated staff and student body to all Trenton elementary, middle, and high schools.

RELIGION MEETS SOCIAL ACTIVISM

Several other achievements distinguish Tom as a civic leader and a dedicated citizen. He had joined the Fellowship of Reconciliation as part of his struggle for racial justice, just before he was sent to camp for conscientious objectors.[8] This organization even included Dr. Martin Luther King, Jr. in its membership. Tom recalls that it "was a peace-loving philosophic, nonsectarian, and nonpolitical group."

At the Fellowship's lectures on nonviolence, Tom befriended numerous Princeton professors and their wives. He was also involved in the Trenton Ecumenical Area Ministry (TEAM), an organization that still unites Trenton's churches and public service organizations today. Still, Tom feels that our society has strayed from its roots in religion. He laments that "the black community is no longer church centered." He feels fortunate to have lived in an era where "anyone supposed to amount to anything went to church." He continually encourages his neighbors and brethren to renew their spirituality.

FAMILY TRAGEDY AND TRIUMPHS

Despite the victories Tom celebrated through social activism, his life took a more mournful turn. "In 1944 I sensed that my mother was ill," Tom asserts. He knew one day when he saw his mother "sitting outside the house" unbathed that there was something wrong, for she was usually "a meticulously clean woman."

Frankie Malloy died in 1946 at age fifty-two, two years after she began her fight with ongoing illnesses. "I was with my mother when she died. I decided [to stay with her] because of my faith," Tom explains. His loyalty as a son was exemplary, and he is glad he was able to be at home with Frankie during her last years.

Tom has always remained saddened that his mother could not live to see integration occur, for she died long before the height of the civil rights era. She never even saw Trenton achieve the social improvements that were made with the help of her eldest son.

Still, Frankie would have surely beamed at Tom's accomplishments. She would also have been proud of Frank, who joined the struggle for racial justice in turbulent times. Spirituality had touched Tom's analytically minded brother Frank in a vastly different way. Yet he worked toward the same noble goals as Tom.

Frank had come to believe that the absolute, scientific proofs he had used in his chemistry career were not really human discoveries. He decided that scientific formulas were merely demonstrations of natural rules set by a higher power: God. This revelation led him to abruptly change careers.

Frank decided to work in a field that dealt with justice and morality and what he thought was the *full truth* about the world. After being a chemist with the Army for fourteen years and receiving a chemical patent for his work, Frank changed course and received a law degree from Temple University School of Law. He made the sacrifice of commuting to Temple from his residence in Fort Monmouth, New Jersey, while he was still working full time.[9]

Frank began practicing law because he felt that as opposed to scientists, lawyers recognized the limits and human-ness of their work. No one argued about the fact that mankind, rather than God, had created its own civil laws. Furthermore, Frank believed that people who adhered to the law sought to correct their own behavior to follow a moral code that may have been inspired by God.

Frank Malloy was extremely intelligent. He passed the New Jersey Bar Exam on his very first try. Unfortunately, he was soon disappointed by the black community's lack of faith in him as a black lawyer. Many clients often stubbornly refused to pay his fee altogether. Frank helped fight civil rights battles as the first black Mercer County Freeholder Board Clerk in 1965.[10] In this position, he assisted Mercer County Director Richard J. Coffee's administration. Frank used this opportunity to attempt to end the corruption involved in road-building, power-supply, and other municipal endeavors that he oversaw.

Sadly, Tom believes that white politicians were determined to rid Mercer County of his brother's positive influence. He suggests that they felt threatened by such an effective black trailblazer who sought to root out political corruption. Before he retired, however, Frank was still able to make several pivotal recommendations. In his own way, he assisted Mercer County in its fight against racism and overall injustice.

CANDID REFLECTIONS ON SOCIAL JUSTICE AND SPIRITED LEADERSHIP TODAY

Tom's roots in the church still shape his views on social justice. His long walk with faith causes him to maintain the highest regard for leaders who have firm religious foundations. "I've observed that many of the greatest leaders have spiritual beginnings. Martin Luther King's father was a preacher," Tom asserts.

To Tom, piousness is what enables great individuals to challenge society's problems. He points out that even a conservative like George W. Bush overlooked racial considerations to value religious leadership in his administration: "Bush appointed Ms. [Condolezza] Rice to advise his cabinet, and Rice is not only a black woman, but the daughter of a Presbyterian minister. She is a scholar and a clean, virtuous woman. If she wasn't, she wouldn't last! They wouldn't tolerate the same thing from Monica Lewinsky if she was black either!"

Tom feels that the corruption of leadership is a growing problem for our nation. "That's a sorry lot that are leading today—preachers, elites," he chuckles frankly. Tom looks back to Julian Bond and Andrew Young as "very talented," more exemplary black leaders of the past.[11] He suggests that many honorable leaders are simply too honest to last in the limelight:

"I'm glad Young didn't run for president," Tom ponders, "because he's too humble to play the games!"

Tom recognizes that many honest civic leaders might become overwhelmed after joining political circles that are already saturated with corruption. He adds that often, even the best leaders cannot be depended upon to fulfill their campaign promises.

"Your thinking has to change when you're it [elected]," he begins. "You don't see Margaret Thatcher surrounded by women. Or Hillary Clinton. You don't know what they'd do. I already see some weaknesses in her [Hillary]. First of all, women are going to expect her to hear them and when she chooses not to, they'll say, 'We elected your butt!'"

Tom is also blunt about his ideas about the troubled state of American churches. He feels that there are too many bad influences on religious people and leaders in modern times: "When I was coming up, you had two masters. Serve God or the Devil. This is the problem now: there is too much of the Devil. But Jesus Christ overcame the Devil in the Desert. Yet, there is too much of the Devil in God's church. When I was coming up, preachers would tell you what was wrong. Now church members might snatch him! Preachers are afraid of their congregations now. They think more of living than dying." Tom feels many preachers have simply become more preoccupied with their secular fortunes than their spiritual mandates. He snaps:

> Modern ministers cannot be excused from responsibility for this new crisis of faith. They think, 'My people take care of me. I have a Brooks Brother's suit!' But that makes modern religion a church living on hovels. Jesus Christ himself said so in the Bible when Jewish leaders became corrupt.

Tom is worried about his own church's mission of social justice and leadership, as well. When asked about Cadwalader Asbury United Methodist Church, Tom sighs, "It's dead." He cites a dwindling membership and a lack of new enthusiasts as issues plaguing his beloved church home. "Hopefully the people will come alive," he adds. "But the Devil is busy and don't you forget it! Don't think you can outwit the Devil."

GROWING AS A BELIEVER AND ACTIVIST

Tom is constantly discovering new avenues toward civic leadership and spirituality. Here he describes his continual, personal learning process:

> I am often finding out that questions answered as a child were untrue. I was taught that God loves the good, but God said 'You'll be rejected and face hardship because of your beliefs.' As you get further into life, the journey of life is ever-learning. . .you may see, but not see *fully* until later. The five senses work for you for years.

To assist him on the path toward God and social activism, Tom reads about the "personal philosophies" of inspirational people. He is reassured that philanthropists like Andrew Carnegie and Bill Gates have given money to poorer Americans, and he recognizes the evils that money can present to our society.

Tom is glad that the government is attempting to control large companies like Gates' Microsoft Corporation. Yet he feels that more could be done to protect the average American's socioeconomic interests. "There is temptation of all sorts," he claims. "A lot of people who are rich today—why are they rich? Because they took advantage of poorer people."

Tom remains heartened by the legacy of positive social activism throughout American history. He adds that current efforts to curb monopolies like Microsoft are part of a firm American tradition of defending the poor and preventing corruption. "They go back to the Sherman Anti-Trust Act in 1890," he states.[12] Tom also admits that in the end the goals of social reformers are always slightly overstated. "Sometimes we can overdo it," he remarks. Through the years, Tom has learned that there is only so much one person can do to encourage social change and to foster personal growth within others. "If, for example, I'm teaching you to walk," Tom begins, "I can tell you what is required. But eventually, you have to start walking on your own."

JUDGMENT IN THE AGE OF SCANDAL

Despite Tom's commitment to religious and social reform, he is not overcome by an attitude of conservative, moral superiority. When speaking of controversial issues like Bill Clinton's scandal with White House intern Monica Lewinsky, Tom takes a realistic, practical stance: "Americans waste time thinking of little problems like this. It's crazy! Because the president brought it upon himself, it is his responsibility alone. Our nation has so many larger problems."

Tom personally takes responsibility for many of his community's problems by assisting in any way possible. "I am still a member of People to People," he remarks, naming one of his many charitable efforts. "Speaking, guiding, writing, trying to give leadership, that is my life," he comments. Tom only wishes the world could be ultimately different. He ponders, "I often wonder how the world would be with no hunger, no pain . . . nothing!"

Looking back on his career in the civic sphere and the lay ministry, Tom is generally satisfied. He knows that he has been able to help make many changes in the world: "Everything I've done that makes a difference brings joy. Love your neighbor as yourself is the summation of all that makes a full life. I give all I can to those with need because it's a joy of living well to see them doing well."

Whether he is inviting neighborhood children into his home to color pictures, volunteering in local schools, or lending a spare dollar to needy friends, Tom remains a generous pillar of the Trenton community. He constantly challenges himself to make the world a little better and help a worthy cause. Above all, Tom recognizes that "the need is great everywhere" and that no effort is too small. Tom simply draws from what he deems to be his "little share" of God's fortune and offers his best to those around him.

The leaders of today will soon be replaced by those of tomorrow. Yet people can always gain perspective by learning from yesterday's brave souls. Tom Malloy is only one of myriad people who contributed energy and time to civil rights activism and religious education. And he continues to learn about the struggles of today.

By the mid-1960s, Tom had given much to his community as a laborer, preacher, social reformer, and public servant. He loved Trenton but also yearned to hear speakers in distant locales. He was now in his fifties and quite established. Yet his youthful passion for art still burned brightly within him like a backdrop of fiery stars behind an urban skyline.

Little did Tom know that at this late age, his life's journey was just beginning. His canvas of life had only begun to reveal a work of art. After having dedicated his time to various pursuits and causes, the opportunity of a lifetime was finally around the corner.

Study, Ellarslie Felt Pen, from the collection of Brian and Linda Hill

CHAPTER 7

Art Becomes Life

Ellarslie, (1981), from the collection of the Trenton Museum Society

The leaves on the trees in the park rustled briskly as Tom Malloy sat on his rickety folding chair. The wind blew suddenly, slightly scattering the pages he drew upon. All his energies were keenly focused on sketching the vivid springtime scene. Each bend of each tree branch seemed to reach out to him and beckon him to climb the maple's firm trunk, as he sought to do it justice with intricate brush strokes.

This routine would continue over the years ahead, taking Tom, his simple chair, and his canvas through the picturesque landscapes and the urban byways of northeastern United States. For he was now bent on capturing light, shadow, structures, and forms in all their varied glory.

Tom's path toward an artistic career was neither a steady climb nor an instantaneous discovery. Instead, Tom's shyness about his work and his lack of successful opportunities for exposure made his journey toward the title of "artist" both slow and difficult.

However, after blending life's diverse opportunities together for so long to make a colorful impact in various fields, the time had come to blend real colors together on paper. The gift of companionship at long last was the final hue that made the intriguing swirls of color in Tom's life more meaningful. Now that he had found someone to believe in his dreams, watercolor art could become an integral part of his spiritual, challenging, watercolor life.

A WOMAN TO SHARE LIFE WITH

Tom had ventured into activism, the ministry, industrial work, and various public service jobs by the time he reached his early fifties. Yet the absence of a marriage left a noticeable void in his life. "I was expressing myself in other areas and realized something was missing," he recalls. Tom would often stop and think, "Here I am so busy, *yet. . .*" without actually understanding why he felt so unfulfilled.

The lack of success in most of Tom's past romantic relationships made him afraid of being hurt or abused. "Women try to entrap you! I'd been in many relationships, but they were just not right."

Tom remembers that often, women thought he was too much of a "momma's boy" for their tastes. "If I was dating a jealous woman, she'd say, 'Forget your mother!'" he explains. Rather than living independently during his middle-aged years, Tom still lived in various family arrangements. He lived with his brothers after his mother's death in 1946. "The four of us were left with a house . . . 121 Kossuth Street," he notes. "It was just behind Perry Street and ran behind Coalport to Clinton Avenue." Once their grandmother Ida passed away in 1949, Tom and his brothers "got a share of the house sale." Tom then finally "moved into a rooming situation" for the first time when he was thirty-seven.

Due to Tom's string of bad luck in love, his pleasant first encounter with his future wife, Dorothy Buck, was quite unexpected. Lucky for him, it brought lasting romantic joy after five decades of searching. Tom and Dorothy, who hailed from Baltimore, were introduced by Rosa, the wife of Tom's brother James. Rosa studied with the mature and sensible Dorothy at Providence Nursing School in Baltimore. Tom remembers that "the doctors would hit on Rosa and Dorothy protected her."

After nine years of friendship with Rosa, Dorothy accompanied her to Trenton one week and met her brother-in-law Tom. "I introduced myself," he reminisces. "She was kind of tired from going out and rather tipsy," he snickers. "Usually I'd meet and go!" he jokes. "I didn't see how we had anything in common. She was fifteen years younger."

Yet Dorothy was unlike most women that fifty-three-year-old Tom had met. "We talked on and on," he reflects fondly. Tom eventually began thinking that this relationship was different than others he'd experienced. His streak of romantic disasters had enabled him to recognize the signs of fleeting infatuation rather quickly.

Unlike other women who'd expressed their pet peeves about Tom rather quickly, Dorothy seemed to feel they were very compatible. There was an immediate sense of comfort, maturity, and timelessness between them. Best of all for Tom, who was a soldier of heartbreak, neither of them felt the need to make hasty decisions regarding their relationship.

"I thought, I can't believe this woman!'" Tom recollects. "I'd spark her interest in something and she'd follow it! I always wanted someone to understand me." Tom also realized that Dorothy "had interests that were alien" to him which he truly desired to learn about. This had rarely occurred before in his dating relationships.

A wealth of "different memories" of time spent with Dorothy still flood Tom's mind today. He recalls thinking that his choice to prolong marriage had finally paid off. When Dorothy ended her visit with Rosa and moved back to Baltimore, she and Tom began calling and writing one another daily. They found that they shared many opinions and

sentiments. Tom later agreed to visit Dorothy in Baltimore where "she was a psychiatric nurse."

Little by little, Tom began recognizing the distinctiveness of his new girlfriend. "She was brutally honest," he recalls. "Dorothy was not a bull skater." While other women had attempted to lead him astray with cunning, Dorothy spoke from the heart. She also had a straightforward sense of humor that he found refreshing. "During the visit, I was questioning her every moment because she was so candid," he recounts. Dorothy once even jokingly alerted Tom to the wiles of her sister. She warned him, "'she's a charmer, intelligent, and able!'" Tom relished his visit with Dorothy in her hometown of Baltimore. He recalls how they toured Peabody Library and how she took him to the municipal park. "She introduced me to her friends, resume-ing each," he says. Although they had not yet mentioned sentiments of love, Tom feels that "she was starting to be" in love with him. He therefore became confident that he'd found someone special and patient to love back.

Dorothy's personal background was particularly impressive to Tom. "She was from wholesome God-fearing people with social manners," he notes.

Dorothy was the daughter of a railroad worker and his wife, a Presbyterian couple. Her parents ran a "mom and pop ice cream store" in Baltimore at the time Tom met them. Tom remembers that Dorothy's mother was "a great cook with strong Indian features."

One striking similarity between Dorothy and Tom resonated deeply within Tom. Tom had always followed his grandmother Ida's advice to seek educated, inspirational company despite his humble beginnings. He had developed a diverse circle of friends but usually felt odd about that fact because he dated women with smaller, narrower social circles. Tom was therefore relieved to realize that Dorothy shared the same taste in friends. Although they were both working-class blacks, they easily gravitated toward people of various social backgrounds and racial groups.

Dorothy Buck's family also shared the Malloy family's interest in transcending class boundaries through learning the manners and customs of prosperous, educated people. Just as Tom's family strived to mimic the wealthy "Big Bukra" landowners back in South Carolina, the Bucks were "ordinary workers who lived next to doctors [and] were [therefore] on their best presentation."

BAD TIMING, BUT FATEFUL BONDS

Tom's relationship with Dorothy actually arrived at an inopportune moment. However, it proved to withstand several tests. In addition to the fifteen-year age difference between Dorothy and Tom and the late stage of their lives, they were also both hesitant to marry. Looking back, Tom now chuckles, "It's strange how something you'd never thought you'd do happens."

He explains, "I was breaking away from someone else at that time, and Dorothy was divorced but resolved to stay single!" Dorothy's former husband had been "a popular musician" who Tom describes as extremely "good-looking." Tom had become more laid back during the time when he was courting Dorothy, and remembers that Dorothy's forty-ish friends thought she would have trouble adapting to Tom's mature, subdued lifestyle after being married to a carefree musician. However, in a short period of time, marriage proved to be too wonderful a prospect to resist. "I got to know her so well," Tom muses with tiny sparkles of light dancing in the lenses of his glasses and in his eyes. During the year that they dated, Dorothy's character struck more and more of a deep chord within Tom's psyche. Soon he was bent on making her his bride. Tom now confesses, "It was the turn around. My meeting Dorothy and then my marrying her. I wrote her a letter every day for a period of time and always had something different to say."

Today, Tom cannot help basking in the joy of listing all the wonderful qualities that attracted him to Dorothy. He was especially inspired by Dorothy's dedication to the civil rights movement around the time that they met in the mid 1960s. "She was active in CORE[1] and in the March on Washington," he remembers. Dorothy also shared Tom's rare interest in psychiatric health. She personally advocated for troubled patients as a nurse at the New Jersey Neuro-Psychiatric Institute in Skillman, New Jersey.[2] Dorothy's individuality also won Tom over. He asserts, "She was an innovator. She always did something different!" At the same time that Tom was finding Dorothy to be an ideal potential wife, Dorothy had luckily begun showing more intense interest in him through her letters. "She told me she was thinking of me on her job, remembering all our times together," Tom sighs dreamily.

After considering his past, Tom decided he was finally up to the challenge of matrimony. He figured that despite the odds, he and Dorothy could keep one another young and happy. He explains:

"All my life I dealt with all kinds of people, and all of my girlfriends before had been much younger. Yet they and many of my peer women were unable to be lighthearted because they were so intense in religion or social image." Tom therefore appreciated the fact that Dorothy was "not damning or judging" of others but kept as open a mind and as

gay a spirit as his own. He knew that those qualities were things he could no longer do without in a companion. While he felt that many women in their fifties would "anger easily" and grew more serious with the times, his temperament was just the opposite. He felt that even as a lay minister at age fifty-three, he was never too serious to be a constant student in life's discoveries.

Tom decided to propose to Dorothy in his apartment on Spring Street "in less than one year after meeting her." Yet he still had jitters after years of bad luck. He confesses, "At first, I didn't think it would last six months!" Tom's fears were somewhat allayed by the fact that his family strongly approved of Dorothy. His brothers and their children instantly called his fiancée "Aunt Dot" and enjoyed her company. The two became engaged in 1965 and began to plan their life together.

WEDDING BELLS ARE RINGING

Tom and Dorothy wed in 1965 at Baltimore's Grace Presbyterian Church, which was the Buck family's house of worship.[3] Tom boasts that while the church "was not big, the who's who in Baltimore went there!" Both Tom and Dorothy's pastors attended the service. Tom remarks that "the best black caterer" catered the reception using "unique designs" to decorate the party. Like all husbands, Tom had small difficulties adapting to married life at first. Having spent over fifty years as a bachelor and being a deep thinker by nature, Tom had odd, slightly depressing habits for a future husband. "I was accustomed to thinking of heavy subjects in the morning and now that I was married, I wanted to share. But at the start of the day a woman wants to be hugged!" he exclaims cheerfully.

Luckily, Dorothy's bold personality kept Tom's quirks at bay and encouraged a healthy lightheartedness. Tom remembers, "I was always unable to engage in small talk, and this turned many women off because I was acting strange. Dorothy used to say, 'You think way up in the sky!'"

Occasional differences in their temperaments never prevented Tom and Dorothy from forging a strong bond as a couple.

MARRIAGE EXPOSES THE ARTIST AT LAST

It did not take long before Tom's new wife became the major influence that would finally lead him into the art world as a professional. Although Tom had never even told his first girlfriend, Consuela Dare, of his love for art, he trusted Dorothy immensely. Dorothy led him to a new world of openness and pride, and he felt comfortable enough to share all his interests and talents more easily than ever before. It was as if a huge weight had been lifted off Tom's chest and he could finally let his personal truth fly free. "I told her I had always wanted to be an artist," Tom states matter-of-factly.

Dorothy's deep understanding of Tom soon led her to insist that he start exploring his hidden passion further. In Dorothy, Tom found someone who believed in him enough to respect his diverse, colorful interests in life. Tom had finally found a soul mate to help his secret dream of artistry come true. One of the reasons Dorothy encouraged Tom's art was because she was taken by surprise upon seeing the rapid growth of Tom's hobby after their marriage. Tom had become obsessed with painting in his spare time now that he felt comfortable revealing his art projects around the house. While Tom kept his factory job and remained an active public servant, he painted furiously from then on.

Tom remembers, "I even put watercolor papers in the bathtub until they got as limp as a rag. Then I could squeeze excess water out and attach them to a board so they'd be as tight as a drum on the canvas." This process made it easier to paint because it prevented "ruffles" from forming on Tom's painting surfaces.

Ultimately, Dorothy became frustrated because it seemed that Tom underestimated his hobby and his potential. Her frustrations led her to urge him toward a whole new career. "She got sick and tired of coming home after having worked as a nurse to see my papers that were soaking in a bath," Tom laughs. It was clear to Dorothy that any hobby important enough to clog up the bathroom day after day needed additional space and perseverance! Dorothy recognized that painting meant more to Tom than he even knew, and she felt that Tom's art should rise to its proper place.

Dorothy began encouraging her husband to find a studio in which to practice his art. Tom heartily comments that this is how he "found a way around that bathroom artistic technique!" At the same time that Dorothy insisted upon Tom's studio work, Tom's brother Frank—the brother who had always remained closest to Tom—gave him an additional push into the art world.

THE FIRST FORMAL ART COMPETITION

As Clerk of Freeholders in Mercer County during the 1960s, Frank Malloy had the privilege of being far more civically informed than most members of the black community. When Frank heard that there would be a Senior Citizens' Art Competition in Mercer County, New Jersey, in 1968,[4] he recalled his brother's longtime passion and Dorothy's newfound encouragement, and he rushed to tell Tom of the competition. Frank's knowledge about the competition was a stroke of luck because

otherwise Tom would have never heard of it. Despite numerous achievements in various fields and success even as an art teacher, Tom had never thought of himself as a serious contender in art competitions. He was shocked and ecstatic to receive an Honorable Mention after entering a previously finished painting in the contest. Without Frank and Dorothy, Tom would never have had the confidence to expose his art in a statewide contest against many veteran artists.

"Receiving a ribbon on my first try told me to continue," Tom proclaims. "It said 'You're on your way!' Because many in the contest were rejected on their first try."

SKILLS FROM A NEW ART SCHOOL SHAPE A PERSONAL STYLE

With newfound stamina gained from the award he won at the senior citizens competition, Tom sought formal art education in order to further improve his work. Tom was determined to become the best artist he could be, and he now sought to reach a skill level with which he could be completely comfortable. Tom had learned the techniques and philosophies to establish his understanding of watercolor art while briefly attending art classes in New Hope and New York in the past. Now, in the 1960s, he began fortifying his God-given talents with a personal twist, thanks to new teachers. Tom began to learn that art itself means "obeying rules to successfully capture moods and feelings." His teachers explained how many artists go wrong by "overdoing" their work and "zapping" the spectator's eye while failing to convey a deeper meaning or message.

One of the most valuable lessons Tom learned during this period was that "illustrative art tells a story and sells a story to others." This idea would shape his work throughout the following decades.

FULL FORCE INTO THE PROFESSIONAL ART WORLD

Shortly after marrying, when Tom was in his late fifties and was enrolled in new art classes, he finally decided to retire from Trenton Folding Box to pursue art full time.[5] He had worked at the company for 24 years and retired in 1970.[6] "My wife got me out of it when she discovered my artistic gifts," he explains.

The civil rights movement and Tom's intense ministry years had ended, and he felt he'd reached a mature age at which he could devote time and energy to art without competing worries. Other people urged him to stay in the public eye now that he was retired. Tom affirms:

> Again my wife comes into the picture. If I waited for people to come here to discover me as an artist, I'd be waiting now! Dorothy

knew that you have to go where there's exposure. I never thought I'd be selling any art work until she helped me start exhibiting at shows that gave monetary prizes.

One of the most effective ways Tom's art received continual attention was through art shows on the boardwalk at the New Jersey shore and in other East Coast states. Tom recalls that "the little shore towns" advertised in art magazines and invited artists to display their work alongside the scenic boardwalks.

Tom was luckily attuned to local artistic publications and accepted the offers in the magazines. "It was in the summertime and September mostly," he points out. Even though Tom was much older than most amateur showmen, he and Dorothy began determinedly packing up his work and heading out to the sea during those months when artists' work was put on display.

LEAN YEARS AND RARE SALES

Unfortunately, the fees charged by the shoreline art shows proved to be an obstacle for Tom. He and Dorothy sacrificed throughout these years to pay for the possibility of selling even a small painting. Their efforts hardly paid off at first.

"Once I spent as much as $1,000 to go to Virginia Beach, and I only sold one piece of art," Tom recalls. At that time, he sold all of his paintings for less than $100. Tom survived on the small reassurance and compliments he received from supporters at these shows. It was this warmth alone that kept him from giving up entirely.

"People would say to Dorothy, 'We know you haven't done well this year but your husband attracted a lot of attention,'" Tom declares. These spectators urged the couple to return to the next year's shows. While Tom and Dorothy "never got a chance to go back to Virginia Beach," this strategy of drawing attention to Tom's art at various shows became a key to Tom's career.

Tom now explains the reasons for showing art extensively regardless of the sales: "Many of these people will eventually buy your work after a certain period of time," Tom asserts. Sometimes it seemed that spectators simply sought to figure out whether other people would buy an artist's work first. In the long run, such ventures were profitable, but they caused Tom difficulty and demanded countless sacrifices at the time. As if the numerous art shows weren't enough, Tom and Dorothy also sold Tom's art at a booth at the Columbus Flea Market in Columbus, New Jersey.

A TEST OF TALENT OVER SALES

Although Tom's paintings did not sell at the shoreline shows at first, Tom was a constant hit with the judges at shows and competitions, which was true proof of his artistic skill. Tom remembers that these art experts formed "a select committee" that was pushed along the boardwalk in the legendary rolling wicker chairs that still dot Atlantic City's picturesque boardwalk today. "A sign that said 'Judge' was attached to the top of their chairs," notes Tom with a small smile.

Thinking back to those shows, which drew a mix of professional and amateur artists, Tom now jokes:

> If you came to an area on the boardwalk in Atlantic City, it could be peanuts! If your art didn't impress a judge, he'd signal and move on. But if he got out, you knew you were in the right place. It's amazing how rapidly my recognition came when considering our lack of preparation! Even today if you go to one of those shows, you prepare yourself!

The judges' approval of Tom's work heartened him despite his lack of money and formal preparation for the shows. Judges often left their quaint rolling chairs to take lengthy, close looks at Tom's watercolors, but Tom admits that he and Dorothy hadn't the foggiest notion about what to say or do before the judges.

BLENDING LONGTIME INTERESTS

Boardwalk art shows also enabled Tom to pursue his interest in networking with inspiring people. Now, however, Tom could finally combine his passion for art with his love of meeting dignitaries. Local town and city council members, business associations, and various art appreciation groups flocked to the boardwalk exhibits. Tom reminisces:

> There was the National Watercolor Association, Art Is Equity, and others. Art Is Equity was the only group that could afford to have lobbyists. They were advocates for artists-- if you were a member. The National Association for the Arts eventually came from Art is Equity.

Meeting members of such important national artistic organizations helped Tom to expand his intellect and his circle of friends while he learned about new art shows. To increase his chances for recognition as an artist, Tom eventually became an associate of one sponsoring organization—the National Watercolor Association. He selected this group because it did not distinguish its associates from other, prize-winning artists featured in their catalog of artists. Tom felt this association had an extremely generous method of providing exposure to budding artists. Elated that his name would be listed in a catalog alongside all types of professional watercolorists, Tom's heart soared with pride and a new sense of legitimacy. He beams today and says: "People would move to Trenton, see the catalog, go to shows . . . maybe at a college . . . and get my card."

NEW ARTISTIC ASSOCIATIONS BRING NEWFOUND OPPORTUNITIES

Many art collectors and other citizens remembered Tom's name from the New Jersey Watercolor Association catalog simply because they were eager to see that an accomplished watercolorist lived nearby. The fact that they hadn't seen his work often made no difference. Instead, the catalog helped spark curiosity. "They would contact me and say, 'Is there any way we could see you?' They were often a professor at this place or that," Tom informs.

As readers of the Watercolor Association's catalog passed Tom's name and contact information along throughout their institutions and communities, more and more people learned that Tom Malloy was a skilled local painter.

Tom recalls the day he finally began to get significant offers for a painting. "I sold it low because I was of little renown," he confesses shyly. Other support for Tom's artwork also came from friends outside of his family who had known Tom but were unaware of the full extent of his talent.

One exceptional stroke of luck appeared in the person of Ben Whitmire, a man who owned an art gallery on North Hermitage Avenue in Trenton. Whitmire had been attracted to Tom's work at one of the many Atlantic City boardwalk shows and in 1972 decided to give Tom his first major show. Whitmire was particularly impressed by Tom's art's subject matter because Tom and the late artist Peggy Gunmere were some of the only artists at the time that were devoted to depicting Trenton's architecture. A personal admirer of Tom, Whitmire once told *Trenton Times* reporter Cathy Viksjo of Tom's special qualities, remarking, "Tom is one of the most humanitarian and cherished and decent people I know. . . I absolutely adore Tom Malloy.[7]

Another big break came for Tom when he sought to befriend Rex Gorley. After studying art both in Chicago and Europe, Gorley collaborated with the Princeton Art Association to promote artists in the Mercer County area.[8] Gorley was a black artist who hoped to add vitality and innovation to the conservative Princeton and its surroundings.

Tom was greeted warmly by Gorley and was surprised to discover that he was the first black amateur artist to seek the Princeton Art Association's help. Although many wealthy white students often flocked to Gorley's studio, which still stands today, Gorley had never had a black student.

While the artistic instruction Tom sought from Gorley was not what Gorley had in mind, Tom found an invaluable friend in him. Tom relays how his meek, "I would like to study with you" received a humble, "'You know enough already!'" from the accomplished Gorley. It turned out that Gorley already admired Tom's work and therefore vowed to be one of his chief promoters.

Another opportunity presented itself when a spectator who saw Tom's art in Atlantic City encouraged Tom to do a show at the Trenton Public Library in 1967. That show led to shows at the First Presbyterian Church in Trenton, the Camden County Library, and the University of Pennsylvania Museum. Tom feels he owes this man a wealth of gratitude, although he never caught his name.[9]

With Gorley's and others' encouragement, Tom began the task of finding an ideal studio to develop his work. When he and Dorothy discovered the house that now stands as Tom's residence on Garfield Avenue, they were instantly impressed. They named the high-ceilinged front room "Studio 101," and Tom created art in that room for several decades thereafter. The original black sign saying "Studio 101" adorned the green doorway of Tom's studio until 2002 when Tom moved to South Clinton Avenue.

The white cursive writing on the sign welcoming people to Tom's Studio 101 brought a touch of sophistication to the simple Trenton row house on the corner of Garfield and Walnut Avenues. Perhaps it will become a historical landmark.

TOM SPREADS HIS WINGS AND HOSTS A SHOW

After setting up Studio 101, Tom and Dorothy decided to take a crucial step. "We thought it would be a wonderful thing to forget race and give to those in the art world who'd shown themselves to be friends," Tom explains. He and his wife had decided that their diverse group of friends in the art world had earned the right to "come and have a joint show" in Tom's new studio. This show was a way that Tom and Dorothy could say "thank you" to the individuals who helped start Tom's professional art career.

This first show in Tom's studio was given in the early 1970s and was followed by other shows at Studio 101.[10] It exposed the art of Tom and his local friends to a variety of new spectators.[11] Huey Lee Smith, another black artist, assisted Tom, Dorothy, and Rex Gorley in developing the show. The four soon became close friends and decided to form a group called "Friends of Studio 101." The successful show featuring art by Malloy, Gorley, and Smith was given that very same name. The chic name of the show attracted newfound attention to the studio and helped the three artists gain further popularity.

MARRIAGE IS AN ART, AS WELL

Tom also explored the endless aspects of matrimony at this late stage in life. He realized that the development of a beautiful marriage could add as much joy to life as a gloriously painted landscape. In fact, the chemistry between Tom and Dorothy was so remarkable that they both proved to be artists at interpersonal relationships and caring.

Tom and Dorothy often embarked on exciting intellectual adventures together. "I went to the Guggenheim with her to look at modern art," Tom recalls. The pair also attended a year-long metaphysics course together where they learned that "the power of positive thinking brings right action." The couple's adoration for one another also grew with time. Tom confides, "As we got to know each other, she couldn't believe I was all these things—a singer, an artist." Conversely, Tom found a multitude of new facets within his wife's mind and maturity. He gained even more respect for Dorothy's no-nonsense understanding of life, for example.

"There's a should world and a real world. That's what she always reminded me," Tom remembers. Dorothy often good-naturedly teased her husband about his idealism, as well as the bookish way he adopted new vocabulary into his everyday speech. "She used to stop me when I'd begin saying a quote and say, 'Is there anything you know that doesn't come from a book? You're just a bookworm!'" Tom chuckles. While Tom's marriage flourished, he was deeply saddened by the death of his brother James on December 2, 1977.

A CHANGING RELATIONSHIP WITH CIVIC ORGANIZATIONS

As Tom delved deeper into his fledgling art career and into married life, his civic activities also changed. He finally decided to stay closer to home instead of assisting broad-based regional groups. Tom stopped

meeting with the Fellowship of Reconciliation specifically "because they never came to Trenton."

Several times, Dorothy had initially invited the small Fellowship of Reconciliation to meet at her and Tom's Trenton home, but the group refused to come. The constant traveling required to regularly attend Fellowship meetings was too demanding for Tom and Dorothy, however. The couple therefore decided to focus their energies on promoting Tom's art.

Tom suggests that the Fellowship most likely declined to meet in Trenton out of "fear" rather than inconvenience or racism: "When blacks blame whites and say they're racist, it is often because the whites see lower class blacks in an area and run," he notes.

Tom feels that these same fears about personal safety and class differences may have prevented the Trenton Ecumenical Area Ministry from enabling religious unity in the area in the late 1960s and 1970s. He and Dorothy therefore decreased their involvement with this organization, as well. The pair was quite contented to make Tom's art their primary concern, with Dorothy's constant employment in the health profession also filling up her own time.

REFLECTIONS ON A LATE, BUDDING ART CAREER

Today, Tom considers his late shift into the professional art world to be a wonderful, timely choice. He does not regret delaying his painting at all. "At a time when scientists are now recently finding out the human mind settles down to a long period of relaxation, retirement, and inactivity, I was beginning a whirlwind new career," he proudly declares. Tom is happy to stand out among his peers as a senior citizen not "only on the go" but "on the make" in an entirely new field.

Tom attributes his artistic success wholeheartedly to his wife, Dorothy. "She spent her whole retirement 'vacation' and her life sacrificing for my art," he confides lovingly. Whether buying Tom's art materials with her own pocket money or "skillfully" nagging him to sell his work, Dorothy was always there to help Tom's dream develop when he needed her.

INCREASED RECOGNITION AT LAST

Since the late 1960s, Tom's career has continued to grow. By 1978 he was teaching art classes in Surf City and at Mercer County Community College. In addition to the shows already mentioned, Tom had a show at the Trenton YWCA in 1970[12] and was featured in a show called 5 *Black Artists* at the Hermitage Collectors Gallery in November of 1972.[13] Tom's work was also featured in group shows at the New Jersey State Museum, Studio on the Canal, the Balch Institute, AT&T in Short Hills (NJ), Kenkelaba (NYC), Trenton State College, the Germantown Gallery, and AT&T at Basking Ridge (NJ).

Tom also had shows at the Princeton Medical Center in August 1978;[14] at the Trenton City Museum (Ellarslie) in November of 1981 and summer 1998;[15] at Stuart Country Day School's Considine Gallery between February and March of 1986; at Ellarslie in December 1989 (conciding with the dedication of the Arthur T. Holland Gallery, which was named after the late mayor of Trenton); at Lambertville's Genest Gallery in 1989;[16] at the Gallery at Capital Health System at Mercer in 2001; and at Monmouth College, Merabash Museum, Bellevue Gallery of Fine Art, Western Electric of Hopewell, IBM in Dayton (NJ), Bristol-Meyers Squibb, and Artworks.

Tom's work was also featured at the Philadelphia Civic Center and on a greeting card used by the National Multiple Sclerosis Society of Central Jersey. Tom's mentee and friend, Larry Hilton, stated in 2002 that he recalled framing more than 1,000 Malloy paintings over the years,[17] and Tom's productivity is astounding. Tom was honored with a "precious musical gift" of song by the American Boychoir in 1987 at a charity event benefiting the Trenton Artists Workshop Association and the Princeton Art Association, as well.[18] In 1989, Tom was affectionately coined the "Dean of Artists in the Community" by Arthur Holland's wife, Betty, and many still use that moniker for Tom today.[19]

In an early August 2000 interview with me, Tom noted, "I feel something big is about to happen to me in art this year." His wise prediction soon proved correct. Subsequently, someone from the New Jersey State Council on the Arts told Tom, "You're about to get recognition that's been coming for a long time." Later that year, Tom found himself receiving the unique honor of being commissioned to paint a work that would be given to Penny Lattimer, the outgoing chair of the Council board, by the board members.[20] Tom remarks with pride and surprise, "I didn't know her [Lattimer], never met her, but the Council thought, 'This must be the only artist to do a fitting work!'"

This special commission was one of many indications that Tom's artwork had become well-respected and intriguing to art lovers and to Tom's local community. After being the first artist to have a one-man show at Rider College's art gallery when it first opened in the 1970s and after giving shows in Rider's Student Center, Tom received an honorary Doctorate of Fine Arts from the school (now Rider University) during its 127th commencement on April 13, 1992.[21] On April 5, 1997, Caldwalder

Asbury Methodist Church also honored Tom with a celebratory luncheon, which was an event full of accolades, tributes, and spiritual songs.

THE TOAST OF THE LOCAL MEDIA

The local media have enjoyed covering Tom's work since his career first began. One 1977 *Sunday Trentonian* article captures the uniqueness of Tom's personal journey while exposing the beauty of his urban watercolors.

Other articles note Tom's accomplishment of managing the only independent show at Cadwalader Park's Ellarslie Mansion. Many reports about Tom love to comment upon apparent changes and features in his work. A continual buzzword in the Mercer and Bucks County art circles for several decades now, Tom's name is often mentioned and his shows at places like Lambertville's Genest Gallery. Mention of Tom's name is usually accompanied by complementary stories about his life, as it is impossible to know Tom and not admire his zest for living.[22]

Highly grateful for his supporters and media interest, Tom is also unsurprised by their astuteness about art. He feels that New Jersey has often shown strong art appreciation: "This is the first time that 20 million dollars will be spent in the state of New Jersey on the arts. Former Governor Kean began and encouraged this and said that the New Jersey arts were second to none. We are now only third in the nation in arts funding," Tom informs.[23]

Fortunately, the increasing recognition of the New Jersey arts means increasing appreciation of Tom Malloy's artwork in the future.

GAINING COMMISSIONS

Even during his eighth and ninth decades of life, Tom continues to tackle several commissioned artworks at a time. Tom is aware that this capacity is indeed remarkable for his age. Commissions are a true trademark of success in the art world. Commissions emerge as people request an artist to paint something specific for a negotiable or fixed price, trusting the artist's ability to capture the particular scene. Numerous private citizens, collectors, and even civic associations have given Tom commissions.

Tom has also been painting a commissioned work to form a permanent part of Trenton's War Memorial Building. He describes the painted scene as one of "industry" that will be enlarged to immense proportions for fitting at the War Memorial Building.

ENJOYING LIVING A MULTICOLORED DREAM

As his community recognition increases, Tom is also being sought as a professional art teacher now, which he especially loves. "I was a hit with students at the Governor's School," he recalled excitedly. "I was asked there again." Tom was additionally invited to teach and lecture at Douglass College, the Serendipity Workshop, and the Trenton and Baltimore Public Schools.[24]

Larry Hilton feels that all Tom's accolades are timely and well-deserved. Hilton remarked in 2002:

> [I]t's great that the city [of Trenton] recognizes the contribution that [Malloy]'s made as an artist, not only as an artist, but his whole positive image and the spiritual value of goodness that he generates in his art and personality. He's been like a true guiding light and an inspiration.[25]

The most remarkable part of Tom's life as a late-budding artist? Although his painting has become his focus, he remains multifaceted. Tom attends church and participates in church programs. He is also an avid reader. Tom has never stopped sharing his interests or his gifts.

He paints numerous watercolors in one week, working fervently on a painting that appears flawless to the untrained eye, then, unsatisfied, begins it once again in search of fuller artistic refinement. He is a perfectionist.

Unending enthusiasm surrounds Tom today the same as it did when he excitedly chased tobacco-curing wagons as a small southern boy. "The art business has taken me places I've never dreamed of. I met people I never dreamed I'd have the privilege of meeting—at the War Memorial event, in other places," Tom bubbles.

In short, Tom's longtime dream finally came true, but Tom's dream itself underestimated the possibilities. He has succeeded beyond his wildest dreams. His success is proof that it is never too late to do anything or remain a diverse practitioner at the art of living. Thinking of his recent achievements, Tom simply proclaims, "I'm ready to paint up a storm now! I'm thinking big!" Now that dreams of art have turned into a real-life career, Tom has only increasing hope and colorful plans for the future of his work and his life.

From Childhood to Adulthood, (1968), courtesy of Tom's dear friends "The Worthams"

CHAPTER 8

The Art of Tom Malloy

Broad strokes of grey swirl their way across the canvas guided by a steady, bespectacled eye. A perfect shade of yellow is blended to make a yellow orb and light radiating from it more palely as the distance grows. In 1999, Tom Malloy remained busy at work creating a unique lighthouse scene. This process of painting the sky grey, the lighthouse grey and maroon, and of painstakingly creating birds and seaside shacks, is a form of praising God for Tom, whose religious foundation guides all he does. Tom daydreams as he paints. One can almost see the sparkles in his aged eyes reflecting the rich imagination that lies behind them.

Tom is storytelling in his mind and "conjuring up images," as he calls it, of times past and times yet to come. His paintbrush strokes will capture the timelessness of the lighthouse, the scattered seamen, the sky, the birds, the shacks, and the tugboat. He encourages viewers of the painting to think about the feelings and history of the place, hoping they'll be inspired to imagine endless possibilities for the world and their own lives and creativity.

Tom Malloy's talent for watercolor painting was a gift long-developed but late-blooming. Ever-evolving but always true to Tom's heart, the art of Tom Malloy has a story all its own.

ART IS COMMUNICATING WITH GOD AND OTHERS

The spirituality that flowed freely in Tom's pastoral career took on new meaning as he developed his own artistic style. He soon began to realize that God's work—the world—is all art, and that art, in turn, is a way to do God's work of teaching and reaching others. Even the minutest aspects of art have deep meaning for Tom. "The fourth Gospel says, 'In the beginning, we were in darkness until Jesus appeared,'" he explains. "You cannot comprehend light if you are in darkness." Tom therefore makes "an understanding of light" crucial to his artwork. To Tom, knowing the principles of color, light, and vision translates into recognizing the goodness Jesus brought to the world. "The Gospel brings clarity to a lot that's dim in life, brightening up my work," he comments. Two types of light—spiritual enlightenment and visual light—are inseparable to Tom. He is always overjoyed when "people claim they've been through something or some setting" that is depicted in his work because he feels that this demonstrates that he is making a true connection with God and other people through art. For Tom, watercolors are merely words surging forth from a pulpit at which he proclaims joy, hope, peace, and knowledge.

THE MEANING OF MALLOY'S PAINTINGS

The essence of Tom's artistry is subtle storytelling that resonates deep within Tom's heart. "There is a self-evident, reflective message in each painting," he explains. Every time he paints, Tom attempts to challenge our tendency to view the world from only one perspective or time frame.

Tom muses:

> I like to, from time to time, remember a scene that is no longer there while sitting in its place now. I think it was important to the city, for people to see what it looked like before. I may look in books to see what something looked like, or remember in my mind to capture its importance to our story.

> Once a man asked what I was doing when I was painting dwellings in downtown Trenton. I answered, 'I am painting this place.'

Although the man called the place an "eyesore," Tom replied, "You see an eyesore which is to be carted away, but I can see a time when it was the dwelling of a happy family. If this dwelling could tell it's story, it could hold you until the sun goes down!" Tom wants his artwork to invite others to think about endless possibilities for humanity and the world. He paints locations that are at risk of disappearing due to redevelopment, accident, or age, and he seeks to capture the deeper essence of immobile location and settings. Although he was actually painting the dilapidated shell of a building at the time of his conversation with the disillusioned man, Tom felt that his brush strokes immortalized the dwelling.

"I hear the babies cry in the buildings I paint," he professes. "Someone loved them. Unless you research it for sure, no one knows their history. I see the unlimited story behind these objects. I ask myself what caused me to think about them. The shape that can look like a barn, in my subconscious, is therefore resurrected."

SEEING AND THINKING

By capturing the slight details of an object and forcing us to examine it in his paintings, Tom encourages viewers to use their imaginations and contemplate history. As an audience scrutinizes dilapidated buildings in Tom's work, they think about the meaning and purpose of Trenton itself. Journalist Cathy Viksjo noted that Tom's "urban realism has been compared to the late American realist painter Edward Hopper,"[1] while journalist Louis Cooke notes that Tom "likes to play with oddly juxtaposing angles." [2]

Regardless, Tom hopes that his depictions help us to see how even the cracks and crevices he paints might have gotten on the buildings, how the building used to be, and the way those same imperfections might change or mend someday. Tom calls this idea "creating an atmosphere" to "conjure up images" in viewers' minds. Although Tom's rural landscapes have a quite different meaning to Tom than his cityscapes, he uses the same philosophy to paint them. He explains:

> When I see an abandoned barn I think, 'This barn isn't used for its original purpose today! I see people shucking corn in that barn. People had edibles stored in there. I want people to hear the horses kicking against the stalls, to see evidence of the field mice running through the stored crops long ago when they see that painting!'

First and foremost, Tom hopes that his paintings will inspire others to create for themselves. He therefore does not want his work to express one lone idea or image. "All of us are creative. Maybe not by painting, like me, but through something they follow. There are always new ways to show something," he notes. Tom hopes to awaken the artist in everyone by making them look closely at their world and by challenging them to reinterpret it through their own senses and talents.

TOM'S FAVORITES

When asked if there is a special type of scene or subject he prefers to paint, Tom candidly confesses that he is "an urban person at heart." These words reveal Tom's deep love for a place he migrated to after his vastly different, rural sharecropping beginnings. Tom often concentrates on Trentonian cityscapes because he feels that urban settings are particularly historic.

"In an urban society, a building shows it was a habitation. Even if abandoned, you know from looking that at one time it was occupied. Cities therefore hold a certain history," Tom comments. Tom feels that past images are often less interesting to conjure up from first glance in more natural, rural settings.

"When you show country vistas, you see what a big wall of buildings won't allow. No minimized space or crowding. But the more crowded a place becomes, the more difficult it is to see why it's there." Trying to understand why a building is there, to Tom, is the true function of history. Tom also feels that artists' subject matter tends to reflect their own life experiences, regardless of race. He once told a reporter, "You tend to relate to that which you know; beyond that, one becomes uncomfort-

able."[3] However, Tom remains true to his nature as a consistent, enthusiastic, multifaceted student of the world. He strives to observe and paint all types of subjects well. "I constantly study trees, buildings. . .anything spiritual and visual that I feel." He asserts, "The author [Percy Bysshe] Shelley once said to an artist friend, 'If there are only birds and bees, paint them!'" Tom sees beauty everywhere. "*Look at the dawn! Look at the waves!*" he shouts grinning and tapping his cane upon the floor.

Tom also admits that at times, his creativity grabs him in ways that he simply can't explain. He was elated to find the book *Understanding Beethoven,* which put his own experience of artistic passion into words: "[Beethoven] said all of a sudden, whatever I'm doing, all of a sudden I hear 'bum bum. . .' [Tom sings]. . . .That grips me. That's what happens to every creative person. Something takes hold!"

OPTIMAL LIVING THROUGH VISION

As he ages, Tom Malloy desires to see all aspects of the world as equally good subjects of a painting. He feels this will edify his life and spirituality in general. He explains:

> If I can see anything, I can see the moods of nature. Cold, chill If you're creative, there's no such a thing as never being able to do something. I like finding the ability to think beyond limits, at the wonders all around. I like to see something in a way nobody has ever thought about it, to ask, 'Is there another way to do this?'

ANYONE IS A PAINTER

To Tom, "the possibilities in the world are never exhausting." He is therefore amazed that so many people are kept from art "because they say, 'I don't know what to paint.'" Tom feels that the plethora of possible subjects in the world should encourage everyone to paint simply to explore their feelings and to observe.

Tom describes the source of his ideas as "imagination" although an actual scene is always the final product on the canvas. "I create scenes or figures, too. Once you know the nature of water and the essence of the movement of water, for example, you don't need to see the water to draw it," he says.

CHOOSING WATERCOLOR, CHOOSING A WAY OF LIFE

Tom experimented with many artistic media throughout his life. "I tried to paint in high school whenever possible," he recalls of his early days. He chose watercolors as a primary medium after learning sketching and other art forms.

Unsurprisingly, Tom's reason for choosing watercolors is typical of his spontaneous, open-minded approach to life. Tom finally settled upon watercolors because they preserve the unplanned, impromptu nature of art and constantly test an artist's skill. "Oils are less challenging because you can see the end result of mixing colors right away when you paint. But not with watercolors. You never know what you will get," he explains. His artistic ideas encapsulate the easy-going, experimental manner in which Tom allowed himself to impact his world in various careers. Tom also favors watercolors because of "the quickness" with which an artist can use them. "Oil painting is a slow process," he states. Imagining himself as an oil painter, he remarks, "There is no way I would be able to finish a painting in a number of days or hours!"

Watercolors intrigue Tom because they additionally have a magical ability to capture the world in its present form. "If you avoid using white paint," he notes, "watercolors are as close as a painting can come to the beauties and nuances of nature." More than any other medium, Tom feels that watercolors "paint an atmosphere."

DEVELOPING A DISTINCTIVE TECHNIQUE

While Tom may not need countless hours to paint a watercolor, he downplays his talent by saying that it is neither distinctive nor painstaking. When asked if there is a special mechanical technique he employs, Tom answers humbly, "I have a god-given gift of art. There is no difference between painting and drawing. A painting is a drawing completed with paint." He then demonstrates how he could use paint to create a picture in the same way that sketch artists use pencils. Malloy's work is truly quite ingenious.

Gently dipping a little brush into blue watercolor paint, Tom glides the brush across a piece of scrap paper as if it was a pencil. With an only slightly shaking, aged hand, Tom slides the brush up and down the page to form the outline of a blue house with a blue tree beside it. "Then I must choose a dominant color for the sky, the tree's leaves, and the rest of the scene depending on the season. If it is to be a sunny day, the dominant color will be yellow," he informs.

When considering if he has changed from his previous methods of painting over the years, Tom decides that trial and error have led him to his own distinct approach to art. "I was constantly experimenting on my own. I was one of the oldest people in the New Hope art class," he recalls.

Some followers of Tom's artwork have noted the changes in his style themselves. For example, in 1982, journalist Louis Cooke noted that Tom's artwork had developed "a new emotional urgency not apparent in his earlier work." Cooke suggested that it was "the terrible beauty of violent nature itself" that stimulated Malloy's paintings then, as opposed to the "more placid and restrained urban street scenes that Malloy is noted for."[4] Overall, Tom himself feels his style has become much more defined in the past few decades regardless of its varied subject matter, as he has learned and practiced new methodology.

One glance around the brimming Studio 101 revealed the beginnings of many rural and urban paintings. Yet the immense detail within Tom's work suggests that there is far more complexity to his artistic methods than he wishes to divulge. Above all, Tom is extremely humble about his skill. Tom also admits that he concentrates on urban essences because he is somewhat of a "frustrated architect," as Dorothy used to say. Tom always sought to be a skilled sketch artist and "was always fascinated by buildings." He particularly paints buildings for the challenge that depicting brick, wood, and other building materials brings to his watercolor technique. Getting the angles of a building perfect on paper is also difficult, and Tom notes, "I am striving for perfection, though I'll never reach it. Matisse did one painting six-hundred times before it was perfect and he finally got it." Balance within a painting is also a priority for Tom. He pulls out a huge, unfinished commissioned painting he is currently working on. It is a frontal view of the War Memorial Building and its steps, which causes him to frown. "If there are too many tall buildings, you don't notice what's on ground level," he comments. Tom is eager to succeed in this difficult task and honored that he was chosen as the painter.[5]

Tom complains about his inability to balance the height and shadow of the lanterns in the foreground with the people there and proves himself a perfectionist. He explains that many of the people he has painted ascending and descending the steps are on various angles and heights. But to the untrained eye, the painting appears complete and perfect.

Tom pulls out another huge version of the scene that seems similarly flawless. Yet neither will be the finished product. He will make many attempts until the final product is something he is completely pleased with. Tom finds that a sense of space is especially important in cityscape scenes. His technique has earned him this War Memorial commission and the respect of other artists.

SELLING WORKS OF ART

Tom finds irony in the fact that he can now sell his artwork for impressive prices, since he came from such humble beginnings.

Although he never even imagined he would actually sell his work when he was sketching as a younger man in his spare time, his supporters have now urged him to sell his paintings for competitive prices that other professional artists would receive.

Tom recalls that a particular show in Lambertville's Coryell Gallery encouraged him to raise his prices.[6] The gallery's owner, who is now deceased, had visited Studio 101. He saw the plethora of handsome, unsold works, and insisted that Tom was undervaluing his talent and his potential to sell art. This gallery owner invited Tom to show his work there and suggested competitive prices that soon proved reasonable to happy art lovers. Tom had simply never considered that people would seek to buy even a small Malloy painting for over $20 before that time.

"Now some people say, 'You are now famous and I can't afford your work!'" he says in a surprised voice. "But many people insist that I should not charge less than $30 for a very small painting or sketch." Tom is slightly hesitant to charge a lot of money for his work, but he understands how following important advice from art dealers will assist his career and reputation as an artist. Above all, Tom finds it important to also stay grounded and charge varying, reasonable prices so that everyone can enjoy his work. "I'm glad I haven't gotten huge offers!" he admits laughingly. For, he fears such offers might tempt him to try to charge even more. "I see people polluted by money," he adds conscientiously. Tom's humility keeps his artwork a product that *his* people—Trentonians—can enjoy within their homes, whether they are grand or humble.

"MASTERING" ART?

Tom recognizes the perfectionism that he shares in common with artists throughout the world. "In art school, I learned that the typical genius continually destroys as he creates, turning his work around when it goes astray," he remembers. He therefore feels better knowing he himself is often highly dissatisfied with his sold work. The pull of fastidiousness seems to challenge him even more with each passing year. "I often can't finish a painting," he confesses candidly. Despite his likable style and financial success, Tom's insecurities about his artwork remain. "I recently read a book about a famous artist who had trouble drawing people. And I do too, so I feel better!" he confides.

Tom continues modestly, "People always ask me, 'Where did you learn to draw so well?' but I always envied animation artists. I was so impressed by the treatment of other artists and fascinated to see their demonstrations. I just couldn't help it." Tom is constantly in search of new skills to help him recapture and represent the world on paper. He maintains a realistic attitude about the potential of his skills:

> I saw forms in my head even before I knew what I wanted to do with them! I know I can never be the master. I learned so much in those art courses. I couldn't change it for the world. I took courses with distant teachers, but they'd make you think aesthetically about what you're all about. But it's up to you how much you want to use.

Luckily for Trenton and Tom's many patrons who are always pleased with his work, Tom chose to use his art education to its fullest extent and even continues to strive for improvement during his ninth decade of life.

Tom Malloy has never tired of doing artwork—be it in secret or as a noted painter—in over ninety years of life. Malloy's artwork has a unique flair and has become a world to which myriad people are now committed. The countless collectors of Malloy paintings understand the artist's drive to capture multiple possibilities in time and space and to do justice to the world's beauty and grace. This is the reason that Malloy collectors feel especially enriched after viewing the art of Tom Malloy every day within their own homes.

In Tom's small apartment at the Pellittieri Senior Citizens' Housing complex, one can still get lost amid hundreds of paintings, brushes, and the watercolors that brought him distinction beyond any other career he had begun. Sitting and quietly talking to Tom in 2004, it remains evident that miracles do exist. For one can see this sharecropper's son painting a scene of Trenton's War Memorial and perfecting a technique that other talented artists can only envy.

Thanks to devoted loved ones, unlimited talent, and several strokes of luck, Tom Malloy continues to inspire people with his philosophy of painting that sparks historical memory and imaginative musing. Although Tom Malloy remains humble, his dream has at last come true. Each painting is a separate statement and invitation to the world that brings Tom a step closer to God.

[Trenton] Steps in Time, (1999), courtesy of Ted and Jane Boyer

CHAPTER 9

Trenton's Son Remembers a City of History, a City of Change

On August 25, 2001, the day of Thomas Malloy's eighty-ninth birthday celebration at Triangle Art Center in Lawrenceville, New Jersey, Tom was surrounded by people from numerous locations and backgrounds. All were elated to be a part of Tom's celebration because they treasured both the man and his incredible gifts of art. Tom beamed a broad smile and spoke of his pride at being honored by hundreds of people over the years.

The room felt alive and electric. The people within it were filled with solidarity, wisdom, and hope. Yet what radiates most from this warm memory is Tom's humility and calm capability of being the focal point of it all. As a knowledgeable Trenton resident, Tom knows the source of every painting he has created and the historical legend that goes with it.

With over eight decades of perspective, Tom knows Trenton far better than its young residents and recent migrants could ever hope to know it. While his old world of a bustling downtown packed with horse-drawn carts, early movie theatres, and a successful manufacturing center has faded, it is recently gaining recognition through urban renewal efforts around the town. As Trentonian history himself, Tom is a precious resource who thinks highly of his home and has numerous things to say about its past, present and future.

A LOVE OF TRENTON'S INDUSTRIES

In addition to recalling his own childhood in Trenton, Tom Malloy values the city for its rich history and importance. He prides himself on being an amateur historian and remarks: "Trenton started as a Quaker gristmill. The remains of the Stacy Gristmill are in Stacy Park today. The water rolls down the Delaware River fast at the falls at Trenton, which is why this location was chosen for the mill."[1]

Tom is ever-ready to espouse the virtues of Trenton, which was once a very famous city. When asked whether he was fond of the busting old days of Trenton's industrial age, Tom cries:

> Heaven's above! That's why we're here! Although many young people don't know it today, up until World War II, Trenton was one of the great ceramic capitals of America. Maddock, Lenox, and other ceramics-makers came because the soil here makes very good clay. Using chalk from the Dover cliffs in England, these people would make porcelain.

Today, Tom is in the process of doing several commissioned paintings of buildings on Clinton Avenue, which used to be the site of Trenton's old pottery manufacturers.[2] Tom relishes this opportunity to capture his beloved second hometown's industrial greatness through his work. Pondering about his privilege to witness many of the enterprises that made Trenton great over the years, Tom utters:

"In my youth, you could see men placing plates into kilns. I knew some men who worked there, most were white immigrants, often Italians. When the Depression came, blacks were able to get more work in the steel industry. Many jobs came through the Roebling plant, where I worked."

In addition to his artistic awards and commendations, Tom's industrial efforts have been rewarded, as well. He was featured in *Now You're Set For Life: Oral Histories of the John A. Roebling Son's Company, Trenton, NJ* in 1994.[3]

TOM'S FAVORITE PART OF THE CITY, AND PAINTINGS AS HISTORICAL EVIDENCE

When asked to name what he feels is the best part of Trenton, Tom mentions an historic, cultural section. "The part from the Cathedral toward Five Points, to the Battle Monument and down Broad and Warren in South Trenton," he decides. "I also love the Mill Hill area for its visual and historic qualities. These areas have been important since George Washington and others fought here." Incidentally, Tom's paintings of these areas are some of his most famous works.

Many of Tom's paintings depict locations that have become particularly controversial parts of Trentonian history over time. One journalist once noted that "in many instances, his exacting portrayals of demolished landmarks are historically the only documents that remain."[4]

Molly Merlino, wife of the late state Senate President Joe Merlino, owns one such painting. Her 1983 Malloy painting of the Delaware & Raritan Canal in Trenton reveals an open waterway with no pedestrian paths alongside it—a subject that has become quite significant in recent years.

Since around 2000, public sentiment has arisen regarding the issue of creating bike paths to link this exact portion of the canal to bike paths extending from Maine to Florida. This makes Tom's painting especially valuable as a marker of the shifting public concern over the decades.

Merlino explains, "I think that's the interesting part of the painting because I don't think Tom was ever thinking of that [in 1983], but I think now it's important." Environmental groups and tourism officials are especially concerned that Trenton's canal area should not remain excluded from the East Coast's project to connect waterways for recreation and preservation. Unknowingly ahead of his time, Tom found the subject worthy of scrutiny and spent considerable time observing it before he painted it.[5]

TRENTON'S DISTINCTIVE AMERICAN CHARACTER

Tom recognizes that industry is not the only thing that put Trenton on the map in U.S. history. Relishing life in the city where a decisive Revolutionary War battle was fought, Tom names a bit of largely unknown Trentonian history. "Near St. Michael's Episcopal Church on Warren lie the remains of Napoleon Bonaparte's brother's wife. She is the one who told Napoleon's brother to flee France and come to the U.S."[6] Tom is very glad he has remained in Trenton, and proudly muses:

> If my family had decided to move to another place when I was young, I would have had to go. But, more than any other place in the world, Trenton is unique and represents what this country is about. Even this little spot I live in!

Tom then points outside his studio window on a rainy afternoon to the quiet corner of Garfield Avenue.

PERSPECTIVE ON RACIAL HISTORY

Tom is proud of Trenton's struggles for racial struggles' justice, which he nobly assisted. He prides himself on the fact that he is one of the only remaining charter members of Trenton's NAACP chapter. He declares:

> Before the Civil War, Trenton was supposed to be the most discriminating northern city! Blacks couldn't even sweep city hall. The highest number of blacks working was in sanitation. But now when I see a black man in charge—Mayor Palmer—I know how special Trenton is.

In addition to political progress, the social dimension of racial mixing and mingling in Trenton is also quite remarkable, in Tom's opinion. "In 1925," he recounts, there was one Mexican in all the town, and only a couple of Indians."[7] Yet Tom points out how quickly the town's minorities increased their numbers and even intermarried. He recalls:

> Black folk here used to be called Jersey niggers. The black writer George Schuyler, father of the musical genius Phillipa Schuyler,[8] once said all over the country, 'The black population is an island of blackness in a sea of whiteness.' Yet, Trentonian blacks soon married Indians and even whites.

Tom recalls that feelings of fellowship have also always thrived in Trenton despite the existence of racism. This kindness inspired him to remain here in tough times. He asserts: "There is something about when we came here. There was a black part of the street, a Polish part of the street, a German part of the street. But, neighbors looked out for one another and different races were treated with respect."

Tom remembers that Trenton's groups were not always encouraged to intermarry by the Old Guard in the city, however. As was the case throughout America, white women were usually denounced by their communities when they married a black man. Tom still feels that interracial marriages stand as proof that Trentonians were unafraid to see one another as people first and foremost. "We are still race-conscious, but this atmosphere has all colors," explains Tom.

THE TERRITORIALITY OF TRENTONIANS

Tom also chuckles about the pride he sees in other Trentonians. "Everyone believes they live on the 'good side' and tries to claim their part of the city is better. Try to say to them they're like us! But if you're from East Trenton, you'll claim you're better than the West, and vice versa," he jokes.

A CITY OF PROMISE FOR TOM

Trenton is beloved to Tom especially because it offered him success, love, and opportunity. "I had a chance to escape many times, but I am here now because of my wife. My wife found this house [on Garfield Avenue], which was ideally suited for years and years. She worked hard to find it. I'm here on this corner because of my wife," he states proudly. Tom happily describes the sights and sounds that dotted the Trenton of times past:

> The Gaiety Theater was here in East Trenton before,[9] and we would go there for Saturday matinees. The circus ground was at Trenton High before the high school was built on Greenwood Avenue. Billy Sunday,[10] the Billy Graham of his day, would meet at his tabernacle here. It was a wooden structure that could seat

ten thousand people! It doesn't seem that long ago that I moved here as a small boy.

FRANK CONCERN FOR THE FUTURE

Tom does fear that Trenton has changed somewhat, partly due to the general tendency of the world to become more fast-paced. "People don't know how to relax now," he admits.

Fortunately, Tom can recall the days when people acted much differently. "It used to be much safer. I used to take a walk daily. But now people are dangerous. Street thinking is a whole different mentality," he ponders. Tom feels that "today is a time of anger" not simply in Trenton, but all around us. He notes that angry confrontations are more frequent.

"If there is something of value, most people will take it," Tom alleges. He feels that in the Trenton of long ago, people could leave their door unlocked. Tom admits that he misses a Trenton where the majority of families remained in a neighborhood for decades. "We no longer have an old neighborhood," he comments. "People move in and out so you can't even list the block now."

At the same time, Tom laments the passing of black solidarity that was present during his youth. "Black on black gangs in East versus West Trenton are unfortunate," he asserts. Tom attributed such sad changes to "drugs" and the creation of a "greedy world" of increased materialism. "The average person, smart or not, can't see through materialism without fantasizing and getting jealous," Tom says sadly.

Although he was never a biological father, Tom remains a moral mentor to his neighbors. He feels parenting has much to do with today's social ills. "Parenting now and then is as different as night and day," he begins. "Before, there was deprivation for the night if you refused something simple as a meal. Now, children control their parents. But before, families used to be mutually protective of one another. Parents would send brothers to check on their sisters. Now, if you ask a parent, 'Where's your daughter?' they don't know!"

When asked about his views on the future of Trenton, Tom makes a special call for racial reconciliation on both a local and a national level. "Race is the most divisive issue today," he asserts. "We must do something about it before it destroys our nation."

JOY IN CULTURAL RENAISSANCE

Despite his worries about Trenton, which are surely shared by many city leaders and families, Tom remains highly impressed that Trentonians and New Jersey residents in general seem to be taking a renewed interest in Trenton. "Now they're talking about a new Renaissance in Trenton," he explains. Back in 1992, Tom was also confident that Trenton could have a cultural renewal, and even then he pledged to lead Trenton in establishing itself as a center for the arts. At a reception in his honor at the Trenton City Museum, Tom asserted, "I accept your challenge to be in the vanguard, to be in the lead, as we restore Trenton to the place it should be."[11]

Tom now feels that the recent cultural explosion in Trenton is both justified and part of a long tradition. He states:

> It's not by accident that the state has put money into restoring the War Memorial Building recently. That the Roebling Building is being preserved as Pellittieri Senior Citizens' Housing. They are preserving the manufacturing museum as well.

To Tom, it is imperative that the world knows about Trenton's industrial and cultural potential. In order to assist the renaissance, Tom donated a watercolor painting of Trenton's old Normal School to Trenton State College (the successor of the old Normal School) in 1989.[12]

The sparks flying freely in welding enterprises and the bright fires burning the kilns in Trenton's ceramics factories have long since cooled. Yet Trenton has survived the end of the industrial age as has Tom Malloy, a veteran of Trenton Folding Box Co., and Trenton construction efforts. Tom has witnessed Trenton's transition into a city of the future and hopes that it will only improve with time. He has become an important part of Trenton's history not only by taking part in events that shaped the city and influenced the turning tide of a nation, but by fervently depicting watercolor scenes that will keep the memory of old Trenton alive.

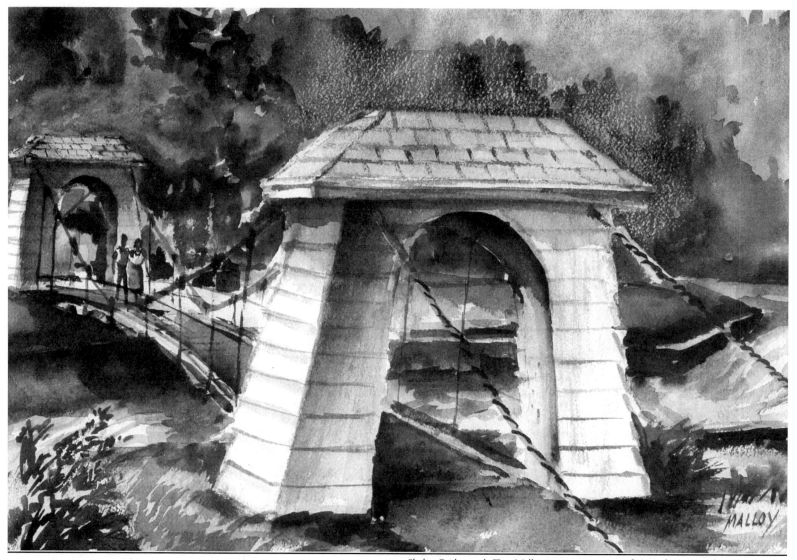

Shakey Bridge, early Tom Malloy painting, courtesy of Mr. and Mrs. Joseph P. Teti, Triangle

CHAPTER 10

We've Come This Far

Sunbeams warmed the dark pavement of city streets as children frolicked in flip-flops on the sidewalks in front of their houses. The chirping of the birds went uninterrupted even as cars darted through the Trenton streets. Inside the place known as Studio 101, Tom sat quietly on this summer day. He was sketching an urban scene as formal-sounding voices from the television in the next room drifted into the studio. The musty air was heavy with the scent of paint but a rusty fan circulated the air to at least provide a little coolness.

Meanwhile, Tom's brother Frank was relaxing in the adjoining living room, being briefed on current events by the local television news and simultaneously reading the newspaper. As Tom stopped sketching and began to talk, he confided that both he and Frank are often worried. Like other men in a portrait of the life of American senior citizens, the Malloy brothers represent a generation. They both appreciate the progress the world has made, feel uncertain about the years to come, and ultimately try to live the best life they can.

This chapter is about Tom's views on life today, as a person who has witnessed much of history and who can provide insight into years to come. Tom's impressions of today's world may especially resonate with other older Americans who share his concerns, hopes, fears and dreams.

NEW TRAGEDY BRINGS FURTHER DEVOTION AND KINDNESS

Tom's wife Dorothy was a chief influence on his already benevolent attitude and she remains an exemplary model guiding his moral choices today. Tom constantly praises the way that Dorothy treated others and devoted time to those in need. Dorothy died of cancer in 1990 after Tom had watched her go through intense pain.[1]

"Seeing my wife's suffering touched me. She was always a very good nurse," Tom recalls with eyes gently closed. Tom's sadness about the death of his wife is apparent when he speaks of her illness. He continues to follow her lead as a moral, generous person.

PONDERING MORALITY AND FAMILY TODAY

While Tom follows Dorothy's example and remains an avid churchgoer, he is astounded by the changes he sees in behavior in society at large. He freely shares his opinions about our moral state:

For example, young women today appear to think with their sexuality. They often think their sexuality will bring them everything they want in life, and the next thing you know, they're too far in to get out.

Although Tom believes that "a virtuous woman is always hard to find," he remains convinced that "the greatest gift God gave man is a woman" due to Dorothy's influence on his life. Tom is therefore grateful for what he calls the gradual American "rediscovery of traditional values." He explains, "Women are rediscovering good home cooking with cookbooks after so long being into the age of TV dinner."

Tom is quick to note the undying merits of female leadership and the special struggles of black women throughout the ages. "The black woman is the most marvelous," he raves. "Children are always attracted to her because of her many sacrifices. Throughout my life I had good women caring for me and I loved these women."

In all things, Tom's faith helps him stay patient when acquaintances treat him unfairly. He believes that morality is a constant struggle for everyone. "Let me tell you," Tom begins, "we are two-sided people—every one of us. And often you're dealing with the evil side! None of us are perfect! There's a side of you that if certain things happen, you are gonna show that other side! It's human nature. And often it comes to you as a shock. [You may say] 'What have I done to get this kind of retaliation? I've been as nice as I possibly could. I thought you were my friend…a person who cared and understood me!'" Tom recognizes that frailties of character are in us all, and he does not let that realization keep him from seeing the good in himself and others.

TOM'S HOPES FOR THE BLACK COMMUNITY

Surviving both the old sharecropping south and the civil rights movement has given Tom a valuable view of the black community in the 21st century. "The civil rights movement is yet to accomplish its job, but it certainly has made improvements," he suggests. Tom is disheartened that "young black males involved in crime don't realize the struggle was made to give them all these opportunities." He also confesses that although the black community has come extremely far in a short period of history, it has lost certain valuable treasures in the new, modern way of life.

"In a segregated system," Tom reminisces, "blacks had a forum to talk about outstanding black issues with outstanding black leaders without concern about others' opinions." He similarly resents "whites

coming into our black neighborhoods to buy drugs," and he witnessed the drug war's beginnings in Trenton after World War II.

"I am concerned with the matter of us coming together as one race," he admits. "I know there's no utopia since man is a sinner by nature, but I hope blacks can unite as a group when trouble arises."

A NEW VISION OF BLACK LEADERSHIP AND ACTIVISM

When asked who he considers to be the most influential black leader today, Tom pauses then responds. "I can't say. . . .But a very promising leader now is Colin Powell. He understands blacks and their needs."

Certainly, Powell's unconfrontational style of black leadership resonates with Tom, who was also unconfrontational in the civil rights era, despite being an active, strong supporter of social justice. Tom recognizes that black activism must reach a more mature level and "play by the system now," as he previously did. "It has to be more subtle action, involvement and profound thinking," he explains.

SEEKING TO HELP TODAY'S YOUTH

Issues such as high school dropout rates and the value of American schools also concern Tom deeply. Tom feels that the educational system has become corrupted in many ways, despite the advances in technology and national prosperity.

"When I came out of Trenton High School, you had a college preparatory education. Students were more well-rounded and refined," he asserts. While Tom learned Latin and other challenging subjects in public schools, he alleges that "educational levels have gone down now" and that the opposite of his school experience is all too common.

"When I was on the Advisory Board of Mercer County College, a man was saying to us 'Go back and tell those high schools to start teaching their children reading and math!' But we don't have time to be teaching them remedial skills!" Tom exclaims. Tom also hopes the direction of teaching will change. He remembers his days as an art teacher in Trenton and notes: "I'm not versus unions, but unions have no business in education. If they consent to teach, unions should not be in the picture." Tom feels that the common threat of "no contract, no school" is detrimental to the philosophy of universal education. "There's something wrong there. The sole mission is to teach," he asserts. Today's parents also strike Tom as particularly inactive in their children's educations, unlike his grandmother Ida. He recalls, "When I was in high school, fortunately, I had family that made sure I was ready." "Now, families waste quality time which could be spent on reading together or helping children prepare their homework. It's partly because of television. That's the damnation!" he says. In Tom's view, students are also to blame, however. "Last [September] when schools opened, there was a plot to raise hell on the part of the students," he alleges. Tom is referring to several students' efforts to fight and create chaos at Trenton High School that year, which resulted in low student morale among more promising students and suspicion among administrators. "Half of Trenton's police were there on the first day of school," he recalls. Lastly, Tom recognizes that the changing economy and society may also be causing the troubles of today's unprepared students. Like many older Americans, he remembers a time when the job market was different, and when a person's education was not as important as strength and work ethic. While "a lot of blacks were not prepared for college after Trenton High School" in Tom's day, he points out that they "had the option of going down South" to work or "would be working on city buildings for at least two or three years." Yet with industrial jobs dwindling today, Tom notes that "sons can't go out and just dig a ditch if they have little education." The failure to educate every student is therefore a complex problem. Tom hopes that American schools will improve so that American students will also have a chance in the high-skilled jobs that workers "coming from India" and other countries now gain easily. While he is glad America is growing more diverse, Tom is sad that so many American students are unable to fulfill the positions in companies that come from their own communities.

POLITICS, WAR, AND TERRORISM

Like many Americans, Tom's understanding of the world has sharpened and expanded since national politics took a new direction and since terrorism hit home with unprecedented vigor.

Tom was shocked at the problems America encountered with the election of 2000 and remarks, "The Supreme Court said 'It's time to stop this!' For the first time the Supreme Court had to step in and decide who would be president."

The tragedy of September 11, 2001, also had a deep impact on Tom, and he was saddened by the resulting deaths and the financial dilemma the attacks caused. "September 11th changed this nation forever," he begins. "The terrorists took [away] the World Trade Center—the high technology we have, and the place where the money is supposed to be calculated."

In addition to feeling tormented by the results of terrorism, Tom is frustrated at America's inability to predict the attacks of September 11th. "What makes us so angry is this is a bright country with the Internet and everything and we did not see it coming! We were supposed to [be able to] see them [the terrorists] breathing! If you were president of the United States you'd be in a hell of a fix!"

Despite his outrage at what happened on September 11th, Tom's pacifism remains a cornerstone of his faith. He refuses to view war in Iraq or anywhere else as a sound approach to terrorism in the United States or abroad. Even before the Iraq war, Tom asserted:

"Never in the history of nations have I seen something like what's going on with Iraq. No-fly zones. . .Like you'd have to go down to Florida to fly from here. Saddam Hussein got in after Ayatollah and drove him out of power. We allowed the same man to get into war with Iran and a million men.

> No war has ever solved anything. Even [General William T.] Sherman who was instrumental in bringing the Civil War to end said, 'War is hell.' The president has tried to take other actions but next month [February 2003] there's gonna be something. The inspectors will determine it. They're reporting to the United Nations. Bin Laden hiding. . . .Saddam [causing problems, as well]. . . .It's really pathetic and tragic.

> Our church used to go to the U.N. every year. If we could reach a point right now where there could be pacifism! But people have too much invested in war, oil. . . . Too many people have their money and their fortunes invested in war. Bush said, 'We're gonna put the oil of Iraq in trust for the Iraqi people,' but it's a racket! Those people are gonna end up dead.

Tom's Musings, Written "At the End of the [19]70s"

"Exciting, in[]spite of tensions and uncertainties, something meaningful is taking place[.]

Old systems of exploitation and oppression are ending; new systems of justice and equality are being born. Martin L. King, said this new way of betterment makes the future encouraging and hopeful.

In[]spite of life's difficulties, and uncertainties, cris[es are] filled with dangers. These very dangers, present opportunities for service [which] lead ultimately to human betterment.

The crisis of today can le[a]d to either human salvation or human doom.

This world is one of mass confusion, inspite of high tech and massive resources to make us better informed, thereby able to solve the common problems that plague all of us."

Never afraid to express his opinion or to analyze the complex issues of the day, Tom Malloy is a source of strength and faith for those who know him. Ripe of mind and quick to laugh, storytell, and inform, Tom is the ideal granddad for anyone astute enough to value his opinion and time. While some older Americans have given in to a life of relaxation, Tom constantly challenges himself by painting and aggressively following and debating the news.

Tom's views on the world today reveal that he has both pride and concern. The clarity of his mind and perspective reminds us that older Americans can always be engaged in public life. Tom is proof that older Americans' ideas and input should never be excluded by others

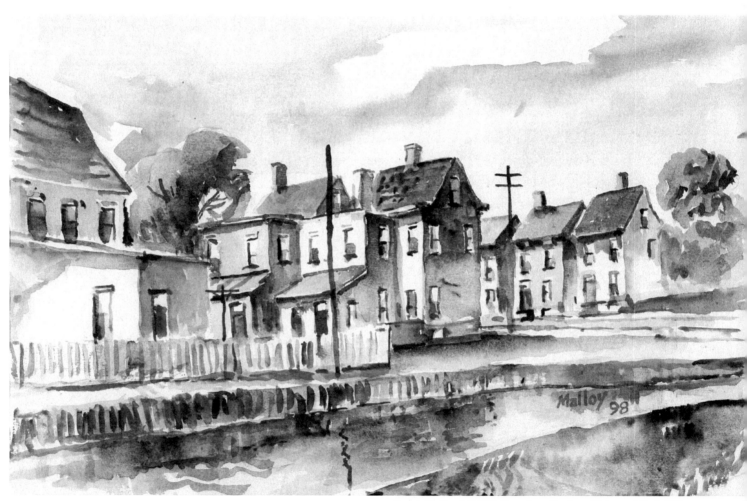

Passaic St. Canal, (1998), from the collection of Brian and Linda Hill

Baltimore Harbor, (1980), from the collection of Kathi and Fred Bedard

CHAPTER 11

An Artistic Legacy

Footsteps echo down the stately marble halls of the great museum. A group of children is accompanied by their teacher into the room where the watercolors of Thomas Malloy are displayed. The children are excited at the chance to tour the museum and see "real watercolors." For they have been practicing watercolors themselves in art class—albeit with some trouble and unexpected spills—for several weeks now.

As she explains the difficult technique in which colors are blended together to create a scene on paper, the teacher smiles. The students' gaze shifts from the teacher's expectant face to the myriad paintings of landscapes, cityscapes, and other scenes. The students gape at the paintings and some smile as they whisper to their neighbor which one is their favorite.

Several children are especially touched as their teacher recounts the story of how Mr. Malloy waited until he was over forty years old to embark upon an art career. "Forty! That's older than mommy and daddy!" they think to themselves. Some students think to themselves that they would like to begin an art career sooner than that. And their minds begin to soar, imagining the life of people in the worlds depicted in Malloy's many artworks.

Other students not inclined to study watercolors a minute longer in art class are still amazed and think to themselves, "Well, I guess you can figure out what you want to be when you grow up even when you are old!" The teacher turns and walks among the paintings herself, letting the children roam the room freely before gathering them to tour the next room.

It is my hope that this scene will recur throughout the years in New Jersey and other museums long after Tom Malloy ceases to walk Trenton's streets. He is surely deserving of a true legacy and has spoken about the issue candidly.

HOPE FOR LOCAL TALENT AND OTHER BLACK ARTISTS

Tom does not hesitate to express his hopes for his legacy. "I'd like to be remembered as a person who had a vision beyond his time that can inspire even the youngest person," he admits. To assist budding artists and share his experiences, Tom works with community groups and schools from time to time.

In 1999, Tom served as a judge in an "ideal neighborhoods" children's art contest sponsored by Isles and Artworks at the Urban Word Café in Trenton. This contest encouraged children to depict their hopes and dreams for their neighborhoods, and Tom was thrilled to lend a hand and a well-trained eye. Hoping that today's youth will one day paint Trentonian cityscapes as he does, Tom told a reporter in 1999, "it is interesting that these children are thinking so much about the naturalness of the city and what is right.[1]

In 2004, the Passage Theatre in Trenton also invited Tom to collaborate with them and the children there because the theatre's director, June Ballinger, felt that Tom was such an inspiration to her.[2] Tom immensely enjoyed working with the theatre and seeing the Trenton art teachers and young artists who knew him. Tom has additionally worked with children's art programs in many of Trenton's elementary schools.

Tom has a wealth of advice and hope for young artists. He suggests, "If you want to really be in art, don't hide your work." He recommends that young artists go to "local shows" and seek as much exposure as possible.

Recalling his own rough start, Tom describes the unsteady nature of art salesmanship, urging amateurs not to become discouraged. "You go to a fair in Princeton, get no action, but people may pick up a card. It's like that for ten shows, but then all of a sudden people may buy! It's like prospecting for gold!" Tom is frank about his opinions regarding Trentonian black artists today. Feeling that there is a wealth of talent, he vents his anguish about the reluctance of black artists to seek instruction and exposure. He is troubled that Mercer County College professors often direct black artists to his studio because he feels that such students need multiracial exposure and that he alone may not be the answer to their search.

"These educators think they don't have the ability to reach these artists the way a black mentor could, even with their degrees," Tom explains. While highly flattered to receive the students, Tom notes that most are thus isolated from the mainstream.

MAINTAINING HUMILITY AND PATIENCE

Tom also admits that many students arrive at Studio 101 with a cockiness that will not serve them in the art world. "Some think 'I want to show you what I can do!'" he exclaims! Yet Tom feels all artists need the patience to learn artistic skill.

"One fellow thought he was ready for the Louvre!" Tom reminisces with a deep chuckle and a gentle tap of his oakwood cane. "He felt that because he was black, he'd received no recognition. I told him that might be true, but also what was right and wrong about his work."

Similar to several young artists Tom has met, this student still lacked certain abilities that he would need to progress in his study of art. "I told him he had good organization of space and objects, but he didn't understand human anatomy! The arms on his people in the pictures were not correctly connected to their bodies!" Tom recognized that there was great "potential" and only a "small barrier" keeping his student from better work. He recommended that the gentleman study an anatomy book to learn how to best represent the human form in his art, and he volunteered to help him further. The young man never returned, however. When asked if he has ever had a young black artist who has studied under him as a constant pupil, Tom responds, "I am yet to have my first." Several other students have since come, only to disappear soon after. "One guy left all his materials here, saying, I'll be back' but never showed up again. Some hear I charge $10.00 an hour for teaching and decide not to come," Tom explains. "Yet I've taught a number of white people, large groups of black children, and schools whose artists go on to improve their work." Tom hopes that young black artists will similarly seek mentors and persevere in their learning. "These students pique my interest in their work, but opportunity knocks but once," Tom sighs. Tom is sad at the continual disappointment—black students not returning, or vowing to arrive for a meeting, only to never show up. He fears the artists who might have benefited from his tutelage have retreated into obscurity or decided to relinquish their goals, but he prays that they will continue to cultivate their dreams.

"Not to develop this potential" is unfortunate, in Tom's opinion. He proclaims, "A mind is a terrible thing to waste," quoting the United Negro College Fund's motto.

While Tom finds that many prospective students "don't want to pay the price for the effort and work," he himself knows the value of hard work in a lifetime. "People who get things cheap don't appreciate the value," he chides.

AND THE ACCOLADES KEEP ROLLING IN

No longer an obscure artist who sells paintings by the shore, Tom is now the recipient of over sixty prizes and awards.[3]

In addition to his aforementioned recognition by the Jersey Arts Council and his honorary doctorate of fine arts from Rider University, Tom has earned other honors. Trenton Mayor Douglas H. Palmer named Tom Artist Laureate of Trenton in November 2001.[4] City leaders Jim Carlucci and Bea Scala-Fischler helped recognize Tom's art in Trenton throughout the years, and Francis E. Blanco of the Department of Recreation, Natural Resources and Culture for the City of Trenton helped bring about the Artist Laureate commendation. A formal celebration of the honor was held at Trenton's Ellarslie Mansion on January 19, 2002, in conjunction with a reception for the New Hope/Lambertville arts organization Artsbridge.[5]

Tom notes that as the special honoree, he had a room in the city museum named after him. Tom has also received awards from the sororities Alpha Kappa Alpha and Delta Sigma Theta,[6] from the Trenton Chamber of Commerce, and from the Merchants Association. His paintings are displayed prominently at Trenton's City Hall, at the Roebling Complex in Trenton, and at the Lafayette Yard Mariott hotel in Trenton.

Tom was also appointed to Trenton's Landmarks Commission for Historic Preservation by the late Mayor Arthur Holland, and he was Holland's friend and artistic advisor.[7] He served as a trustee of the Trenton Historical Society[8] and was featured in a New Jersey Network TV segment entitled *Grey Eminence,* which highlighted the work of older artists on November 19, 2004.[9] On February 27, 2005, Tom was also awarded the S. Howard Woodson, Jr. Lifetime Achievement Award in a ceremony at the Hedgepeth-Williams Middle School in Trenton. Cordelia Staton and Andrew Bobbitt of the Trenton Recreation Department helped award Tom that considerable honor.

Tom is a member of the Garden State Watercolor Society, the National League of Professional Artists, the Trenton Artists Workshop Association, Artworks, Artist Equity National, the Morrisville Art Group, the Princeton Art Association, the Trenton Arts Commission, the Art and Humanities Committee of the New Jersey Bicentennial Commission, the Capital Health System Art Committee at Mercer (founding member), and the Trenton Museum Society. He was also a founding member of the Arts Commission that renovated the Ellarslie Mansion to make it the Ellarslie Mansion.[10]

Through all the accolades, Tom prays that he will stay focused on art and not retreat into a life consumed by fame or money as the years go by. "It is easy to lose sight and perspective," he asserts. "Others give in

to money and forget their first gift when being a commercial artist. I try not to do that."

Today Tom Malloy paintings adorn countless homes, bank halls, government buildings, and corporate offices.[11] This proves that Tom's legacy will indeed last a long while.

If Frankie Malloy, Ida Malloy, Tom Malloy Senior, and shoutin' Easter Farley could all see Tom Malloy Junior now, it is certain they would all embrace his career and achievements with joy and pride. One can imagine a hearty celebration back in Dillon, South Carolina, celebrating the fame of that city's native son who has since also claimed Trenton as a home city.

Tom's relatives had lived their lives the best way they knew how and instilled in Tom the virtues that would guide him through a colorful, expansive lifetime. Despite the fact that Tom was raised at a time when art careers were generally looked down upon, Tom has risen to fame, inspired countless individuals, and stayed as God-fearing and kind as his deceased relatives.

Tom's legacy is evolving and is destined to be great. Today he has a host of relatives, including Frank Malloy Jr., Frank's son; Frank Jr.'s wife Cathy Reeves-Malloy; Rosa Walker, James' wife; Ida, Mary, and Jane, James' daughters; and the myriad grandchildren of Frank and James. Tom's artistic and human legacy will certainly provide hope to generations of Trentonians and others.

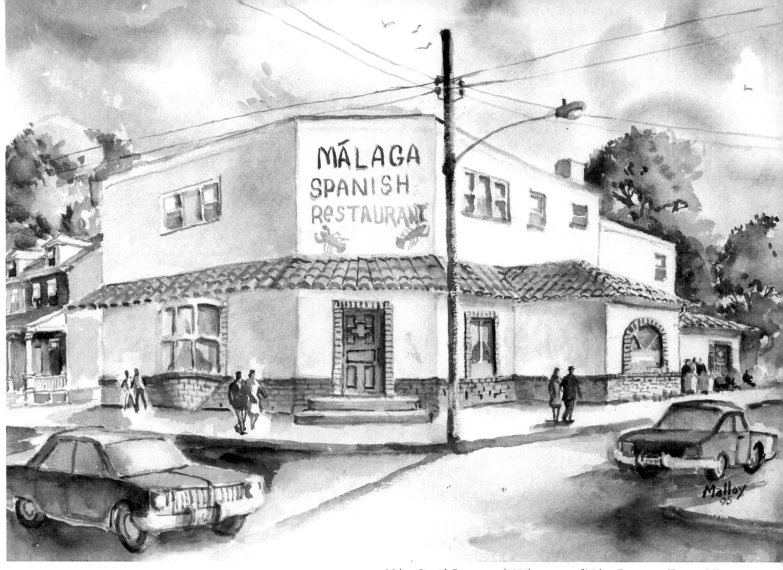

Malaga Spanish Restaurant, (1995), courtesy of Malaga Restaurant, Trenton, NJ

Covered Bridge (Stockton), from the collection of Charles H. Smith

CHAPTER 12

The Ever-Blending, Unfading Colors of Life

Sunlight streams through Tom Malloy's large window in his apartment at the Pellittieri Senior Citizens' Housing complex. The sun's rays create warm, comforting shadows that dance off of an overstuffed bookcase and the paintings and sketches strewn across couches, bureaus, and chairs.

Tom himself sits with folded, creased hands as he reads his daily paper. His cat Calico romps beneath the drafts of myriad paintings as charcoals and watercolor paint sets dot the main room.

Although Tom's remarkable life has painted rich colors upon the canvas of time and history for over ninety years, the colors refuse to fade. Instead, new shades of love, learning, and opportunity enter into Tom's view. They help Tom to impact history's canvas further, and Tom Malloy—and his watercolor life—paint on.

A COLORFUL MIND BUT A MORE PEACEFUL LIFE

At age ninety-three, Tom Malloy is still quoting Socrates, Paul, Robeson, and Revolutionary War History. He admits that he is amazed at "the mind's capacity." A constant student and avid reader, his most recent favorite book is *The Greatest Miracle.* Although he underwent major surgery in 1988,[1] Tom remains in considerably good health in his early nineties.

One reason for Tom's uncanny mental alertness at such a late age may be his continued willingness to learn and grow. His longtime mentee Larry Hilton remarks, "Tom has such a thirst for knowledge—history, art, and education. He even asked me to bring over a computer to teach him how to use it."[2]

In his successful attempts to keep in touch with the rapidly changing world, Tom learns about new styles of fashion. He tracks various struggles around the world through a plethora of newspapers and magazines that flood his home.

Tom keeps abreast of current music, as well. He feels that "most rap music puts women down and that much current music "doesn't purify your soul" like it should. When I ask how familiar he truly is with current music, he jokingly chides, "How can I miss it? I hear it outside my door every morning!" Tom enjoys solitude at this late age. He muses, "I like to be alone at times. My studio is my quiet place." After helping Tom develop his career, Tom's brother Frank resided with him on Garfield Avenue until his death on July 21, 2002.[3]

Now, Tom fills his days with television and painting. He watches mostly educational and public television, and The History Channel is a favorite. Tom feels that "no one in their right mind would take seriously" many other televisions shows today. He is comfortable both with his success and with his own company since Dorothy's and Frank's deaths. He points out that "it's a lonely road, the higher you go."

Tom still relishes his role as a perpetual teacher, however. "I have to share my knowledge but many others offer nothing," he explains. Tom feels that his need to lecture at length often alienates him, but that it is something that comes naturally to him. "I've always liked to give. Not money, but knowledge," he smiles.

OLDER ISN'T ALWAYS BETTER

Tom admits that as he gets older, "people feel threatened to invite him into situations." He thinks this has happened because he tends to speak at length about stories of the past, in a preachy way. He confesses that many "Johnny come latelies" in his church say "Don't let him say a word!" when he gets up to testify about the goodness of God. Tom knows that some people dread that he will speak for long periods of time.

Yet Tom's gift for long and abstract speeches still bring him praise and advantages. He has numerous friends and family members who call daily just to hear his stories. Tom enjoys outings with these loved ones. In August of 2000 he was particularly excited, and he boasted, "My neighbors are taking me to Atlantic City as a gift for my eighty-eighth birthday!"

Though Tom delights in life as a vibrant elderly person, he does share the same fears and frustrations that all older Americans face. "Sometimes arthritic pains take over and my memory goes," he sighs. "I don't know what will be my life when it takes over with pain fully." In August 2003, Tom shared the story of a recent trip he had to the hospital and admitted that his health may be slowly catching up to his age:

> I just celebrated my birthday. I'm now ninety-one years old. I went to the hospital for my heartbeat. Something within me tells me when things aren't working right. I woke up one morning and said 'Something's wrong up here.' [He places a hand on his chest] [My nephew Frankie] said there wasn't anything to do but call 911. Unlike many men, I'm one of those men that listens. I have sixteen medications. Before the day is over I have four more.

While he feels blessed to live in his neighborhood, Tom recognizes the dangers facing him as an elderly person. "Old people get robbed

and beaten every day," he notes seriously. Tom also speaks candidly about his waning patience. "Certain things I can't tolerate anymore. The noise of children I can still tolerate. But I can't tolerate the inability of people to show basic respect." The use of crack cocaine and the bad attitudes of many people that Tom sees sadden him more as he grows older.

SAVORING THE COLOR OF LIFE'S LESSONS

Tom Malloy's various careers, encounters, family members, friends, mentors, and mentees have given him the tools to age with grace and happiness. He asserts while beaming, "My dear, I've had—for a black man [that] lived on the wrong side of the tracks—an exposure and an unusual life! Each person I met enhanced my life and gave me something I didn't have before."

> *Tom is extremely grateful for such diverse life opportunities and is pleased with his success. He speaks of his joy with sparkling tears in his eyes and a dashing smile upon his dark, trembling lips:*
> *"This world is amazing. And all of my god-given gifts I had and could use in a way unwasted. I lived long enough to see and express myself creatively. . .Inspiring and enriching others."*

DESPITE THE MANY MEANINGFUL MOMENTS IN THE JOURNEY OF THE WRITING OF THIS TEXT, I AM MOST MOVED TO RETURN TO MY THOUGHTS DURING TOM'S EIGHTY-NINTH BIRTHDAY CELEBRATION. THOSE MEMORIES COMPLETE THIS BOOK, AS THE *AFTERWORD*.

AFTERWORD

Written on August 25, 2001—the day of Thomas Malloy's eighty-ninth birthday celebration at Triangle Art Center

Returning from the festive celebration of Tom Malloy's 89th birthday at Triangle Art Center in Lawrenceville, NJ, I am proud and grateful. Proud that the New Jersey and Pennsylvania communities are increasingly aware of Tom Malloy's talents and accomplishments, and grateful to Tom for his humility, which can teach us all so much.

What struck me the most about Tom's birthday celebration is that although the crowd consisted of about 150 noted artists, educators, business professionals, dignitaries, admirers, children, and other acquaintances, each and every person considered themselves to be Tom's friend.

Many of the guests are members of the Trenton Artists Workshop Association and similar organizations. In a world where fame and achievement can bring instant publicity and cause egos to soar, Tom remains as cordial and grounded as we all should strive to be.

Mingling among the handsomely adorned tables, I hear people boast of their closeness with Tom. "I used to see him just waiting for the bus and offer him a ride. I always told him, 'You shouldn't wait out here. People can give you a ride!'. . . He is so independent," one guest comments. Another guest adds, "He always used to come and talk to the children and teach them things about art." A neighbor and fellow artist at another table is reminiscing, "He used to come over and have sing-alongs with us. He's such a riot!"

It seems that everywhere Tom Malloy goes, he has spread love and makes others feel familiar with him. When Triangle's president and CEO Joe Teti mentions to the party's crowd that Tom's true birthday was earlier in the week, I was amazed at the response. His reminder is interrupted with a resounding chorus of "Mmmhmm—it's the 23rd"! I instantly realize that people cannot help but become interested in everything about this remarkable man.

When the birthday cake is cut, we sing, "Happy birthday dear Tom," and no one entertains the thought of calling him "Mr. Malloy." For an informality surrounds Tom although his career continues to bring him more honors and success.

As more and more people learn of Tom Malloy's art, they join what he today called "a revival of culture in Trenton," which was once allegedly coined a "cultural desert." I am elated that the community around Tom has continued this revival by buying his work, and even more glad that many people have been well aware of his gifts for a long time.

It is my hope that we can continue to acknowledge the edification that he has given our city landmarks, neighborhoods, and home collections as the years go on. Tonight he was awarded the first Lifetime Achievement Award from the Garden State Watercolor Society, and he deserves it for numerous reasons.

Tom brings living proof that our communities are still brimming with culture and, more importantly, with a sense of kinship that will remain wherever and whenever Malloy watercolors exist. As Tom lifted a proud, creased face towards the bright lights before him after two hours of hand-shaking and seeing old friends, he thanked others for his success during his acceptance speech.

Autumn, courtesy of Mr. and Mrs. Joseph P. Teti, Triangle

NOTES

INTRODUCTION

1. *Encyclopedia Americana,* Vol 28. Danbury, CT: Grolier Educational Corporation, 2002, 461a. Also consulted: *World Book Encyclopedia.* Vol. 15. Chicago: World Book, Inc., 2002, 39; Jane Turner, *The Dictionary of Art,* Vol 32. London and New York: MacMillan, 1996; Marilyn Stokstad, *Art History,* Vol II. Upper Saddle River, NJ and New York: Prentice Hall and Harry Abrams, Inc., 1995; *The Encyclopedia of Visual Art.* Vol 10. Danbury, CT: Grolier Educational Corporation, 1985; Kimberly Reynolds with Richard Seddon, *The Illustrated Dictionary of Art Terms.* New York: Peter Bedrick Books, 1981.

CHAPTER 1: BEGINNINGS

1. The preliminary Emancipation Proclamation was signed by U.S. President Abraham Lincoln in January 1863. This document declared that all persons held as slaves within any state should be freed. The final proclamation was printed and signed by Lincoln in June 1864. Courtesy of Historical Documents-Emancipation Proclamation-African America Narrative-Resource Bank-Teachers Guide: WGBH/PBS Online.

2. The sharecropping system began as the American plantation system waned after the Civil War. Plantations had been very large farms with twenty or more slaves where crops like cotton, rice, and tobacco were harvested. The plantation system collapsed as former slaves refused to work in gangs or to accept labor discipline, and the land was then divided into small sharecropper farms.

 The owners of the farms wanted a docile labor force and the freed people (former slaves) were turned into wage laborers. Landowners refused to sell the land to former slaves and only agreed to permit them to farm independent plots of land, paying them a share of the crop at the end of the year. The landowners continued to own the land, tools, and crops; the share became the equivalent of a wage. The former slaves owed money at the end of the year to the landowners and local storekeepers and therefore were kept in a form of debt peonage. The sharecropping system lasted about a half century. Once plantations converted to mechanized operation, hundreds of thousands of former sharecroppers migrated to cities. The new machine-intensive plantation environment lasted until 1960 in the South. (See Robert William Fogel, *Without Consent or Contract: The Rise and Fall of American Slavery* (1989); and Gavin Wright, *Old South, New South Revolutions in the Southern Economy since the Civil War* (1986). Tom's recollections about the share-cropping system around Dillon, SC, are corroborated by the stories of elderly members of the Dillon community, such as Mrs. Ruby Carter, who was interviewed by the author on May 12, 2005. Among the recollections shared were memories of often being shortchanged by landowners in the system; memories of discouragement of education for black children; memories of entire families working the land together to make ends meet; memories of separate public and private facilities for blacks, whites, and Indians; and memories of family time spent storytelling or gathering around a rare battery-operated radio if one could be afforded.

3. At the SC Archives, 1920 Census records show an entry for the Maloy [Sic.] family with the family members Tom, Sr. (age 31), Frankey [Sic.] (age 26), Tom, Jr. (age 7), John (age 6), James (age 4), and Frank (age 2) on Reel 574, E.D. 32, Sheet 18, Line 76.

4. Booker T. Washington was born a slave in 1856 but later helped the Tuskegee Institute in Alabama to become one of the leading facilities for black education in the United States. A number of presidents, as well as business leaders, relied on Washington as an advisor, but some black intellectuals and leaders, notably W.E.B. DuBois, opposed Washington's message of political accommodation in favor of economic progress. Washington died in 1915. See web site of the Corcoran Department of History at the University of Virginia at http://www.virginia.edu/history/courses/fall.97/hius323/btw.html.

 Dr. Irving Garland Penn was the editor of *The Laborer,* a small African American newspaper. He received good criticism from the white press and was able to gain support from many high-profile benefactors. Penn served the Methodist Episcopal Church throughout his life and spoke often to mend the rift between the North and South that was caused by the slavery issue. See Joanne K. Harrison, and Grant Harrison, *The Life and Times of Irving Garland Penn,* Philadelphia: Xlibris, c2000. p.412i).

 Charlotte Hawkins Brown dedicated herself to improving the status and quality of life for black U.S. citizens. She became nationally recognized and respected for forming preparatory schools. She was well known as a lecturer, religious leader, and educator. Brown received several honorary degrees, and her associates were W.E.B. DuBois, Eleanor Roosevelt, and Booker T. Washington. Courtesy of the Website of the Charlotte Hawkins Brown Historical Foundation, Inc. found at http://statelibrary.dcr.state.nc/us/nc/bio/afro/brown.htm.

 Walter Francis White was a civil rights leader who served the NAACP from 1929 until his death in 1955. He was fair-skinned and

blue-eyed and could have been comfortable within the white community, yet he devoted his life to helping to gain equality for blacks. White wrote several books including two novels, *Fire in the Flint*, New York: Alfred A. Knopf, 1924, and *Flight*, 1926; works of nonfiction, *Rope and Faggot*, New York, Arno Press, 1969, and *How Far to the Promised Land?* (1955); and an autobiography, *A Man Called White* (1948). See http://www.hometoharlem.com/Harlem/hthcult.nsf/notables/walterfranciswhite).

Mary McLeod Bethune was born in 1875 and founded the Daytona Normal and Industrial Institute for Negro Girls (now Bethune-Cookman College) in 1904. She was a leader in the black women's club movement, president of the National Association of Colored Women, director of Negro Affairs in the National Youth Administration, consultant to the U.S. Secretary of War, consultant to the charter conference of the UN, founder of the National Council of Negro Women, and vice-president of the NAACP. Bethune was awarded numerous international awards and died in 1955. Bethune's brother-in-law, whom Tom speaks of, remains unidentified.

5. Tom remembers that the Hamilton family was headed by a man named Bud Hamilton. At the South Carolina Archives, the 1920 census records for South Carolina have several Bud Hamiltons (Reel 498, Census E.D. 156, Sheet 10, Line 45 and Census E.D. 96, Sheet 13, Line 16) but none of them were registered in Dillon County. Bud may have been a nickname for a name of which Tom is not aware.

6. At the SC Archives, 1920 census records state that there was a Thomas A. Dillon family on Reel 574, Census E.D. 33, Sheet 3, Line 82. *The History of Dillon County, SC* by Durward T. Stokes— Columbia: Univ. of South Carolina Press, 1978—also discusses the history of Dillon and Thomas A. Dillon's important role. James W. Dillon entered the mercantile business in 1853, and he and his son Thomas A. Dillon obtained options on land in Dillon and deeded half of the land interest to the Florence Railroad Co., creating Dillon, SC (p. 124). Thomas A. Dillon was president of People's Bank of Dillon, a director of the Dillon Chamber of Commerce, and a charter member of the Main Street United Methodist Church (pp. 127, 134, and 203-204).

7. At the SC Archives, 1920 census records reveal that there was a Frank Nance in Dillon (Reel 525, Census E.D. 21, Sheet 15, Line 80), a Roy V. Nuntz (Reel 525, Census E.D. 77, Sheet 27, Line 56), a William E. Nantz (Reel 525, Census E.D. 119, Sheet 20, Line 12), and a D.F. Nantz (Reel 525, E.D. 86, Sheet 15, Line 83). Tom is uncertain of the spelling of the last name of this family, and the family's head may have been registered under a different first name, so any one of these records may have represented the family of which Tom speaks.

8. The Tuskegee Institute is a major social, political, and economic school for African Americans. It was established by the State of Alabama in order to educate newly freed blacks and their children at the close of slavery. The school opened on July 4, 1881, under the auspices of the African Methodist Episcopal Zion Church. Booker T. Washington was the first principal. The school gained world status with teachers such as George Washington Carver and Robert Taylor. In 1974 the site became a National Historic Site as part of the National Park System. Courtesy of the National Park System web site at http://www.nps.gov/tuin/.

For a discussion of the divergent views of Booker T. Washington and W.E.B. DuBois on the role of institutions like Tuskegee, see PBS Online at http://www.pbs.org/wgbh/pages/frontline/shows/race/etc/road.html).

9. An interview with James C. Crawford of Dillon, SC confirmed that this school was called the Dillon Colored School and that the original school building still stands at the site of Maple Junior High School at 901 9th Avenue in Dillon. Crawford himself entered the school around 1925. Most institutions for black children in Dillon County around the time when Tom Malloy was a child were one-teacher schools, and there was $11,500 in property valuation of black schools around 1910. *The Herald*, May 10, 1923. See also William C. Lee. *Dillon (SC) County Schools*, 2001 (a university project catalogued in the Dillon Public Library).

10. This song was written in 1932, which would make Tom 20 years old at the time the song came out. Courtesy of The History of Santa Claus web site: http://www.geocities.com/~perkinshome/history.html. The song was written by Haven Gillespie and J. Fred Coots. Courtesy of the Central Valley Christian School Christmas 2004 web page: http://www.cvc.org/christmas/santaclausiscomingtotown/).

11. Saint Stephen's Methodist Church is located on West Jackson Street in Dillon, SC. The original building was a white, wooden structure on First Avenue, which has since been replaced by the red brick building on West Jackson Street. Interview with Jas. F. Davis, May 13, 2005; and Durward T. Stokes, *The History of Dillon County, SC*, p. 277.

A May 13, 2005, interview with Isabella Davis (a delightful, 102-year-old resident of Dillon) revealed that Saint Stephen's is still a flourishing church that has changed significantly throughout the ages and continues to provide service to the community.

12. Kelly Warboys, "Trenton Artist Receives Lifetime Achievement Award," *The Trenton Times*, Sunday, August 26, 2001, sec. #3.

1. Great Negro Migration was an exodus of hundreds of thousands of black Americans from the rural South to cities throughout the United States during the 1920s and early 1930s.

2. An exhaustive search was conducted to verify the existence of a steam boat called *Queen Elizabeth II* that went from SC to GA. To date, further history of this boat has not been found.

3. In "Portrait of the Artist as an Older Man," *The Trentonian,* August 31, 1978, 45-46, Diane E. Dixon confirms that the Malloy family moved to Trenton in 1923.

4. Bill Dwyer, "Bygone Days with Bill Dwyer," *The Trentonian,* Sunday, December 11, 1977, states that Tom was "about 10 years old" when the family "came to Trenton around 1923." Cathy Viksjo, "City of Hope," *The Trenton Times,* May 15, 1998, Good Times section (sec. F) states that Tom "was 12" when his family "headed north to Trenton" but provides no date for the move; Anne Levin, "Trenton Honors Tom Malloy as Artist Laureate," *The Trenton Times,* January 17, 2002 states that "Malloy moved to Trenton in 1923."

5. The location of Escher School and New Lincoln School were confirmed by information in the Public School file in the Trentoniana collection at the Trenton Public Library. The Trentoniana card catalogue entry on Junior High School No. 5 says: " 'New Lincoln School' later named Junior #5, built 1923, addition added 1940." The *Trenton Board of Education Annual Report 1922-1924* (available in the Trentoniana) features Escher School in a list of schools on p. 50, "Table Showing Number of Pupils on Roll at the End of Each Month by Schools." Escher was reported to have 254 pupils in February 1924. New Lincoln School was reported to have 892 pupils in June 1924.

 The *Annual Report* says on p. 40 that "in March 1924 the New Lincoln School built for colored children was occupied. . .to accommodate all the elementary and junior high school grades with a capacity of approximately 1,100 pupils. The bond issues for the building and the equipment amounted to $690,000. . . contains. . . classrooms, an auditorium, swimming pool, cafeteria, library, shop and domestic science room. . . .enabled us to close the following small antiquated schools which had been occupied by colored pupils—Lincoln, Nixon, Escher, Livingston, —and of course enabled the pupils in those buildings who had been on a part time schedule to receive a full time day." The fact of Escher School's closing in 1924 is confirmed by the absence of the school's listing in Fitzgerald's City Directories after 1923.

 "Junior High Plan Entails Pupil Shifts," *Trenton Times,* May 25, 1945, no author, describes the plan to change the New Lincoln School from being a solely Negro school due to redistricting dictated by a 1944 "state supreme court holding that no pupil can be assigned to a school outside his or her district because of race, color or creed." All pupils living in the new Lincoln area were to be assigned to that school from then on, with some transfers possible but not if based upon race, color or creed." Also see Dwyer, "Bygone Days with Bill Dwyer," 25.

6. An unmarked new article in the "YMCA – Carver Center" file in the Trentoniana collection in the Trenton Public Library verified that Arthur T. Long was principal of New Lincoln School: "The initial step to correct the situation was taken when Arthur T. Long, first principal of the New Lincoln School, suggested the formation of an inter-racial committee" (to assist the plight of migrant newcomers to Trenton).

7. Viksjo, "City of Hope," F3; also see Dwyer, "Bygone Days with Bill Dwyer," 25.

8. Ibid, Dwyer.

9. Ibid.

10. Ibid.

11. See "A Prophet with a Palette: Dean of Trenton Arts Still Going Strong at 84." *The Trentonian,* January 22, 1997, 29.

12. Fitzgerald's Trenton Directory in 1929 (Fitzgerald Dir. Co. Publishers) confirms that the Salvation Army Hotel and the Salvation Army Social Center were at 512-518 Perry Street.

13. In the *Annual Report* cited in footnote 18 *supra,* there is a table listed as Table No. 9, from 1924 (no page). That table is entitled "Showing the Failures by Subjects in the Elementary Schools and the Percentage of Number of Failures in Each Subject is of the Total Number of Failures." The table lists school course offerings such as "reading, language, spelling, geography, history, civics, arithmetic, writing, *drawing,* music, phys. cult., science, hygiene, and sewing [author's emphasis]. The table thus reveals that art classes were on required curriculum back then.

14. Dwyer, "Bygone Days with Bill Dwyer," 25.

15. Ibid.

16. The 1937 *Bobashela* (yearbook of Trenton High School) states that Friebis Siegfried and Daphne Koenig taught basic principles of general and commercial art and the relation of art to industry. It also stated that "one of the main purposes of the art course is to develop art appreciation." Also see Ibid.

17. Viksjo, "City of Hope," F3; also see Cathy Viksjo, "Art, Life: Practicing What He Preaches," *The Trenton Times,* Sunday, February 19, 1989.

18. The Harlem Renaissance was originally known as "The Negro Movement." It was a period in which African American artistic expression became well known and more defined. In Harlem there was a tremendous outpouring of literature and other artistic work, as artistic blacks bonded and celebrated their brilliance. The period lasted from the

1920s into the 1930s and was known to be the height of African American writing. Black writers of the Harlem Renaissance wrote about life from a black viewpoint. W.E.B. DuBois became a great influence on the Renaissance as editor of The Crisis magazine, which continues to be in print. Other celebrated Harlem Renaissance figures include Countee Cullen, Langston Hughes, Zora Neal Hurston, Rudolph Fisher, and James Weldon Johnson. See Arna Bontemps, *The Harlem Renaissance Remembered*. New York: Dodd, Mead, 1972. Also see http://www.usc.edu/isd/archives/ethnicstudies/harlem.html.

19. Viksjo, "Art, Life: Practicing What He Preaches," CC6.

20. Dwyer, "Bygone Days with Bill Dwyer," 25.

21. Ibid.

22. An interview with Wendy Nardi at the Trentoniana section of the Trenton Public Library on March 23, 2005, confirmed the custom of ice cream vendors and other vendors wagons during this era.

23. Many articles on Trenton area boxing cite the boxing prowess of Jesse Goss around the early 1930s, which was coined the "Golden Age of Boxing" by later journalists. See "Bushy Has Own Ring Museum" (Jim Fitzsimmons, *Trentonian,* July 20, 1984, 27); "Brooks Plants Boxing Seed" (Ted Larve, *Trentonian's Neighbors Sunday,* September 28, 1982, 31); "Thirty Years Ago Today, Terry-Jones Bout Made Trenton Ring Capital: Trenton's Buzz-Saw Made Gallant Title Bid" (Randolph Linthurst, *Trenton Times,* April 26, 1962, 25). An untitled article in *American Jewish Life* (July 27, 1973, 22 & 27) describes Goss as "the forebear[er] of a local and national ring dynasty."

 News articles and interviews could not confirm or deny the particular account of the racial incident Tom mentions, but former boxer Roosevelt Butler (a.k.a. Van Butler) said on March 28, 2005: "I don't remember that but Jesse was my trainer for quite a few years. Maybe I have [information about the incident] but it slipped my mind. When I was coming up they would try to intimidate us with fans. Back in 1940 to 1945 I remember things that happened and they talk about out of towners coming in and they had to hide a [black] boxer under the ring [for protection] because [white] fans got rowdy. Things like that went on."

 An interview with Tommy Goss, son of Jesse Goss and proprietor of Goss & Goss Gold Medal Boxing Club, revealed no recollection of the incident, but Jesse had stopped fighting by the time Tommy was born.

24. The Great Depression was the longest and most severe economic downturn in U.S. history. Most historians agree that it began with the stock market crash of 1929 and lasted until the United States became involved with World War II. During the Depression, unemployment surged (as much as one-third of the population was unemployed at one time), the amount of labor output shrank, nearly half of commercial banks failed, and crop prices fell by over 50 percent. Tens of thousands of migrant farm workers roamed the United States looking for work, while homelessness, poverty, and general despair plagued the nation. (See Toys of Depression Era Greenbelt by Daniel Kapust at http://www.otal.umd.edu/~vg/msf95/ms10/project4.html; and *Encyclopedia Americana,* Danbury, CT: Scholastic Publishing, Inc., 1996.

25. The 1934 *Bobashela* shows that Alfred Neuschafer was "Instructor of Swimming."

CHAPTER 3: WHAT TRENTON MAKES

1. A 1934 *Bobashela* lists Tom among the seniors. Cathy Viksjo's "City of Hope" also states that Mr. Malloy graduated from Trenton Central High School in 1934.

2. Viksjo, "City of Hope," F3; idem, "Art, Life: Practicing What He Preaches," CC6.

3. The Anglican Episcopal Church has been important to Afrcian Americans. It linked American blacks with Anglicans in other parts of the world such as Africa and the Caribbean. The African American presence in North American Anglicanism has not been large, yet it has existed since the arrival of the first Africans in Virginia in 1619. A significant number of the most influential and important members of the black community were active in Episcopal churches. See Wade Clark Roof and William McKinney, *American Mainline Religion: Its Changing Shape and Future,* New Brunswick, N.J.: Rutgers University Press, c1987, pp. 142ff.; George F. Bragg, *History of the Afro-American Group in the Episcopal Church,* Baltimore: 1922; and Arthur Ben Chitty, *The Saints are Marching in: St Augustine's College,* New York: 1980.

4. The Trentoniana collection at the Trenton Public Library contains a file on the Carver Center / Trenton Colored YMCA that confirms Tom's account. "Trouble on Fowler Street" (Sally Lane, *Trenton Times,* Tuesday August 3, 1982) reads "built in the twenties, 40 Fowler Street's name has been changed a little over the years but its approach has been remarkably steady. Whether as a Black Elks Hall, neighborhood center, or branch YMCA, the Carver building has always been a community resource.

 The proposal to make the Carver Center a historic landmark also verifies the history of the building and Mr. Jensen's presence. Written by Rebecca R. Mitchell in January 1977, the proposal mentions that the Carver building was offered for sale to a fund-raising committee comprised of members including Dr. A.L. Thomas, Sr.; *Mr. Hilmer Jensen* [my emphasis], Dr. William Wetzel, Mr. Moses Johnson, Mrs.

Louise Austin, Mr. Willie Williams, Mr. Squire Newsome, Mr. Charles Freeman, Dr. Charels Broaddus, and others.

The proposal also notes that on New Year's Day 1944, the building was formally bought by the YMCA and named "Carver" in honor of George Washington Carver, the black scientist of Tuskegee Institute. The proposal states that the building became the focal point for community activity and the regular meeting place for local civic and social organizations. The YMCA hosted conferences of the NJ Federation of Colored Women's Clubs and the state conference of the NAACP. In 1975 the building was bought by the NJ Federation of Colored Women's Clubs and became the club's headquarters. An interview with Florence Bishop on March 3, 2005, confirmed this information.

5 An interview with Leslie Hayling on March 29, 2005, confirmed that the late Leon Higginbotham, Jr. frequented the Carver YMCA around the time that Tom Malloy was there, noting "Tom Malloy was always around when we were kids at the Y. He was older than we were." Hayling remembers that Higginbotham enjoyed playing basketball, pool, and tennis with other boys including former New York Mayor David Dinkins.

Higginbotham became a chief judge emeritus of the United States Court of Appeals for the Third Circuit, and an internationally known advocate for human rights. Higginbotham was appointed to the federal circuit bench by President Jimmy Carter in 1977, after having served as a federal district court judge in the eastern district of Pennsylvania for thirteen years. Higginbotham served as public service professor of jurisprudence at Harvard University's John F. Kennedy School of Government and was appointed commissioner of the United States Commission on Civil Rights by President Bill Clinton in October 1995.

Citing Higginbotham's commitment to equality and civil rights, President Clinton awarded Higginbotham the Presidential Medal of Freedom, the nation's highest civilian honor, in September 1995. After retiring in 1993 from the Court of Appeals, Higginbotham served as an international mediator during South Africa's 1994 elections and was counsel for the Congressional Black Caucus in a series of voting rights cases before the United States Supreme Court.

Higginbotham was of counsel to the law firm of Paul, Weiss, Rifkind, Wharton and Garrison. He served as vice chairman of the National Commission on the Causes and Prevention of Violence under President Lyndon Johnson and as commissioner of the Federal Trade Commission under President John F. Kennedy, becoming the youngest person to hold that post. Higginbotham is also former president of the Philadelphia chapter of the National Association for the Advancement of Colored People.

The recipient of more than sixty honorary degrees, Higginbotham earned a bachelor's degree from Antioch College in 1949 and a law degree from Yale Law School in 1952. Since 1964, he has received several national and international awards, including One of the Ten Most Outstanding Young Men in America; Outstanding Young Man in Government; and the Martin Luther King Award for outstanding service in the field of human rights. Biography of Higginbotham courtesy of *The Northeastern Voice* Web site: http://www.voice.neu.edu/960516/ higgin.html. The Info Please Web site, http://www.infoplease.com/ ipa/A0771107.html, notes that Higginbotham died on December 14, 1998.

6. Countee Cullen was born in 1903 in New York City. He attended DeWitt Clinton High School and was known as a metrical genius and a star of the Harlem Renaissance.

7. The WPA was established in 1935 by executive order, to offer work to unemployed people during the Great Depression. Congress appropriated $4,880,000,000 for highways and building construction, slum clearance, reforestation, rural rehabilitation, and other programs such as the Federal Writer's Project, the Federal Arts Project, and the Federal Theatre Project. The program was renamed the Work Projects Administration in 1939 and it was terminated in 1943. (See Info Please at http:// www.infoplease.com/ce6/history/A0852725.html, and *Encyclopedia of American History,* 7th ed. Jeffrey B. Morris and Richard B. Morris, eds., New York : HarperCollins Publishers, c1996.

8. The Lend-Lease Act passed Congress on March 11, 1941, and authorized the president to lease war material to any nation whose defense was considered necessary for U.S. national security. The act was initiated by President Franklin D. Roosevelt and provided aid to Great Britain, the Soviet Union, China, Brazil, and other nations. See The Great American History Fact-Finder at http://college.hmco.com/history/readerscomp/ gahff/html/ff_112700_lendleaseact.htm and *The Columbia Electronic Encyclopedia,* 6th ed. 2005.

9. Stacy Park originated in 1891 as a fill of dirt taken from the Assembly Chamber of the NJ State House, and it was made into a legislatively-sanctioned project in 1911. It was named after Mahlon Stacy, the founder of a gristmill that marked the originating site of the city of Trenton. The Park extends from "Calhoun Street to Brookville" or from the modern State House and the Old Barracks Museum to the Delaware River, and has since been partially overtaken by a parking lot for public employees, legislators and the planetarium. See *A History of Trenton*, Edwin Robert Walker, Princeton: Princeton University Press, 1930; "Trenton in Bygone Days: Our Municipal Parks," *Trenton Sunday Times Advertiser,* February 2, 1953; *Trenton Sunday Times Advertiser,* February 8, 1953; Sally Lane, "Stacy Park: A Little History," *Stacy Park News,*

Issue 1, Vol. 1, 1993. (*Stacy Park New* was a special section of *The Times*); "Kean Wants to Save Stacy Park Tree from the Ax," *Trenton Times,* July 25, 1989, A5; Jim Hooker, "A Tree Grows in Trenton and Will Continue," *The Times,* August 2, 1989, A1 & A7. These and other articles in the Trentoniana section of the Trenton Public Library do not mention work projects done on Stacy Park during the WPA years, but the project Tom worked on may have been a minor one that wasn't captured by local media. The aforementioned *Trenton Sunday Times Advertiser* articles from 1953 state that the park was a beautiful setting featuring a man-made stream.

10. Dwyer, "Bygone Days with Bill Dwyer," 25. See also "Local Artist to Receive Honorary Degree," *The Trenton Times.* February 1, 1992, B2.

11 The web site for Stuart Ng books, (http://www.stuartngbooks.com/catalog11faap.html), verified that the Westport Institute for Commercial Art existed as early as 1949.

12. In "Bygone Days with Bill Dwyer, Dwyer also mentions that Malloy's course was offered by the Famous Artists' School in Connecticut. A call to the school produced an interview with Robert Livsey, who stated that the school was founded around 1947. The web site of the Famous Artists' School, http://www.famous-artists-school.com/index.php/fas/about/, states that the school was founded by illustrator Albert Dorne along with other famous artists and illustrators including Norman Rockwell, Stevan Dohanos, Robert Fawcett, Ben Stahl, Harold Von Schmidt, Al Parker, Austin Briggs, Jon Whitcomb, Peter Helck, Fred Ludekens, and John Atherton. In 1981 the Famous Artists School and the Famous Writers School—also founded by Dorne—were acquired by Cortina Learning International, a leading publisher of home-study courses, which has continued Dorne's commitment to providing a complete course of study rooted in the basic principles gleaned from the knowledge of some of America's best artists.

13. Dwyer, "Bygone Days with Bill Dwyer," 25.

14 The Art Students League of New York was founded in 1875. "Post-Civil War prosperity effected an artistic awakening in some sections of America, most notably New York City, which in the 1870s was rapidly becoming the artistic capital of the nation. Its major art institution, the National Academy of Design (founded in 1825), was one of the oldest organizations of its kind in America....[W]hen it was rumored that the National Academy, due to financial difficulties, would cancel all classes until December[, s]tudents were alarmed.

"... Since there were no alternative means by which art students could engage in any formal course of study from live models, the students were particularly eager to deal with this dire situation before it was too late.... The result of their meeting was the formation of the Art Students League.... In addition, the students were dissatisfied with the rigid and limited course of study the Academy offered. They identified, and soon aligned themselves with, those artists who would soon form the Society of American Artists (and who would later become the chief instructors at the League).

"Like the National Academy, the League was established as a membership organization, but there was one major difference: unlike the Academy, where one had to be elected to a relatively small and elite group of artists, the Art Students League offered membership to any candidate with acceptable moral character and the means to pay his dues." Courtesy of the web site of the Art Students League: http://www.theartstudentsleague.org.

15 Diane Dixon, "Portrait of the Artist as an Older Man," 45-46.

16 *The Sunday Times Advertiser,* November 5, 1972.

17 Judi Mauro. "A Tribute to a Special Artist." *The Trentonian, Sunday Morning.* February 22, 1987, 43.

18. The WPA ended in 1943. The Great Depression lasted until the advent of American involvement in World War II.

19 The State Normal School was renamed the State Teachers College in 1937 and later became Trenton State College in 1957. It began in 1855 and was also called the Normal and Model Schools. Its main buildings were on the corner of Clinton and Monmouth Streets in the mid-19th century. See file on "State Teachers College" in the Trentoniana section of the Trenton Public Library.

20 "Economic Life." *Middlesex Somerset Mercer Regional Study Council Newsletter,* October 1984. Additionally, in 1950, 10,000 Trentonians worked in the metal-machinery trades and 4,500 workers were employed in other durable goods-producing industries such as stone, clay, glass and instruments

21 Viksjo, "City of Hope," F3.

22. See Diane Dixon, "Portrait of the Artist as an Older Man," 45-46. Most of the Roebling industrial buildings were in Chambersburg.

23 See *Now You're Set For Life: Oral Histories of the John A. Roebling's Sons Company,* under the entry for Tom Malloy: http://www.inventionfactory.com/history/RHAoral/malloynf.html.

24 Tom himself states that he worked at this factory for 24 years. Viksjo, "Art, Life: Practicing What He Preaches," CC1, states that Malloy spent "24 years at the Trenton Folding Box Co."; Idem "City of Hope," F4, notes that Malloy spent "23 years at the Trenton Folding Box Co." Also, in "Bygone Days with Bill Dwyer," 25, Dwyer claims that Malloy worked at Trenton Folding Box for "something like 25 years."

25. Warboys, "Trenton Artist Receives Lifetime Achievement Award," A4.

26. "Frank Malloy Sr., One of Trenton's First Black Lawyers," *The Trenton Times,* July 21, 2002, Obituary section, n.p.

27. Dwyer, "Bygone Days with Bill Dwyer," 25.

28. Viksjo, "City of Hope," F3 mentions that Malloy was a charter member of Trenton's NAACP chapter.

29.. The death dates of these individuals were confirmed by members of the Malloy family.

CHAPTER 4: THE SPIRIT ALWAYS CALLS

1. At the time of the formation of the National Baptist Convention of the U.S. in 1895, the convention had 3 million members and was the largest single denomination of black Christians in the world/ See *The Negro Almanac*, Harry A. Ploski, ed. (with Otto J. Lindenmeyer [and] Ernest Kaiser), New York: Bellwether Pub. Co., 1971.

2. John Wesley lived from 1701 to 1791. He founded the Methodist Church and preached in the streets and fields of England. Wesley traveled 250,000 miles on foot and horseback to spread the gospel, and he preached four or five times daily, preaching an estimated 40,000 or more sermons. Wesley wasn't welcomed in local English churches and was a victim of violence there. Wesley died leaving over 600 preachers to carry on his work, and at the time of his death there were nearly 200,000 Methodists. See *The People's Almanac*, David Wallechinsky and Irving Wallace, eds., Garden City, NY: Doubleday, 1975, pp. 1270-1271.

3. On November 14, 2002, Malloy added to the older interview discussion in the text by noting that Allen formed the AME Church because the northern and southern Methodist churches were disputing whether or not blacks could participate equally in services. Methodists had long since instructed blacks to receive communion last, as did servants in Europe where Methodism also resided. Allen thus declared that the AME Church would exist for blacks to worship, and Allen became a prosperous Philadelphia preacher. This account is confirmed by The African Methodist Episcopal Church Sunday School, which noted that Allen started his church to protest the inhumane treatment that blacks were forced to accept from whites at the Saint George Methodist Episcopal Church in Philadelphia. See *http://www.ame-church.org/amehist.htm*.

4. Asbury Methodist Church began in theory in 1923. Rev. Price Edwards began laying the groundwork for the church but lacked adequate finances. Later, the Delaware Conference of Methodists affirmed that the Trenton area needed a Methodist church to serve Trenton residents and others migrating from the South. The Conference founded the John Wesley Methodist Episcopal Church and appointed Rev. Charles W. Winder as pastor. The church name was soon changed to Asbury Methodist Episcopal Church, and news of the growing church began to appear in *The Trenton Times*. In 1925 it had fifty-three members and a Sunday School attendance of thirty-nine.

Also in 1925, Rev. Robert (R.W.) Cheers, of whom Tom speaks fondly, was appointed pastor of the church. He helped reorganize it, and the church moved to 533 Perry Street in 1928. The new site served as the church's home for the next 20 years. The church moved to 49 Fountain Avenue in 1945 and became much larger and more socially conscious throughout the years. In 1976, what was then known as Asbury United Methodist Church was merged with Cadwalader Heights United Methodist Church to form Cadwalader Asbury United Methodist Church. Other pastors of the church were the Reverends Joseph Bullen, L.S. Perry, W.A.T. Miles, A.W. Martin, Edward Holmes, Frederick D. Arnold, Perle E. Ford, Theodore M. Booth, Frederick D. Wilkes, J. Evans Dodds, and Willie Mae Nanton. Courtesy of the "Cadwalader Asbury United Methodist Church History 1924-2003," faxed to author on May 3, 2005.

5. Francis Asbury, namesake of Cadwalader Asbury Methodist Church, lived from 1745 to 1816. He was born in England and traveled to America as a missionary. Under John Wesley's direction, he became one of the most important Methodists of his time. He preached in Trenton for the first time on May 20, 1772. Asbury supervised the system of lay ministry and under his leadership, the Methodist church grew to be the second largest denomination in America. See the World Book Online Reference Center at *http://www.aolsvc.worldbook.aol.com/wb/Article?id=ar032940&sc=-1* and the Trenton Historical Society web site entry for Asbury Street at *http://trentonhistory.org/Exp/streets.htm*.

6. Dwyer, "Bygone Days with Bill Dwyer," 25. Dwyer confirms that the church used to be on Perry Street, although he does not provide an address as Malloy does.

7. Ibid.

8. These quotes are featured in (microcassette taped) conversation between Thomas Malloy and Melissa Chiatti on December 19, 2002. Chiatti is a Trentonian handicraft artisan and an amateur photographer who photographed Malloy paintings to assist the author.

9. As the United States evolved from a "fragmented, agrarian economy into. . .a powerful industrial economy. . .[t]he Victorian value system that prioritized restraint. . .gave way to the more relaxed morals of the twentieth century. In an increasingly consumer-based society, leisure and pleasure were now prized over hard work and self-denial."

A particular area of 1920s conflict was "the changing role of women in American society. . .[After] enjoying the freedom that comes from an independent source of income, many women created a new culture. . . . based on consumer culture and mass entertainment. Many, however, considered the new woman to be a threat to social morality and opposed the flapper

[the term for modernized women of the 1920s] and what she represented." Courtesy of the Ohio State University History Department web site: *http://history.osu/ed/Projects/Clash/Introduction/Intro.htm*.

10. Viksjo, "Art, Life: Practicing What He Preaches," CC6.

11. Archivists at Boston University confirmed that Reverend R. W. Cheers graduated from the Boston University School of Theology in 1922.

12. Dwyer, "Bygone Days with Bill Dwyer," 25 (notes Tom was a deacon).

13. Ibid.

14. The author's interview with Malloy on January 24, 2002, clarified that Malloy was a lay minister for only nineteen years. In "Art, Life: Practicing What He Preaches," CC6, Viksjo mentions that Malloy served in the lay ministry for 40 years. However, it is more likely that Tom served in various functions since his mid-twenties (putting the number of church service years at 60) and was a lay minister for only nineteen years. This fact is also supported by Viksjo's article "City of Hope"—which was written nine years after "Art, Life: Practicing What He Preaches"— where Viksjo claims Malloy was a preacher for "nearly 20 years." Dwyer's "Bygone Days with Bill Dwyer," 25, also supports the idea that Tom's church service varied over at least forty years.

15. Reverend Dr. S. Howard Woodson Jr. (1912-1999) was the Pastor of Shiloh Baptist Church in Trenton. He was well known throughout New Jersey as preacher, a civil rights leader, a legislator, a former Speaker of the House, a former member of the Governor's Cabinet, and a director of the Division of Equal Employment Opportunity and Affirmative Action. He served as president of the local branch of the NAACP and chairman of the board of the Carver YMCA and was called upon to speak around the country. In 1940, Woodson became the first graduate student to matriculate into the newly developed School of Divinity at Morehouse College. He also received the first graduate degree (Bachelor of Divinity) ever offered at Morehouse, going on to do his postgraduate work in sociology at Atlanta University. In 1960, while serving as president of the State Conference of the NAACP, Woodson convinced New Jersey Governor Richard Hughes to endorse some of the most progressive housing legislation ever enacted by any legislative body in the nation. Before leaving his post as the head of the Department of Civil Service, to which he was appointed in 1972, he encouraged the governor to issue an Executive Order creating the first Division of Equal Opportunity and Affirmative Action (EEO/AA) in the United States.

While still in the Legislature, Dr. Woodson led Shiloh's congregation in a building program that resulted in the erection of a new worship center, making Shiloh the first minority group to erect two new church buildings in a single century. Woodson also guided his church towards the adoption of numerous community outreach and internal development programs. During Woodson's tenure at Shiloh, clergy of all races met at Shiloh to help dissipate racial tensions before going out into the community to foster racial harmony. As a result of his personal involvement during these times of racial distress, Rev. Woodson was cited by the New Jersey State Legislature for helping to bring calm back to the city. Courtesy of the Shiloh Baptist Church Web site: *http://www.shiloh-trenton.com/woodsonbio.htm*.

16. Viksjo, "Art, Life: Practicing What He Preaches," CC6.

17. Viksjo, "City of Hope," F4.

18. Ibid.

CHAPTER 5: LOVE, WAR AND WISDOM

1. The Tindley Temple United Methodist Church grew out of Zoar Methodist Episcopal Church in Philadelphia. It was first housed in a building on Bainbridge Street in 1837 and it was named Bainbridge Street Methodist Episcopal Church at that time. In 1907 the congregation changed the name to Calvary Methodist Episcopal Church, and the name was again changed to East Calvary Methodist Episcopal Church in 1914. In 1924, the name of the church was changed to Tindley Temple, in honor of the distinguished Pastor Charles A. Tindley. Additional church history can be found at the church's Web site: http://www.gbgm-umc.org/Tindley/.

2. It is uncertain whether Methodists were the majority of World War II conscientious objectors. The author has attempted to confirm this fact but has not found confirmation to date.

3. Raymond Pace Alexander entered practice in 1923 in Pennsylvania, specializing in criminal law. In the late 1920s, Raymond established offices in Philadelphia. Between 1924 and 1950, Alexander represented clients in racial discrimination and segregation cases, in addition to being a defense attorney in numerous criminal cases, many of which involved a racial or civil rights issue.

Alexander's success brought him much publicity. Alexander was active in the Clark-Dilworth reform democratic movement and won election to the Philadelphia City Council in 1951 and 1955. In 1959 he was appointed to the Court of Common Pleas No. 4 by Governor George M. Leader and subsequently began a full ten-year term on that court. After his term expired in 1970, he continued in the capacity of senior judge until his death in 1974. Courtesy of the web site of the University Archives and Records Center of the University of Pennsylvania: http://www.archives.upenn.edu/faids/upt/upt50/alexander_rpa.html.

4. Selective Service registration allows the United States Government to maintain a list of names of men who may be called into military service in case of a national emergency requiring rapid expansion of the U.S.

Armed Forces. Federal law requires that men who are at least eighteen years old, but not yet twenty-six years old, must be registered with Selective Service. This includes all male noncitizens who permanently reside in the United States. Courtesy of the Web site of the U.S. Dept. of Homeland Security: http://uscis.gov/graphics/howdoi/selsvc.htm. An interview with Dan Amon of the Department of Public Affairs of the Selective Service on April 26, 2005, confirmed that the Selective Service had alternative public service programs for conscientious objectors during World War II.

5. Father Divine was a popular black religious leader whose real name was George Baker. Baker founded the Peace Mission to end poverty, racism, and World War I. He founded a New York church in 1915 and received nationwide support from many blacks.

 Tom recalls that at Divine's events, "Everyone came to New York to 'the big feast' where he came on the loudspeaker. Then they would go wild!" Yet Divine's personally luxurious lifestyle was criticized by the media, and his peculiar religion was accused of resembling a popular cult. His followers called themselves "angels," lived together in houses called "heavens," and began regarding him as God. Supplemental information courtesy of the *World Book Encyclopedia*, Chicago: World Book, Inc., 2000.

6. Dr. Harry Emerson Fosdick (1878-1969) attended Colgate University, Union Theological Seminary, and Columbia University. He was ordained in 1903. Among other positions, he was pastor of Park Avenue Church from 1929 to 1946. The church has since been renamed Riverside Church and is in New York City. Courtesy of the *World Book Encyclopedia Online*: http://www.worldbook.com. An exhaustive search was done to verify information about a Methodist Bishop Barry (from the era Tom mentions), but no significant information was found.

7. Tom recalls Everett Scott as the first black U.S. Secretary of War. The role of such an Everett Scott in U.S. government is not confirmed. Documents listing the past secretaries of war and army do not list Everett Scott. Courtesy of William Gardner Bell. *Secretaries of War and Secretaries of the Army: Portraits and Biographical Sketches.* Available at: http://www.army.mil/cmh-pg/books/sw-sa/SWSA-Fm.htm.

8. Admiral Richard E. Byrd (1888-1957) led the second major U.S. expedition to Antarctica in 1928. Courtesy of the *World Book Encyclopedia Online*: http://www.worldbook.com.

9. William Edward Burghardt (W.E.B.) DuBois (1868-1963) "emerged as a leading opponent of Booker T. Washington's accommodationist approach to securing civil rights for African Americans[,] advocating instead organized political and legal resistance to segregation. . .[H]e launched the Niagara movement in 1905 and in 1909 founded the National Association for the Advancement of Colored People. . .[He]

was the foremost early-20th century American proponent of Pan Africanism[,]," which was dedicated to "ending European colonialism in Africa, and was committed to promotion of universal friendship and tolerance, and sought the cooperation of sympathetic whites."

 After high school, DuBois was awarded a scholarship to Fisk University, from which he graduated in 1888. He then entered Harvard University as a junior and graduated *cum laude* in 1890. W.E.B. went on to complete a Ph.D. at Harvard.

 W.E.B. DuBois' writings include *The Souls of Black Folk* (1903); his dissertation, *The Suppression of the African Slave Trade to the United States of America, 1638-1870; The Philadelphia Negro* (1899); and a biography, *John Brown* (1909). In 1900, Dubois served as secretary of the first Pan-African Conference in London. He joined the U.S. Communist Party in 1961 at the age of ninety-three, convinced that the sources of racism were to be found in the capitalist system. In 1961 he accepted the invitation of President Kwame Nkruma to live in Ghana, and he became a citizen of Ghana in 1963. He died in Ghana and was buried there in 1963. Courtesy of *Encyclopedia Americana*, Danbury, CT: Scholastic Publishing, Inc., 2004, pp. 439-441.

CHAPTER 6: FIGHTING FOR SOCIAL JUSTICE

1. On April 26, 2005, Bobbi Kelly, employee at Pendle Hill, confirmed that Pendle Hill has been a Quaker center for study and social activism for decades, training service workers who were sent all over the world. Pendle Hill is located about three miles from Swarthmore College.

2. Amiri Baraka (1934-) studied at Rutgers and Howard Universities, served in the U.S. Air Force, and the joined artists, musicians, and writers in NY's Greenwich Village. An author, educator, and activist, he came to international prominence for expressing in compelling literary forms the revolutionary mood of blacks in the 1960s.

 Baraka's plays include *Dutchman* and *The Toilet,* and he also wrote music criticism, political essays, and experimental fiction. Originally, Baraka was an avant-garde Beat poet and boxer known as LeRoi Jones, but he took a Muslim name after the assassination of Malcolm X. In 1965, he founded the Black Arts Repertory Theater/School in Harlem and later founded the Spirit House Players in Newark. Baraka has taught at several universities. Courtesy of *Encyclopedia Americana*, Danbury, CT: Scholastic Publishing, Inc., 2004, p. 216.

3. Paul Robeson (1896-1976) was born in Princeton, New Jersey and graduated Phi Beta Kappa from Rutgers University in 1919, where he was an All-American Football Player. Robeson received a law degree from Columbia University in 1923, then gave up law for a career on the stage as a singer and actor. He was active in civil rights but eventually spent

much time in Europe where he was received with considerable acclaim. Courtesy of *Encyclopedia Americana,* Danbury, CT: Scholastic Publishing, Inc., 2004, p. 573)

4. W.E.B. DuBois, along with both black and white Americans, fought racism through the Niagara Movement between 1905 and 1910. They demanded integration and voting rights. The Niagra Movement's ideals and programs were transformed into the NAACP in 1909, and the NAACP remained an interracial organization.

5. The Trentoniana collection at the Trenton Public Library has numerous articles in its file on "Schools—Public— Integration." Tom confirmed that he assisted in integrating Trenton's schools some time before *Brown v. Board of Education of Topeka,* during the 1940s.

 "Paving the Way with Courage," Willie J. Smith, *The Times of Trenton Archive,* March 9, 2003) describes the circumstances surrounding New Jersey school integration in the 1940s, stating that the Hedgepeth and Williams families with the NAACP sued the Trenton Board of Education "59 years ago"—which would date the law suit back to 1944. The article states that the state Supreme Court ordered the desegregation of New Jersey's schools after the two families had attempted to register their children in the new Junior 2 school in their neighborhood instead of the black school miles away and the children were refused enrollment at Junior 2.

 See also "Pioneers for Equal Education: How Two Trenton Mothers Fought Segregation and Won," Jon Blackwell, *Trentonian,* February 13, 2005, 4) stating that the Hedgepeth and Williams families' attempted to register their children at Junior 2 in 1943, that Trenton schools' superintendent at that time was Paul Loser, that the Lincoln School began enrolling whites in 1946, and that "in 1920 there were 5,315 blacks in Trenton, four percent of the city. By 1950, they made up eleven percent of the city. Today the figure hovers around fifty percent."

 After the attempts to integrate Trenton's schools in the 1940s, subsequent efforts needed to be made, including a busing, which sparked a lengthy controversy in the 1960s and 1970s to achieve "racial balance" in the schools. During this controversy, the New Jersey courts both permitted and halted busing; the Trenton School Board voted to promote busing along with the Trenton NAACP, the Trenton Urban League, the Black Teachers Organization, the Human Relations Council, and the Cadwalader School PTA; and an organization called Parents Against Busing voiced strong dissent and used a variety of delaying tactics.

6. Tom is unsure of the first name and the spelling of the last name of Dr. Urbaniak. An exhaustive search for this person was done in the files on Trenton Public School integration in Trentoniana at the Trenton Public Library, but no Dr. Urbaniak is mentioned during the pre-Civil Rights Era period Tom mentions.

A Eugene T. Urbaniak served on the Trenton Board of Education during the late 1960s and early 1970s, but it is unclear whether he is the person Tom mentioned. Several Urbaniaks appear in the 1910 Trenton City Directory on p. 1019, although it is uncertain whether any of the following listings represents relatives of the Dr. Urbaniak that Tom speaks of: Frank Urbaniak, a laborer, at 820 Ohio Avenue; Joseph Urbaniak, a presser, at 721 Indiana Avenue; and Michael Urbaniak, a laborer, at 721 Indiana Avenue. Courtesy of the USGenWeb Archives by Desiree: http://ftp.rootsweb.com/pub/usgenweb/nj/mercer/history/local/1910dir01.tx.

7. Diligent efforts were made to discover Mrs. Yard's first name, but this information could not be obtained.

8. The Fellowship of Reconciliation was established during World War I. A European ecumenical conference had been held in hopes of preventing war, and two conference participants—Henry Hodgkin, an English Quaker, and Friedrich Sigmund-Schultze, a German Lutheran—pledged to work for peace despite the conference's failures. Christians later gathered in England in December 1914 to found the Fellowship of Reconciliation (FOR).

 The American chapter of the FOR was founded in 1915 in Garden City, New York. The FOR has since become an interfaith, international movement with branches in over forty countries and on every continent. The membership of the FOR includes people of myriad faith traditions and those with no formal religious affiliation. FOR staff worked with Martin Luther King, Jr. during the Montgomery bus boycott and held workshops in nonviolence throughout the South. Courtesy of the FOR Web site: http://www.forusa.org/about/history.html.

9. "Frank Malloy Sr., One of Trenton's First Black Lawyers," n.p.

10. Ibid.

11. Julian Bond (1940-) was an active civil rights leader and speaker. He became chairman of the board of the NAACP in 1998. Bond fought for civil rights in a variety of roles, including those of a student protester, Georgia state legislator, and university professor. Courtesy of the *World Book Encyclopedia Online* at http://www.WorldBook.com.

 Andrew Young (1932-) was also a civil rights movement leader. He graduated in 1955 with a divinity degree from Hartford Theological Seminary, was active in voter registration drives, joined the Southern Christian Leadership Conference led by Dr. Martin Luther King, Jr., and was elected to the U.S. Congress in 1972, 1974, and 1976. Young also served as mayor of Atlanta from 1981 to 1989. Courtesy of http://www.BlackHistory.com.

12. The Sherman Anti-Trust Act was passed by the U.S. Congress in 1890 to combat monopoly and improper restraints on business competition. It is a statute that has come to be regarded as the nation's economic

constitution. It is an expression of national faith in free competitive enterprise and is supplemented by the Clayton and Federal Trade Commission Acts. Courtesy of *Encyclopedia Americana,* Vol. 24, Danbury, CT: Scholastic Publishing, Inc., 2004, p. 708.

CHAPTER 7: ART BECOMES LIFE

1. CORE, or the Congress of Racial Equality, was founded in Chicago in 1942 by James Farmer. It "envisioned a national movement based on the ideas and tactics of nonviolence and direct action as propounded by Mahatma Gandhi. It focused on segregated public accommodations, discrimination in employment, voter registration, 'Freedom Schools' in the South, and the need of Northern urban black ghettos." (Courtesy of *Encyclopedia Americana*, Vol. 24, Danbury, CT: Scholastic Publishing, Inc., 2004, p. 566).

2. Author's interview and Viksjo, "Art, Life: Practicing What He Preaches," CC1.

3. Cathy Viksjo, "Artist Taps a City's Life for His Work." *The Trenton Times.* September 4, 1995; Viksjo, "Art, Life: Practicing What He Preaches," CC1; Viksjo, "City of Hope," F3.

4. An interview with Carl F. West, former executive director of the Mercer County Office on Aging, on April 26, 2005, confirmed that Tom won the Mercer County Citizen's Art Competition in 1968. Mr. West mentioned that he worked with Tom's brother Frank and that Frank suggested Tom enter the competition because he'd never formally exhibited his work. To Mr. West's surprise, Tom agreed to enter the competition. Tom went on to compete in the statewide competition.

5. In "A Dose of Urban Idealism: Trenton Painter to Lead Arts Crusade," (*The Trenton Time,*. February 24, 1992. AA2), Michael Jennings states that Tom became a full-time professional painter at age 57, in 1969.

6. Viksjo, "City of Hope," page no. unavailable.

7. Ibid.

8. Rex Gorley was a black painter and printmaker who had many art students. Courtesy of the web site entitled Pat Ward Williams: A Narrative Chronology by Moira Roth, where Pat mentions studying under Rex: http://thegalleriesatmoore.org/publications/pwwpww.shtml.

9. Elisabeth Stevens. "He's Preserving Trenton as it Is," *This Week Magazine,* December 12, 1975, 14.

10. Other shows were held at Studio 101 between May 1, 1976 and May 8, 1976 and between June 13, 1983 and July 2, 1983.

11. This show featured Tom's work and etchings by Etiore De Sanctis.

12. "Thomas Malloy: Artist of Month in Exhibit at Trenton YWCA," *STA,* November 1, 1970. (This article was found in the Trentoniana section of the Trenton Public Library. Attempts to discern the full title of the publication *STA* were made, but the full title could not be found).

13. Other artists featured were Walter Culberth, Frank Bridgewater, Wallace Conway, and Tom Overton.

14. Diane Dixon, "Portrait of the Artist as an Older Man," 45-46.

15. Louis Cooke, "Malloy's Marvelous Trenton," *The Trentonian,*. November 9, 1981, 31. (Cooke notes that this 1981 retrospective of Tom's work contained work from 1933 to 1981 and showed a "consistency of style.")

16. This show was called "Thomas A. Malloy Chronicles a City: An Exhibition of Recent Watercolors in Recognition of Black History Month." See "Library's End-user Lab Commended," *Review* (Trenton State College), Vol. 3, No. 2, Spring 1989.

17. See "Tom Malloy: Trenton's Artist Laureate," *Trenton Downtowner,* February 2002.

18. Judi Mauro, "A Tribute to a Special Artist," 43.

19. Louis Cooke, "Dean of Artists' at Ellarslie," *The Trentonian,* December 14, 1989, A9.

20. A May 4, 2005, conversation with Marguerite Daprile-Smith, from the New Jersey State Council on the Arts, confirmed that Tom was commissioned by the council board members as individual citizens and that the commission was not associated with state funds.

21. See Elisabeth Stevens, "He's Preserving Trenton as It Is," 14, for information about Tom's show at the Rider College Student Center in 1975, which featured seventy watercolors . On April 21, 2005, Donald Brown, director of Rider College's Center for Multicultural Affairs and Community Service and dean for multicultural affairs, confirmed that Mr. Malloy had a show at the Rider Multicultural Center around 1992. Brown noted that Malloy was "one of the artists" Rider had "coveted" for some time. Tom's honorary doctorate is mentioned in *Full of Promise: The Story of Rider College 1865-1994* by Walter A. Brower, Dean Emeritus. New Jersey: W.A. Brower, 1997. See also "Local Artist to Receive Honorary Degree," B2.

22. Dwyer, "Bygone Days with Bill Dwyer," 25; "Museum Show Reveals Awareness of Black Life," *The Trentonian,* September 27, 1982, 29. Viksjo, "Art, Life: Practicing What He Preaches," CC1, CC6; "Tom Malloy on the city as art," *The Trenton Times,* December 3, 1999, A19.

23. This fact has not been confirmed.

24. "Local Artist to Receive Honorary Degree," B2.

25. Joe Emanski, "Tom Malloy: Trenton's Artist Laureate," 7.

CHAPTER 8: THE ART OF TOM MALLOY

1. Viksjo, "Trenton Watercolorist is Realist," *The Trenton Times.* December 17, 1989, CC1.

2. Louis Cooke, "Dean of Artists' at Ellarslie," A9.

3. Viksjo, "Art, Life: Practicing What He Preaches," CC6.

4. Louis Cooke, "Museum Show Reveals Awareness of Black Life," *The Trentonian,* September 27, 1982, 29.

5. John Holley, director of the Trenton Symphony Orchestra, confirmed that Tom was asked to paint a scene depicting people in front of the War Memorial in 2000. The painting was to be a gift from the orchestra to the orchestra's trustees and owners.

6. Janet Hunt, director of Lambertville's Coryell Gallery, confirmed that Tom's work was exhibited there from April 20 to May 18, 1980.

CHAPTER 9: TRENTON'S SON REMEMBERS A CITY OF HISTORY, A CITY OF CHANGE

1. The Mercer County historical web site (http://www.mercercounty.org/history/history.ind_giant.htm) confirms this account of Trenton's founding: "From the earliest days, Trenton was a place coveted for its economic promise. This promise was first recognized early in the eighteenth century by Mahlon Stacy, a Quaker who settled in Trenton and built a gristmill in 1679. He had plenty of business; Trenton's fine soil produced enough grain for every farmer, and every farmer brought business to Stacy. Samuel Green and William Trent (the man for whom Trenton is named) built an ironworks and a forge, and later a mill for cloth. In 1743, Isaac Harrow built a plating and blade mill (on the site of the Old Barracks). Benjamin Bile built a tanning yard, and in 1755, Daniel Cox established his paper mill. Other industries sprouted as well, producing everything from flour to weapons for the revolution."

2. Trenton's pottery manufacturing compounds were spread throughout the city. The Mercer County historical web site notes that "In 1872, Thomas Maddock first successfully manufactured glazed earthenware here. It was extremely popular, and it gave Trenton the reputation of being the "Staffordshire of America," after the town of Staffordshire in England famous for its pottery." (http://www.mercercounty.org/history/history.ind_giant.htm).

 The painting referred to was later completed and sold instantly for $300 when exhibited at Tom's birthday celebration in August 2001.

3. Published by the Trenton Community Development Corp., p. 12.

4. Viksjo, "Art, Life: Practicing What He Preaches," CC6.

5. Molly Merlino, interview with author, Trenton, December 9, 2002.

6. Napoleon's brother's Quaker mistress, Annette Savage, was buried in Trenton. The fact that she convinced her lover to flee to the United States is not confirmed.

7. The *Abstract of the 14th Census of the Population:1920* (U.S. Bureau of the Census; found in the Trentoniana section of the Trenton Public Library) states that in 1920, Trenton had 119,289 inhabitants (p. 58 – Table 12 – "Population of Cities and Other Incorporated Places Having in 1920, 2,500 Inhabitants or More, Arranged in Groups According to Population: 1920 and 1910").

 Page 108 of the *Abstract* (Table 30 – Color or Race, Nativity & Parentage, for Cities Having 100,000 Inhabitants or More: 1920) states that Trenton had 114,902 whites (96.3%); 4,315 "negroes" (3.6%); 6 Indians (Native Americans) (0.1%); 63 Chinese (0.1%); 1 Japanese (0.1%), and 2 people described as "other" (where "other" is defined on p. 14 as "Filipinos, Hindus, Koreans, Hawaiians, Malays, Siamese, Samoans & Maoris) (0.1%). Additionally, in 1920 Trenton had 30,168 foreign-born inhabitants (25.2% of the population) and 20 of those foreign Trentonians were Mexicans (*Abstract* p. 315, Table 75 – Country of Birth of Foreign-born Population, for Cities Having 100,000 inhabitants or more: 1920; and Roscoe L. West, *Age-grade Study, Trenton, NJ,* 1923, (found in Trentoniana collection. Publication information on this book could not be obtained either from the text itself or from Library of Congress records).

8. Phillipa Duke Schuyler, was an American concert pianist and writer, born in 1931 to a black father and a white mother. By the age of four, Schuyler proved to be a musical genius, with uncanny talent as a pianist. It is said that Schuyler's mother physically abused her and did not allow her to attend school. Schuyler was geographically isolated from other black children, but her piano teachers attempted to open doors for her. As an adult, Schuyler faced many challenges, finding success as concert pianist and as a biracial child. Schuyler toured South America, Europe, and Africa and later came to deny her black heritage. Schuyler died in a helicopter accident in Vietnam in 1967. Courtesy of *The Encyclopedia Encarta Africana Online*: www.africana.com/research/encarta/tt_056.asp and Blackseek.com: http://www.blackseek.com/bh/2001/210_PDuke.htm. A February 28, 2005, online edition of the *Miami Sun-Sentinel* noted that famed singer Alicia Keys is slated to play Schuyler in a biopic produced by Halle Berry, http://www.sun-sentinel.com/sports/sfl-mu28aliciafeb28,0,3885026.story.

9. Fitzgerald's Trenton Directory from 1933 confirmed that the Gaiety Theatre was in East Trenton on 101 South Olden Avenue. The theatre was open from 1926 to 1950.

10. Billy Sunday (1862-1935) was a professional baseball player from 1883 to 1891 for Chicago, Pittsburgh, and Philadelphia teams. He was converted to Christianity through the street preaching of Harry Monroe of

the Pacific Garden Mission in Chicago. He left a $5,000 a year salary as a baseball player for a $75 a month for the previously evangelistic YMCA. He was an evangelist from 1893 to 1935. It is estimated that over 300,000 people were converted under the leadership of Billy Sunday. (*See* Elgin S. Moyer . *The Wycliffe Biographical Dictionary of the Church*, 387. (1982). *See also* The Bible Believers Web site: http://www.biblebelievers.com/billy_sunday/sun8.html).

11. Michael Jennings. "A Dose of Urban Idealism: Trenton Painter to Lead Arts Crusade," AA2.

12. "Library's End-user Lab Commended," *Review* (Trenton State College), Vol. 3, No. 2, Spring 1989.

CHAPTER 10: WE'VE COME THIS FAR

1. Cathy Viksjo, "Artist Taps a City's Life for His Work."

CHAPTER 11: AN ARTISTIC LEGACY

1. Mary Sue Henifin, "Tom Malloy on the City as Art," *The Trenton Times,* December 3, 1999.

2. The Passage Theatre was founded by Virginia Brady. June Ballinger, the theatre's current director, has also been working with Tom Malloy since 2004 on an oral history and stage production on elderly Americans and their perspectives on Trenton's past.

3. In 1978, journalist Diane Dixon stated that Tom had received over fifty-three prizes and awards. At least seven more awards, and most likely more, have been awarded to Tom since then.

4. Tom was featured on NBC Channel 10 with Edie Huggins on February 9, 2002, after being named Artist Laureate of Trenton. See also Anne Levin, "Trenton Honors Tom Malloy as Artist Laureate," at *NJ Online: The Times,* January 17, 2002, at www.nj.com/features/times/index.ssf?/features/times/01-17-IIQD2AED.html.

5. See Joe Emanski, "Tom Malloy: Trenton's Artist Laureate," *Trenton Downtowner,* February 2002, 6.

6. "Local Artist to Receive Honorary Degree," B2.

7. Anne Levin, "Trenton Honors Tom Malloy as Artist Laureate," AA1 and AA12; and Viksjo, "Trenton Watercolorist is Realist," CC1.

8. Dixon, "Portrait of the Artist as an Older Man," 45-46.

9. This program is mentioned on an NJN Web site at www.njn.net/about/pressrelease/04archive/04oct-startsmonth.html.

10. Ibid.

11. Arnold Ropeik, "Honoree Profile: Thomas Malloy," *The Trenton Times,* November 10, 1989, 27.

CHAPTER 12: THE EVER-BLENDING, UNFADING COLORS OF LIFE

1. Viksjo, "Trenton Watercolorist is Realist," CC1.

2. Viksjo, "City of Hope," F4.

3. The date of Frank's death was verified by the Malloy family.